LEONIE

DECLAN BURKE-KENNEDY

POOLBEG

Published in 1995
by Poolbeg Press Ltd
123 Baldoyle Industrial Estate
Dublin 13, Ireland

The moral right of the author has been asserted.

The Publishers gratefully acknowledge the support of The Arts Council.

A catalogue record for this book is available from the British Library.

ISBN 1 85371 501 8

Cover photography by Mark Nixon
Cover design by Poolbeg Group Services Ltd
Set by Poolbeg Group Services in Goudyd 11/13.5
Printed by Colour Books Ltd
Baldoyle Industrial Estate, Dublin 13.

For
Mary Elizabeth

"The here and now was always melting before the head of a dream coming towards me or its tail going away. I would be twenty before I learned to be fifteen, thirty before I knew what it meant to be twenty . . . "

Arthur Miller
Timebends

"Boys do not grow up gradually. They move forward in spurts like the hands of clocks in railway stations."

Cyril Connolly
Enemies of Promise

1960

Chapter One

THE FIRST HE heard of the curfew was the night he woke up calling his sister, Angie. Leonie snapped at him as he stumbled into her room, and brought him to his senses with one of her stinging slaps in the face.

"That's for spyin', Cormac Mannion. I'll tell your auntie you were creepin' about the place, spyin'."

Cormac was too stunned to speak. He looked around the strange roof-shaped room.

"An' the Comma'dant'll have somethin' to say too when he finds out there's a spy in the house."

She steered him back across the landing to his bedroom and tucked him in tight.

"I s'pose you were jus' walkin' in your sleep, that's all."

He looked up at her and said nothing.

"Poor mite. I'm sorry I flew at you, but you gave me a woeful fright so you did. In this house you're not s'posed to leave your room after the curfew. That's the Comma'dant's rule, not just your auntie's."

Tonight there was no sound from Leonie's room. A strip of light on the landing told him she was still awake – studying her teeth in a hand mirror, maybe; or flicking through some of the love comics he'd seen on her dressing table. He waited to hear coughing or pages turning. Nothing.

He crept down the bare wooden staircase. The door

separating the rest of the house from what Aunt Maeve called the servants' quarters was closed but not locked.

From outside his aunt's room he could hear her talking to herself. She always muttered in her sleep, even when she nodded off in the verandah after lunch. He was used to waiting for this signal before sneaking off to his uncle's stables or the railway bridge beyond the orchard.

Cormac hurried down the carpeted landing, past the Commandant's quarters: that room was *definitely* out of bounds. If he was caught in there he risked being reported to his uncle when he returned from Africa. The Commandant was a stickler for rules and would take no nonsense from anyone.

When he got to the kitchen he tiptoed across the tiles and stood on a chair in the pantry. He knew the mare liked sugar as well as carrots so he filled both his pockets, taking care not to leave any traces.

He reached up to unlock the back door but the bolt was already back: Leonie must have left it open. She was in big trouble if Aunt Maeve found out. He had heard her being scolded one day for not wearing her maid's uniform right; another time his aunt had threatened to dock her pay for pilfering food for the gardener. Leonie's big round eyes were red with tears for the rest of that day.

There was a clear moon and the air was sharp. Looking back he could see the light from her dormer room. The house, so often a prison to him that summer, was winking at him now, urging him on. He ran down the garden towards the orchard.

Suddenly his legs froze. There was a dark rumbling sound: something was moving beneath the earth, making it shudder. He stood motionless, waiting for the orchard to crack open. Then, with a sharp metallic crash, a goods train burst from the shadows of the railway bridge and thundered past the end wall of the garden, its iron wheels hammering the joints in the tracks.

He sat on the orchard grass and felt the earth beneath him tremble. How could Leonie and his aunt sleep through such a commotion? Even after the last carriage had brushed past the garden wall, the echoes shattered the night.

The grass was damp and he thought of the stable and the

warm straw. Corporal Dwyer had told him the mare stretched out for an hour or so in the middle of the night: if you were lucky you could sit beside her and stroke her ears.

Cormac jumped up and checked his pockets: his supply of sugar lumps and carrots was intact.

In the stable he found the mare lying down, and she lifted her head and peered at him with her enormous brown eyes. If she stayed in that position it was a sign she liked you, the Corporal had said. "Sarah. It's only me," he whispered, moving slowly towards her. The mare continued her long, slow blinking and made no attempt to rise. "I brought you a midnight feast."

She sniffed the carrot he offered her before twisting her lower lip around it and folding it into her mouth. Cormac knelt on the straw beside her and placed a hand between her ears. She munched slowly and he smiled: it was the sound of the recruits' boots bashing the parade ground the day he arrived in Drumaan.

The mare half-closed her eyes and Cormac watched her chewing. "You can't have any sweet things till you eat all your carrots," he told her. She munched on intently. *You don't have to tell me the house rules*, she seemed to say. *I've been living here longer than you. For donkeys' years, in fact.*

Cormac stayed beside her for a long time, stroking her face and telling her how beautiful she was. She expelled gusts of air from her nostrils and he took deep breaths and exhaled the same way. Eventually she put her head back down on the straw – and, as he watched her eyes grow heavy, he rested his face against her warm neck.

The day he arrived in Drumaan he had stood on the empty platform clutching his uncle's telegram.

Estimated time of arrival 1500 hours. Will be met by Corporal William Dwyer. Winter clothes to be collected later if you are to stay on after holidays. Decision will be based on conduct over summer months. Best wishes to father and sister. Uncle Frank. (Commandant Francis D. Connolly)

Corporal Dwyer turned out to be a squat man with a tanned, bristly face. He had black bushy eyebrows and stared out at Cormac from under them as he rolled a cigarette. The train creaked and groaned out of the station.

"So, you're the visitin' dignit'ry I was dispatched to collec'."

Cormac nodded.

"Well, c'mon then. Don't just stan' there gapin'."

As they left the station the Corporal spat tobacco particles on the ground. "You'd wan' to pull up them socks before you meet the Comma'dan'. He's a stickler for the rules, your uncle. A real stickler so he is."

They drove to the military barracks in an army jeep, racing across the side roads of the Curragh. The tyres screeched at bends and sheep fled on either side.

The Corporal glanced at Cormac. "So, what age are you, Master Cormac, if that's not too pers'nal a question?"

"Ten and a half. Well, ten and a bit, actually."

"Ten and a bit. Is that a fac'?"

He swerved to avoid a sheep and just managed to hold the jeep on the road. Cormac clung to his seat with both hands.

The Corporal smiled. "You'll be movin' up to second'ry so, the same as me own young blaggard."

Suddenly they jolted to a halt and the Corporal pointed to a crater not far from the road. "See that holla there?" Cormac looked at a large, scooped-out patch of earth overgrown with weeds and grass. "That's where a Jerry pilot ditched a bomb durin' the last worl' war. He was scarperin' home after bombin' the be-jaysus outa Belfas'. I heard th'explosion from inside in me billet an' thought 'Holy God, Dev's after changin' his mind an' declarin' war'. The question was, though, who'd we be fightin', the Jerries or the Brits?"

Cormac stared at the hollow.

"It was de Valera, y'know, kep' us out of that war – the on'y dacen' thing he done all his life. He stood up to that oul' win'bag Churchill and tol' the bugger where to lave off. An' Churchill near choked on one of his fat cigars so he did."

Near the hollow a ram was clambering on the back of a grazing ewe. The Corporal began to roll another cigarette and made no secret of his interest in the spectacle.

"Wait'll you see when he gets it up," he chuckled. "A ram's horn is near as long as yer arm so it is, I swear to God."

In the barracks Cormac sat on a bench watching recruits being trained for parade. They were instructed by a Drill Sergeant with a strong Scottish accent.

The Corporal leaned close to Cormac's ear. "Paddy the Scotchman, we call him. He grew up in Glasga. They say he's got a Nazi bullet stuck in his ribcage an' it still burns him whenever he's crossed."

"Chrisht in Heav'n," the Sergeant shouted angrily at the parade. "D'ye call this a shtraight line? It's as crooked as a cow's pish in shnow."

The Corporal nudged Cormac and smiled. One of the recruits laughed and the Drill Sergeant charged up to him, roaring commands in his face. Then he ordered the men to stand to attention, turn left, turn right, march in place and present arms, till a coating of saliva formed on his mouth and flew in all directions.

In a calmer moment he told them his special formula. "Th'important thing is to shtand bolt upright, shtraight as a die. Imagine ye're tryin' tae pull a six-inch nail oot of a wall wi' the cheeks of yer arrse."

The whole group broke up in laughter at this and the Drill Sergeant smiled too. Then, after some more yelling and drilling, he winked at Cormac and, to the relief of the recruits, dismissed the parade.

The men relaxed, leaning their rifles against walls and talking in hushed voices – but when the Commandant appeared they jumped to attention and saluted, hiding their cigarettes. Corporal Dwyer saluted too and nudged Cormac to stand up.

The Commandant was a tall man with a blank square face – like one of the cut-outs marksmen use for target practice. He

narrowed his eyes as he examined his nephew from head to toe. His voice was deeper than the Drill Sergeant's but almost as loud.

"Well, boy, what do you think of the army life? This is the first step in turning boys and namby-pambies into fighting men. Stand up straight when I talk to you. Well?"

"It's very . . . nice, really."

"Hmm! I'm not so sure about that. Pull up those socks like a good lad."

When Cormac straightened up again his uncle patted his head and ordered him to accompany him to the barracks gate. On the way he bellowed on about how sad it was that Cormac's mother had "relinquished her post" at such a young age; it was important he didn't brood about it and become depressed. "We don't want you growing into a sissy. Whimpering's for girls, not for soldiers and young men. You've a duty to your mother's memory from now on, always remember that."

Aunt Maeve was his mother's sister and she was never one to shirk her duty; she would look after his education, depending on how he behaved in Drumaan over the summer months; he was to do everything he was told and to show respect at all times. The Commandant was going to the Congo with the United Nations – to put some manners on the rebel tribes – and he would be counting on Cormac to acquit himself well. The alternative, of returning to Westmeath to live with his father, would not be in Cormac's best interest. And he repeated that many times with minor variations: not *really* in his best interest; not *at all* in his best interest; *certainly* not in his best interest.

Corporal Dwyer was at the barracks gate, talking to a young woman. She had a bright, round face and wore a navy-and-white spotted headscarf tied under her chin. She was carrying a shiny blue raincoat over one arm. When she saw the Commandant coming, she stepped back and the Corporal turned and saluted again.

"This is Leonie," the Commandant declared. "She'll walk you to the house. It's a long walk, so I'll have your cases brought

home. And remember, boy, stand up straight. We'll make a man of you in Kildare, you can be sure of that."

As Cormac set off across the Curragh with Leonie, she pulled off the spotted scarf and shook out a mass of shiny black curls. One of the sentries at the barracks gate whistled. She scowled as she glanced at him, but she was smiling when she turned around again.

She had a good-looking face and the kind of girl's figure older boys called "a real handful". Her eyes were almost the same shiny blue as her coat. She hummed various pop songs, swaying her hips to make her skirt swirl around her legs. Occasionally she sang a line or two of the words.

> "So, when your baby leaves yuh
> And yuh wanna new place to dwell
> Jus' hmm hmm down Lonely Street
> And stay in Heartbreak Hotel . . . "

Cormac thought of his mother crouched at a flowerbed at home, scuffling the soil with a hand trowel. She had hummed too, in between telling him the names of various flowers and shrubs: lupins, azalea, clematis and lavender. They all had some special feature. *Rosemary is for remembrance*, she had said one day and smiled at him. Then she had gone on humming and scuffling the dry brown earth.

Leonie looked around and caught him gazing at her. "What's up?"

"Nothin'."

She picked some poppies and put one in the buttonhole of his jacket. "Red suits you so it does. It matches your cheeks."

"Poppies are for soldiers who die away from home."

"Who tol' you that?"

"My mothe . . . I read it in a book."

"A book? A poppy book was it?"

He decided to ignore that. "Do you know what I think?"

"What?"

"I think it was Dev who kep' Ireland out of the last war."

9

"Is that a fac'?"

"Yeah. It was the best thing he ever done . . . did. He told that old windbag Churchill to mind his own business. And he near choked with a cigar."

"Who? Dev?"

"No. Churchill."

She smiled. "What age are you anyway?"

"Ten and a half, nearly eleven."

"Imagine."

"What age are you?"

"D'you not know it's bad manners to ask a girl the likesa that? Have ye no manners at all beyond in Wes'meath?"

"We do so. More than ye have in Kildare."

"Then don't argue with your elders."

She warned him then against breaking any of his uncle's or auntie's house rules, listing them off in a posh voice that was meant to be an imitation of his Aunt Maeve.

"Why's there so many rules? It's not like that at home."

"Why, why-oh-why?" she chanted. "'Why did the young prince have to live among fools, surroun'ed by high walls, fenced in by rules?'"

"Where'd you learn that?"

"I made it up."

"You did not."

"I did so."

A drop of rain brushed against Cormac's face and he looked at the bare landscape. There were no high walls here: no walls at all – and no trees either. Small clusters of gorse were the only shelter.

"Who owns this place?"

"The Curragh? No one owns it. It's common land. Did your poppy book not tell you that?"

A raincloud was sweeping towards them, trailing a dark veil. Leonie cursed under her breath and tied her scarf back over her hair. Then, pulling on her coat, she ran towards a gorse bush. After a moment he followed and crouched beside her. Within

seconds there was a heavy downpour and the rain and hail pelted their heads and shoulders.

"Imagine: hail in June," she muttered. "The world's gone mad entirely, there's no doubt about it."

"It might snow yet."

"It might. An' then again it mightn't."

He had nothing to add to that so he said nothing.

"Did you spen' much time with the Corp'ral?" she asked as the shower eased off.

"Yeah. He's nice. He showed me where the Germans dropped a bomb."

"He drove you out there?" She shook out her scarf and made her way back to the road. "Why do you think he's nice?"

"He's friendly. But he's not as funny as the Drill Sergeant. The Sergeant's a *real* character."

She seemed to lose interest then and he felt a great urge to tell her the Scotsman's formula for getting recruits to stand up straight – but maybe she wouldn't think it was funny. It would certainly be against the house rules.

Instead, he walked on in silence while she hummed "Heartbreak Hotel" for the umpteenth time.

Suddenly he was awake and the mare's coat was shuddering. He looked around the stable. There was a scratching sound from the loft. Rats!

The scratching grew louder and the mare raised her head from the ground. Cormac glanced up at the open trapdoor above the manger and clung to the horse's mane. The sounds clearly upset the horse: she puffed and burred as she struggled to her feet.

Cormac stood beside her, still clutching her mane. It was dawn and a cold light was creeping under the stable door. He kept his eyes fixed on the opening above the manger.

The noise got worse. If they're rats, he thought, they must be in mortal combat. There was a gasping sound that seemed almost human. Then he heard a crescendo of shuffling and floorboards creaking. The mare whinnied and the commotion stopped.

"Good girl, Sarah," he whispered. "You frightened them away."

After some minutes listening to his own heart pounding, he climbed up on the metal bars of the manger and raised his head through the opening. The hayloft was darker than the stable and he couldn't see much at first.

"What's that? I heard somethin' . . . " It was a woman's voice.

A male voice replied: "Keep yer hair on, it's on'y the fuckin' mare."

There was giggling then and a lot of commotion. "Curse them friggin' hayseeds anyway," the woman said.

"Lie still, will you girl. You're worse 'n a ewe with a flea, I swear to God. I'll tell you what: let on you're tryin' tae pull a six-inch nail oot of a wall wi' the cheeks of yer arrse."

The Corporal's words and his attempt at a Glasgow accent sent Leonie into such a fit of laughter that Cormac wished he had spoken up the day they had walked together from the barracks. She laughed so much she had to sit up to catch her breath. The Corporal sat up beside her, putting an arm around her shoulder. Cormac stared in amazement: neither of them was wearing a stitch of clothes.

He stayed as still as he could, his feet balancing on the manger below. The Corporal stroked Leonie's breasts, squeezing the tips between his finger and thumb. At the same time she had a hand between his thighs, and moved her fingers – till he began to look a bit like the Curragh ram they had watched from the jeep.

After a while he rolled Leonie on her front and crouched over her on all fours, looking even more like the ram. Then he lay down on top of her and they disappeared behind a mound of hay. Cormac could hear Leonie gasping for breath. "That's gorgeous, Bill. Keep it like that . . . Oh God! . . . " The motion of their bodies swept the hay beneath them aside and her bare flesh brushed against the floorboards.

The mare whinnied and Cormac lowered himself quietly down to the stable floor. He put both arms around her neck and stayed there for some minutes. Then, as the sounds from the hayloft began to subside, and with them the strange hollowness

in his own belly, he tiptoed to the stable door and made his way back to the sleeping house.

* * *

His cousin Peter claimed Cormac had made up the story about the Commandant's boots. Cormac said he hadn't made it up: they had really tried to attack him. They probably would have trampled him to death if he hadn't got out of the Commandant's room fast. Like a bullet.

He tried to ignore his cousin by hammering a handball against the lawnmower shed door. He was glad he hadn't told him about the hayloft: he'd never have believed that.

Peter hung around and wouldn't go away. "You made it up, Creep. You're tryin' to be famous, I suppose."

"I am not."

"You know what I think? I think Ireland is the most backward place in the whole world. More backward than Ghana even, and that's sayin' a lot."

"Piss off."

"I'm glad I'm not stayin' in this country for long more."

"So am I."

"I couldn't live with a crowd of spooks who think boots can attack them."

"Why don't you pack up and go back to Rhodesia. No one wants you here."

"Don't worry. I'm goin' as soon as my mother's finished her business."

"Good." Cormac kept playing the ball against the shed door.

Peter hovered about, scuffling the ground with the toe of his shoe. "What age are you anyway?"

"Mind your own business."

"I bet you're not even twelve."

"So what?"

"So you're on'y a kid. That's why you're scared of the Commandant's boots."

"I'm not scared, *you* are. You never stop talking about them."

"I bet you never shot a wildebeest."

"A what?"

"A wildebeest, Creep. Don't tell me you never heard of a wildebeest."

"I did so. I just didn't hear you the first time, that's all."

"Well, me an' my Dad go on safari every summer . . . " His voice suddenly faded. "I mean . . . until . . . "

Cormac stopped playing with the handball and looked at him. Peter stared back emptily, his face darkening. "Well, at least my father wasn't a stinkin' drunk." With that he turned and ran indoors.

Cormac wondered what all the fuss was about: the Commandant's quarters was a dressing room and study, that's all. The shelves were packed with old books and trophies. There were pictures of the Commandant on horseback, bending down to accept rosettes from men in bowler hats.

"He jumps for Ireland, you know," Aunt Maeve had told Cormac one day: it had taken him a while to figure out that she meant on horseback.

His heart jumped too when he opened one side of the wardrobe and saw pygmy soldiers swinging by their necks. To his relief they turned out to be army uniforms neatly arranged on hangers. In the other side of the wardrobe he found hunting jackets and jodhpurs. On the floor there were knee-length riding boots with wooden "trees" in the shape of human legs. The boots were black and shiny like the Commandant's best saddle, the one the Corporal was always polishing.

Suddenly the boots started to tap, as if warming up to some ancient tribal dance. As Cormac stared at them open-mouthed, they began to shuffle out of the wardrobe towards him.

He tried to slam the wardrobe door, but one of the boots kicked it open and hopped on to the floor; it was followed immediately by its companion. Then they both stood to attention in front of him, like soldiers waiting to attack.

14

As he ran from the room, a table crashed to the floor behind him, books and trophies flying everywhere. Sooner or later he would be caught – either by Aunt Maeve and Leonie; or, even worse, by the boots themselves clattering up the attic stairs to his bedroom some night when he was trying to sleep. All he could do in the meantime was lie low and keep his door locked.

One morning he heard Peter complaining to Aunt Maeve and his mother. "She wouldn't even answer me. All she does is listen to that radio and sing stupid pop songs."

"And what did you want, dearest?"

"Just another glass of lemonade, that's all. I bet she's savin' it for that stinking soldier who cleans out the stables."

"I'll talk to her, Peter. She has no right to . . . "

Aunt Flo intervened. "Maybe it's the way you asked, Peter darling. Try to understand: it's her job to make sure there's enough of everything to go around."

"Then she's not doin' it very well, is she? I only wanted a small glass."

"Really, Peter!"

"It's all right, Flo. Maybe he has a point. I'll have to talk to the girl. Why don't you run along now, like a good boy, and play with your cousin. Your mother and I have business to discuss . . . "

When Peter and his mother were leaving, Aunt Flo came to the dining-room. Cormac was doing a jigsaw he'd brought from Westmeath. He nearly had all the edge bits joined up when she put her head around the door.

"Cormac dear, I just came to say goodbye."

"Goodbye."

"I'm sure you'll be happy here with your uncle and aunt. Uncle Frank will be back from the Congo soon, so don't worry."

"I'm not worried."

"He may come and stay with us for a while in Salisbury before he comes home. I'll tell him how well you're settling in." She came fully into the room and put her bag on the table. "And one

more thing: thank you for being so kind to Peter. I know he's a bit . . . difficult at present." She powdered her nose, examining her face in a hand mirror. "He really misses his father, you know. Anyway, I hope he wasn't too bossy."

"No, we'd a fabulous time."

Aunt Flo bent down and pressed a powdery cheek against Cormac's forehead. "Now, don't get up. We'll just slip away quietly. This is for you, a little memento." She slipped a coin into his hand and left, pausing to wave back from the door. "You're so like Rosemary, you know. So like her it's . . . uncanny." Then she was gone.

He looked at the coin: on one side there was an image of the English Queen instead of a harp, and on the other a weird animal where there should have been a pig. In small letters it said: "African wildebeest."

Aunt Maeve and her bridge friends were on their third or fourth sherry. From his hiding place behind the curtain Cormac watched the blurry figure of Leonie moving around the card table. She had a decanter and was refilling their glasses.

Aunt Maeve dealt the cards. "Well, what were we to do? We couldn't just build a moat around ourselves. As Frank says, 'Family is the first line of defence.'"

"A saintly act, Maeve, there's no doubt about it," one of her friends chanted in a sing-song County Cork voice and pointed towards the ceiling. "It'll earn you bonus points up there, I'm quite sure of that." Leonie topped up her glass.

Another card player spoke with a husky Northern voice. "But Maeve couldn't have left the wee lad at the mercy of a man in that state, Elsie. Thank you, Leonie."

"There are many who would have, Olive. Believe you me."

"God spare us from men who can't handle their liquor, that's what I say."

"I said to Frank 'Frank,' I said, 'it's the boy I'm thinking of. The girl's old enough. We'll contribute to the cost of her schooling. She'll be finished in a year or two anyway.' But you

know Frank. You might as well be talking to . . . to an armoured car. 'If it's our duty,' he says, 'we've no choice in the matter. After all, his mother was your sister.'"

"So, what did you say to that revelation?" the Cork lady asked.

"'I know, Frank,' I said calmly. 'I know Rosemary was my sister. She may have married badly, but she was still my flesh and blood.' It's your bid, Olive."

The Northern lady sighed. "Poor Rosemary. What a life!"

They were all staring at their cards, fanning them out and moving them from one position to another.

"'I'll leave you to work out the logistics,' Frank says."

"Well, I'll go one diamond."

"A saintly thing to do, all the same. I'll bid one spade."

A shy lady spoke. "It can't be easy at your stage of life, Maeve, settled as you are in your ways. I bid two diamonds."

"It's not easy at any stage, Sadie. At any stage."

"'If it's our duty,' Frank says, 'we've no choice in the matter.' Let me see now: I'll chance two spades."

"But look on the bright side, Maeve. He's not a bad wee lad. And maybe he won't turn out like the father. I think I'll pass."

"You know what they say, Olive: what's bred in the bone . . . is better than . . . two in the bush, I was going to say." They all laughed. "Anyway, I'll bid two no trump."

"That's a queer bid, Elsie."

"'Rule him with an iron fist,' Frank says. 'Make sure you know where he is every minute of the day. Leave nothing to chance.' What was that bid?"

Leonie put down the decanter and set an ashtray on the table. Then Cormac heard her closing the door as she left the room.

One of the card players watched her leaving. "She's very pretty, that wee thing. I couldn't have a maid that good-looking around our place. You know what Myles is like: he'd have his hand God knows where every time I turned my back."

The shy lady spluttered and had to put down her glass. Aunt Maeve patted her on the back. "Well, at least with Frank I've no

worries of that sort. She'd have to be in military uniform before he'd notice her at all. And then he'd only be interested in whether her boots were properly polished."

Everyone laughed and the spluttering lady began to cough.

"Are you all right, Sadie?" Aunt Maeve asked. "Maybe I should close the window. You must be in a draught there."

Cormac held his breath as his aunt's shadowy figure approached. Through the mesh of the fabric he saw her staring at the curtain as if she knew he was there. It was too late to slip out now: her hand was on one of the drapes.

"It's all right, Maeve. It's just the smoke. Sometimes the asthma . . . acts up, you know."

The lady with the Northern voice stubbed out her cigarette. "Gosh, Sadie. Silly me: I completely forgot."

"Actually, I'd prefer if you . . . left the window open. I'm sorry I'm such . . . a wet blanket."

As Aunt Maeve returned to her seat, Cormac released his breath. The room was suddenly full of black-and-silver stars.

"So tell us about the boy's sister, Maeve? How's she getting on? Imagine her stuck out there in that awful concrete monstrosity of a house, alone with the father?"

"Angela? Oh, she's a bright spark. She's well able to look after herself. I said to Frank, 'Frank,' I said, 'if only Rosemary . . .'"

Cormac slid quietly out the french window and made his way towards the orchard. There was still a cool drizzle but he didn't care. Under a crab-apple tree where he did most of his thinking he sat and wondered why the adventure had gone out of his life. Since the hayloft episode he no longer wanted to spend hours helping the Corporal cleaning out the stables; and, even though his night trip to the mare had never been discovered, he had no plans to repeat that excursion.

He took a crumpled letter from his pocket.

Dearest Cormac,
 It was great to hear from you so soon. I'm delighted Aunt Maeve is being so kind – even if she is a bit frosty. Remember Mam used to say Maeve had never really

found her heart – but it's obviously there somewhere, beneath all the rules and snobbery.

I'm sure she will let you ride in due course, but at first she will be v. strict, just to let you know who's boss. Soon, when she sees how good a rider you are, she'll be glad to get you to exercise the mare.

It's OK that they can't get a place for you straight away in the boarding school. It means they'll have to send you to a school in the town where you can meet some local fellas before you're sent off to the outer darkness. Then you'll have friends to hang around with during the holidays.

Of course we'll be together at Christmas – stop worrying. And remember what Mam used to say: if you want to be happy, open your eyes and ears to what's all around you. Keep saying that to yourself and you'll be amazed how it changes everything. It even makes my creepy boarding school bearable!

Dad's asking for you. He wanted to drive over last week, but I thought it might be better to give you more time to settle in. Was I right?

There's no other news so I'll say goodbye for now. Write soon again.

Your loving sister,
Angie

P.S: Great news that Peter and his Mum are staying for a few days. Aunt Flo is so nice. That should be fun.

He saw Leonie coming from the kitchen with a laundry basket and making her way to the end of the garden where the clothes-line hung weighed down with sheets and towels. She was humming as usual and swayed as she walked, ignoring the light rain.

She stripped the line bare before turning towards Seamus who was on his knees between rows of cauliflowers and cabbages. Setting down her basket, she crept up behind the stooped figure and said "Boo!". The old man looked up with a start. Then he flashed a toothless smile and sat back on his heels to talk to her.

Leonie reached back into the basket and from inside a tablecoth took out some food wrapped in greaseproof paper and

what looked like a sherry bottle. The gardener snatched the offerings and stuffed them into the sack he used for weeds. Then he beckoned her close to him and whispered something in her ear. She skipped indoors and, even after Seamus had resumed his cramped work, the garden echoed with her laughter.

After a while Cormac followed her into the kitchen and went to the sink to pour a glass of water.

She scowled. "What do you want?"

She had taken off her white cap and apron and was pouting in front of a small mirror above the Rayburn. She flounced out her hair and admired herself from various angles.

"Nothing much."

He drank the water without taking his eyes off her.

"What are you starin' at so?"

"A cat can look at a king. Or a queen, for that matter."

She laughed. "So you're a cat? Well, I'm sorry to tell you, puss, it's bath-time so it is. And this queen is plannin' on havin' an early night, so you better not dawdle about the place, d'you hear?"

Cormac thought of her in the hayloft with the Corporal. Maybe she was going there again tonight.

"When is the mare going to have foals?"

"The mare? I don't know. Was she ever brought to the stallion?"

"I don't think so."

"Well, in that case she won't be havin' foals, now will she?"

"Do mares always get foals if they go to the stallion?"

Leonie looked at him and smiled. "Not if they're careful they don't."

She took lipstick from her pocket, winding it till the scarlet column rose from the cylinder, and applied it meticulously to her mouth. In the mirror she saw him watching her.

"Well, it's no harm lookin' your best so it isn't, even if you're plannin' on stayin' in."

"Why has Aunt Maeve no children?"

"How do I know? Maybe she never got brought to the

stallion." She laughed again. "Come on, little quizmaster. No more red herrin's. Away you go to your bath."

She returned her attention to the mirror, pressing her lips together and using her little finger to remove a smudge from the corner of her mouth.

On his way past the drawing-room Cormac noticed the voices were louder than before. There seemed to be an argument going on, but it was hard to pick up the threads: all Aunt Maeve's bridge friends were talking at once.

"Haven't we enough problems to be getting on with . . . ?"

"I should have played the ace, Olive . . ."

"You're not listening to what I'm saying, Elsie . . ."

". . . without sending our men out to keep warring savages apart . . ."

"How was I to know you had the trump?"

"God forbid that we'd ever stand aside again, no matter whether they're . . . "

"I'd no more trumps."

". . . black or white. Isn't it . . ."

"Maeve, listen . . ."

". . . bad enough that we were idle when the rest of the world was ridding Europe of . . .

". . . only a few low cards."

". . . Hitler and his cohorts."

"I said to Frank 'Frank,' I said, 'what business is it of ours if these African tribes want to hack each other to pieces?'"

"And what did he say to that, Maeve?"

"Who played the king of clubs?"

Cormac went on up to the bathroom and turned on the taps. The rush of the water drowned out the voices below.

That night in bed he wondered if Leonie was meeting the Corporal. It was hard not to think of them climbing up to the hayloft and taking off their clothes to lie together again. They would startle the mare and he wouldn't be there to console her.

He remembered the softness in Leonie's voice that night in the stable. It was not like her sharp tone when she talked to him – except for the night she came to tuck him in. He wished she was there now, leaning over him and saying gentle things.

After some moments he tiptoed across the landing and knocked on her door. There was no reply, even though her light was on. He went in and stood looking at her belongings – an open jar of white make-up, a green floral dress, some plastic jewellery in a cardboard box, a metal alarm clock ticking noisily on the table.

He found one of her comics and lay on her bed reading about a girl who had a mad crush on a riding instructor called Rod. He treated the girl like a child and this made her sulky. One day the girl's horse bolted – but Rod chased after her and saved her from being thrown. It was only then, when she was in danger, that he realised he loved her – at least that's what he said to himself in a bubble over his head in the last frame of the story. The picture showed the pair as bride and groom on the steps of a church, smiling at all their friends.

Later that night Cormac woke up in a sweat: from downstairs in the hall he could hear the sweetest voice he knew in the world. She had come back and was making inquiries about him! He leapt from Leonie's bed and ran down flight after flight of stairs shouting: "Mammy! Mammy!"

Aunt Maeve was showing her friends to the door. The bridge circle stopped in the hallway and stared up at him in silence.

"Poor wee lad," the Northern lady said. "He's having a bad dream. You go to him, Maeve. We'll let ourselves out. Come on girls: let's leave them in peace . . ."

* * *

"I knew you were a spy, Cormac Mannion, the firs' minute I clapped eyes on you."

Leonie was in his room and had pulled the bedclothes to the bottom of the bed.

"What are you talking about?"

"Don't play the holy innocen' with me. I seen through you the firs' day I met you."

She yanked back the curtains and flooded the room with a cold morning glare.

Cormac wondered if it was a game. "I don't know what . . ."

"You tol' her. You ratted on me so you did."

"I did not."

"You did so. You were spyin', admit it."

He tried to pull the blankets back over his legs, but she snatched them and threw them on the floor. There were red marks around her eyes and she was not wearing her white apron nor the stiff white cuffs and cap that went with it.

"I only went out to visit the mare, I swear."

"What are you bleatin' about? You tol' her I wasn't in my room las' night and she sat up and nabbed me comin' in."

He pulled himself up in the bed. "I didn't say anything. I cross my heart. I never told a soul: not even Angie."

Before he could move aside she lashed her palm against his face. "That's for tellin' lies."

His cheek burned – and his head spun with memories of his father in one of his rages. *Where has she gone? Where is your mother? Don't pretend you don't know.* He had hauled him out of a deep sleep, just as Leonie was doing now.

"You're a liar as well as a spy. That's what y'are."

"I swear." He held up his hand to ward off more blows. "I could've told Aunt Maeve. Maybe I should've, a long time ago. But I didn't."

Her palm was raised to hit him again. She paused. "What do you mean a long time ago?"

"The time I seen you and the Corporal lyin' in the hayloft. You had no clothes on and you were breaking the curfew."

Leonie stood motionless, staring at him, her mouth open. "What are you talkin' about?"

"You and the Corporal. You near scared the daylights out of the mare, on'y for I was there to keep her calm. I could've told on you then, but I didn't, I swear I didn't."

Her cheeks turned crimson. "What are you talkin' about, you little blaggard? What are you sayin'?"

His face was still smarting. "You were above in the loft with the Corporal and I don't care if you get caught. Ye were carrying on, so ye were. I hope you get a baby and everyone knows."

Leonie glared at him.

"If you don't believe me I can prove it: the Corporal told you the Drill Sergeant's joke about pulling a nail out of a wall. Then you went into a fit of coughing and . . ."

"Holy Jesus! You're a spy all right, a master spy, worse 'n I thought." She collapsed into a chair beside the bed and stared in front of her. "I was on'y talkin' about . . . you prowlin' aroun' my room las' night, readin' letters an' stuff. I foun' comics scattered all over the bed."

"I never read your letters. I don't even know where they're kept."

"Well, what were you at so?"

"I went in to read a comic and I must've . . . fell asleep on the bed. I woke up after a while and came back in here, that's all." His voice had gone very faint but she didn't seem to notice.

Slowly the fury was draining from her face. "Well, you left the door open so you did and she seen I was out when she came up – that's why she sat waitin' for me. She must've came up here to check if you were all right. If you'd've minded your own business and stayed out of my room, she'd be none the wiser this minute."

She stood up and started to pace about the room. After a while she took a crumpled ten-pack of Sweet Afton from the pocket of her dress and lit a cigarette.

She seemed to forget he was there and it looked for a while like she was carrying on an argument in her head – with Aunt Maeve, probably. Or the Corporal.

Suddenly she stopped and stared at him again. "O my God, I don't believe it! You were watchin' us all the time."

"It wasn't my fault. I only went out to see the mare."

"That night of all nights. How much did you see?"

"Not much."

"Don't lie to me."

"It was dark. I didn't see much."

"Jesus! An' was that the on'y time?"

He nodded.

"How long ago was it?"

"I can't remember. A couple of weeks maybe."

She put a hand over her forehead and groaned, muttering "Holy Mary, Mother of God" over and over to herself. Then, like a priest in confession, she asked: "How many times?"

"How many times what?"

"How many times was it you seen us?"

"Just the once, honest. I went out to feed the mare and I heard this scratching noise and then I climbed up on the manger and stuck my head through the trapdoor and you and the Corporal were lying in the hay with nothing on . . ."

"All right, all right."

"It was dark. I didn't see much, I swear."

"But you thought we had nothin' on. It musta been the bad light, that's all." She flashed her eyes at him and then looked away. After a moment she sighed. "I tol' him I heard queer noises that night but he wouldn't listen. He hears nothin' he doesn't wan' to hear, that fella. What good he is on sentry duty I dread to think."

She stubbed out the half-smoked cigarette in the fireplace and returned it to the pack, glancing at Cormac. "I s'pose you didn't do it on purpose, though you'd no business breakin' the curfew." She sat down on the chair again. "God forgive me: I s'pose I'm not one to talk."

She tugged her black skirt over her knees and stared at the floor. Cormac lay back in the bed. It was a while before she spoke. "What did you think anyway? I mean, did you . . . have a clue what was goin' on?" Her voice was very low.

He said nothing.

"I s'pose you're just startin' to know about that kinda thing. There's nothin' wrong with that either, as long as you don't . . . spen' too much time thinkin' about it. D'you know what I'm sayin'?"

He shook his head. She seemed almost as uncomfortable as he was and kept straightening her skirt. "Frig it, anyway, it's nothin' to be ashamed of, bein' seen like that either. It's the way God made us." She reached down and handed him back his bedclothes. Then she smiled as he clutched the blankets tightly around himself. "Jus' don't lie aroun' thinkin' about it too much. Not for a few years yet, anyway."

"I don't think about it at all, I swear."

"Good."

She stood up and walked to the door. There she stopped and looked back at him. "Are you goin' to tell on me? I s'pose you will. It's all I deserve."

He shook his head. She was gazing at him with her big moist eyes and he thought of the mare blinking in the moonlight. He turned away.

If you feed her carrots and sugar, she'll let you lie down beside her, the Corporal had said one day when they were cleaning out the stable together and carrying wet straw on forks to the manure pit. *Jus' like a woman. They're all the one: they have to be pampered or they won't let you nex' or near them, I swear to God.* Then he spat a mouthful of tobacco into the steaming pit and patted Cormac on the head.

Cormac's eyes felt heavy and he shut them. When he glanced back at the door, Leonie had gone.

He lay thinking of his mother for a while and pictured her sitting on the end of his bed, turning the pages of a gardening magazine. Then she stood up and walked to the window.

He wanted to ask her about the Commandant's boots but he was afraid: if he spoke she would probably vanish.

Just then a train passed the orchard wall and the frame of the window shuddered. A train: was that all it was? Listening to its vibrations, he wondered if this was his mother's answer.

Later he noticed a creaking sound, like a door or shutter swinging in the wind. His clock said half-five. He got up and stood for a while looking in the mirror above the sink.

On his way past Leonie's door he realised the creaking sound was a woman's sobbing. He had only heard Leonie crying once before, the day Aunt Maeve had given out to her for stealing food for the gardener. At least the sobbing meant she was there and not back in the hayloft with the Corporal.

He ran quietly downstairs, past Aunt Maeve's room and the Commandant's quarters, and, when he got to the pantry, reached up for some sugar lumps. Then he let himself out the kitchen door and went to the tackle shed on his way to the stable.

He found the mare standing up, pulling wisps of hay from between the bars of the manger. She looked around and walked over to greet him; as he stroked her neck she nuzzled against his pockets, first one, then the other, sniffing for the gifts she knew he had brought.

Opening her mouth the way Angie had taught him, he pressed the bit against her teeth and slid the bridle quickly over her ears. He rewarded her then and hoisted the saddle on to her back, ducking under her belly to tighten the girth. All the while he fumbled with the buckle, the mare slobbered, trying to get a sugar lump past the bit in her mouth.

He led her out of the stable yard and down the laneway to the Lindemans' field. She was so big that he had to haul himself awkwardly across her back before he could straighten up in the saddle. She stroked the ground with a hoof while he clambered about adjusting the stirrup straps and her soft brown coat shuddered with excitement.

"Good girl, Sarah," he said, relieved that she didn't bolt off before his feet were secure.

He trotted her first, trying to remember the tips Angie had given him. When his nerves had settled, he urged her into a soft canter and they circled the field a few times, building up to a steady rhythm. He walked her for a while and then cantered again – till the mare's breath and his own made vapour clouds in the morning air.

It was only when they reached the gateway on their way out

of the field that he saw Leonie standing there: she had been watching him and smoking. She didn't seem to mind that he had taken the mare out. His legs were stiff so he got down and walked the horse along the grassy laneway beside her.

"You're a right little chancer so y'are. You could've fell and broke your neck y'know."

"More people die in bed than by falling off horses."

"That's true I suppose." She tossed away her cigarette. "An' more dies of boredom in rotten jobs than ends up gettin' sacked."

He wondered where she'd found out that fact.

"To tell you the gospel truth," she went on. "I wouldn't care if she did give me the sack. I got an offer of a place in Newbridge an' it couldn't be much worse than this madhouse. Or I might pack up entirely an' go an' live in Dublin. I could work in a fact'ry an' I wouldn't have to be a skivvy for the rest of me life."

"What about the Corporal? Would he go too?"

She smiled at the ground ahead of her. "My, you're not such a master spy after all."

"Are you not going to marry him?"

"God save us, I missed that boat a long while ago."

As they entered the yard she glanced at the ladder that led to the hayloft. "Sometimes I don't know why I took up with him in the firs' place. I must've been outa my min'."

He asked her to hold the reins and she stood patting the mare's neck. "Christ, I'm in for it today. I better think up some excuse before I go on much farther."

"Go back to bed and I'll say you're sick."

"After las' night's ballyraggin' I don't think that'd go down too well."

She watched him unsaddling the mare and brushing her down. "You're a mighty horseman so y'are. I never knew you were that good."

"My father and mother used bring Angie and me for treks."

"Your mother as well?"

"Yeah. She was a great rider. She had near as many medals and rosettes as my uncle."

"You don't talk about her much. That's the firs' time I heard you mention her."

"What's there to talk about? She's . . . gone, isn't she?"

When they were back in the house, Leonie stayed in the kitchen. Cormac went to his room and lay down with his clothes on. After a while he turned on his side and closed his eyes. When he woke up Leonie was sitting beside him, sipping tea. She offered him a cup but he shook his head.

"Was I asleep long?"

"Long enough."

"Were you there all the time?"

She nodded.

He looked at where his mother had been.

Leonie glanced around the room. "What are you starin' at?"

"Nothin'."

He noticed a hayseed in her hair and reached up to remove it. Her curls were as soft and light as he had imagined, not wiry like the mare's mane.

She turned and took his hand. "Thanks. You're a dacen' skin, even if you're . . ."

"Even if I'm what?"

She smiled. "Even if you're . . . on'y a young lad." She began stroking his hair.

He spoke without looking at her. "If you go I'm leavin' too. I'll go back home and live with my father. I couldn't stand it here with you gone."

"That's nice," she whispered. Then she kissed him on the forehead and got to her feet. "But after las' night I might have no choice."

"What do you mean?"

"I think this time she'll sack me. She's after warnin' me often enough, God knows."

"Aunt Maeve won't sack you. She's always sayin' how hard it is to get good help. And I heard her tellin' her bridge friends you were a great little worker – even if a bit flighty."

"A bit flighty! That's good." She was shaking her head and

combing curls with her fingers. "You might be right. Maybe she'll dock a week's wages an' that'll be the en' of it. An expensive toss, that's for sure: if on'y it was worth it."

"What did she say when she caught you coming in?"

"She was too ragin' to say much. She said she'd talk to me in the mornin'."

Cormac sat up. "I'll tell you what: let on you came upstairs and looked in here before you went to your own room. Then, when you found my bed empty, you ran down to the stable to see if I was there, walking in my sleep or somethin'. You never thought I'd have only gone over to your room."

"Wait now: say it again."

He repeated the excuse, expanding a little on the detail.

"Jesus, that's brilliant. You're a canny little divil, so y'are."

"There's only one snag. She didn't find me in your room the way you said: it was on the stairs."

"So you *were* walkin' in your sleep."

"Sort of."

"Well, that puts paid to that plan."

"No, it doesn't. I was in your room when you came up and I didn't go downstairs till after you went to the stable lookin' for me. In other words I was sleep-walkin' twice."

"D'you think she'd b'lieve that?"

"It depends how you tell it. You'll have to keep a mighty straight face."

"An' how am I goin' to do that, might I ask, tellin' such a hare-brained yarn?"

"Keep picturin' what'll happen if you don't: that's what I do. And if that doesn't work picture something else."

"Such as what?"

"I don't know. Imagine you're tryin' to pull a nail out of a wall with the cheeks of your arse."

Leonie laughed and patted him lightly on the chin. Then she went to the sink and continued grooming her hair with her fingers.

"I tell you what," she whispered, smiling at him in the mirror.

"We'll make a pact, you an' me, an' that way no one will know our secrets: you an' your mare, me an' my Corp'ral." She came back over and sat on the bed beside him. "We'll build a little moat aroun' ourselves so we will, an' when we're alone we'll do whatever we feckin' well like, OK? You can visit me inside in my room whenever you like an' we'll read comics an' swop yarns." Her eyes were wide open, their tiredness gone. She nudged him. "What do you say? That way we'll beat them at their own game, your auntie, the Comma'dant, the bridge circle, the parish pries' – the whole friggin' lot of them. Are y'on?"

He thought for a minute. "If I wanted to go out to the stable some morning, to take the mare out, you'd cover for me?"

"Sure I would."

"Or if I wanted to go and visit the mare during the night sometime . . . ?"

"We could arrange that too – as long as . . . "

"As long as what?"

"As long as there was no one else usin' the hayloft, if you know what I mean." She smiled and pinched his cheek. "An' if you wanted to go in an' turn the Comma'dant's quarters upside down, I'd tidy it up, the same as I done before. An' I'd say nothin' to no one, the same as the las' time."

She pinched his cheek again and this time he smiled back at her.

"So what do you say?" she asked. "Is it a deal?"

He nodded. He had been thinking in the last few weeks, sitting in the orchard under the crab-apple tree, that as soon as the Commandant came back from Africa he would go home to Westmeath to live with his father and Angela, whatever the consequences. And the decision would be his, not Aunt Maeve's or his uncle's. But now there was a new alternative.

"Well?" Leonie asked. "Will we give it a try?"

"OK!"

"Great. That'll change everythin', you'll see. Now tell me again about las' night: I came up here an' looked in to see if you were all right . . ."

When she was ready to leave the room, she stopped in the doorway: suddenly in his eyes she looked young, even younger than he was. He remembered Angie hesitating one day at the kitchen door, afraid to go to school. That day too it had seemed to him that people could swop ages without warning – just for a short while at any rate.

She looked back in his direction and her face was pale.

"It'll be OK," he told her. "Honest."

"Do you think so?"

"She'll believe you, I swear."

"But the hayseeds?"

"We already went over that. Stop worryin'. Besides, I've been thinking about Aunt Maeve."

"What?"

"There's got to be a heart there somewhere, underneath all the rules and the snobbery. That's what I think, anyway."

"Let's hope you're right."

Chapter Two

AT THE HUMP-BACK railway bridge Eddie saw Tom Egan's Raleigh leaning against a wall. There was no mistaking it: it was the biggest bike in the school.

There was a girl's bike beside it, lying on top of it in fact. If they wanted to let the whole town know what they were at, they couldn't have advertised it better.

Some kids from the Masters greeted Eddie. "Howya, Dwyer?" "Soun' man, Ed." Eddie returned the greetings: "Sound men."

They were leaning over the parapet, tossing pebbles down on the tracks. Tom Egan's voice rang out from below: "Who's tha' thrip thrappin' over *my* bridge?"

The younger kids screamed and ran away. The older ones regrouped on the other side of the bridge and crept back again. They had more pebbles now and a large rock. They threw the pebbles over first and drew another troll response – "Who's tha' thrip thrappin' . . ." Then they threw the rock. There was a crash as it splintered on the railway line and a female shriek: "Mother of Jaysus! Who the fuck threw that?"

Tom Egan's blotchy face peered up around the parapet. He was hanging on by his elbows. "Get away t'hell ouha tha', ye feckin' blaggards, before I skin ye alive." The kids ran away again. "The whole feckin' lohha ye, d'ye hear?"

He turned towards Eddie. "Wha' are you doin' cavortin' with tha' shower, Eddie Dwyer?"

"I wasn't cavortin'. Just passin', actually."

"Is that so *actually*? You didn't *actually* happen to see who flung tha' rock?"

"I didn't."

Egan glared at him. "You don' wan' to be consortin' with them Masters brats, now that you're above at the Brothers. Riff raff, that's all they are. Pure scum."

"Scum is right. I was just passin' – on my way to th'alley."

Egan's scowl softened. "A bihha th'ould wham-bang, eh?" In an effort to demonstrate a handball stroke he nearly hurled himself back on to the tracks. "Phew! Tha' was a near one!"

He was about to lower himself back down from the bridge but instead beckoned Eddie over with a jerk of the head.

Eddie hesitated. "What?"

"C'mere."

Eddie stepped closer. Egan glanced down towards the railway track and then said in a low voice: "How's tha' sisther of yours, El-ean-or? Isn't tha' the posh name for a filly from the Pearse Esthate? El-ean-or. She's got great tits, though, I'll say tha' for the lassie. Very sthrikin' in th'upsthairs depar'ment."

The voice from below called out: "Are you comin' back, Tommy, for Jaysus' sake? I haven't got all fuckin' day."

"Duhy calls," Egan said. He winked and slid back out of sight. Then, using the echo chamber to full effect, he burst into a Pat Boone quaver:

> "They say for ev'ry boy an' girl,
> There's just one love in this wide worl' . . ."

The Masters kids crept out of their hiding place. After a short, furtive conference they sneaked back to the parapet and threw more pebbles – but there was no response. Then, on a herd impulse, they turned and scurried down the road towards the abattoir. Eddie watched them veering off in the direction of the handball alley. He was on his way to the alley to practise, but now he saw he could be pipped at the post.

He snatched the girl's bike out of the way, took hold of Tom

Egan's more masculine machine and started to pedal as hard as he could. The saddle was so high he had to stand on the pedals.

Egan's voice followed on the breeze. He was hollering his name in a high-pitched wail: "Dwyer! Eddie Dwyer! Come back with tha' friggin' bike or you're a dead man. I swear I'll pulverise you, you little basthar' . . . " The details were drowned out by the squeals from the abattoir: today was slaughtering day.

Flashing past the Masters kids, Eddie turned. "Too bad, lads. I'm goin' to get there first. Ye'll have to come back tomorra." Then he ducked his head as a shower of pebbles came at him from the sky.

He glanced over his shoulder again and saw the gang scurrying about in search of more amunition. Beyond them he could just make out Tom Egan standing on the railway bank with his hands cupped around his mouth. He was still yelling unintelligible abuse, while a girl in a green school uniform was attaching a schoolbag to the back carrier of her bike on the bridge.

An enormous truck full of screeching pigs came towards him and Eddie pulled up on the grass to let it pass. It swung in through the abattoir gates and the noise drowned the commotion behind him.

At the alley he practised by belting the ball off his palm. His Da still had welts on his hands from playing the game: he could hit the handball so hard it would ricochet off three walls and make a high-pitched *zing* as it came back and bounced in exactly the same place it had started from.

His father had army medals and a silver cup for handball, but he hardly ever played any more – except for the odd time he tried to show Eddie a trick or two to improve his game. Even then it was only a knock-up for him: he usually got fed up and wandered off after a few minutes. There was no one good enough to give him a real challenge, but Eddie was working on it, getting there slowly.

When the Masters kids arrived they climbed on the lower walls of the alley and sat watching Eddie. They liked looking at

him practising. He tried a bit of fancy footwork to make a real exhibition of it and, in spite of a few wild smashes, they seemed impressed.

"Where'd you learn to play the likesa tha', Dwyer?" Mouse Morrissey asked. Eddie volleyed the ball sharply a few times between his dangling legs, inching it higher and higher. Morrissey wobbled as he took his hands off the wall to cup them over his crotch. "Hey Eddie, don't! You'll knock 's offa the fuckin' wall."

"Beg for mercy, Mouse. Swear you'll never shower me with stones again."

"Mercy! Mercy!" Morrissey squealed.

"Say: 'I swear I won't peg stones at you again, Eddie Dwyer.' Say it."

"I swear I won't peg stones at you again."

"Swear."

"I'm after swearin' already . . ."

"Jaysus!" one of the kids shouted, pointing to the road. "Look who's here!"

Eddie caught the ball. Tom Egan was pulling up on a girl's bike, the owner perched side-saddle on the carrier. She was clutching two schoolbags which she dumped angrily on the grass as she got off.

Egan threw the bike down and marched towards the alley, his blotchy face redder than ever. Eddie looked around frantically: there was no escape.

"I'm goin' to pulverise you, Dwyer. I'm puhhin' an end to your feckin' and skivin' righ' here an' now."

"No, wait, wait. I'll . . . get my Da after you."

Before he could make a break for it Egan had him by the collar. Then, to the delight of the screeching chorus on the wall, he yanked him off the ground and shook him the same way Eddie's mother shook the tablecloth in their back yard every morning.

"Swear!" Mouse Morrissey sneered. "Swear, Dwyer!"

"Wa-it," Eddie croaked into Tom Egan's face. "I'll pl-ay you a ga-me."

"A game of wha'?"

"A ga-me of ha-n'ba-ll."

Egan set him down on the ground in a corner of the alley away from the kids, keeping his grip on Eddie's shirt collar. "An' wha'?"

"An' if I win, you can let me off."

"An' if you lose?"

"If I lose . . . I'll give you back your bike."

Suddenly Eddie was back in the air. "So-rry, To-mmy. I wa-s on-'y codd-in'. I swe-ar I wa-s."

Egan set him down again but tightened his grip on the collar. Eddie was running out of ideas as well as air. "If you win ... I'll get you . . . a date with my sister."

"Wha'?" Egan glanced towards the girl on the roadway: she was well out of range. The kids on the wall were laughing and jeering too much to have heard. "Wha' did you say, Dwyer?"

"I said I'd get my sister to go out with you. That's if you win the game."

Egan glanced at the road again. "Your sisther El-ean-or?"

"Yeah, Elly. I know I can get her to agree. She always does what I ask her, even though she complains at first." Egan didn't seem convinced. "I swear I'll ask her. She owes me a favour, honest."

The likely consequences of his offer were already flashing before his eyes, not least the prospect of a few sharp slaps on the face. Elly had a fiery temper and could lash out without warning. "There's no harm in asking," Eddie said.

"For your sake she behher agree," Egan warned, "'cause if she doesn't, you're fucked." To drive home the threat he pushed Eddie about the alley with his palm, beating out the rhythm of his words on his shoulder. "We'll play a game on Frida', OK? No, Frida' week, make it, straigh' afther school. That'll give you a chance to get some thrainin' in: you'll need it so you will. An' be here on time, or else you'll fuckin' regre' the day you were born. Half-four, all righ'?"

"All right. Friday week it is."

"An' min', it's bethween yerself and meself. No one else has to know wha's at stake."

"No one 'cept Eleanor . . . obviously."

"Yeah. An' you behher have her reply when you come to school tha' mornin'. Have it in wrihin', d'you hear?"

"No problem."

"Yerra Tommy, c'mon," the girl called from the roadway. "He's only a penny ha'penny fart."

As Egan left the alley he growled up at the kids on the wall: "If it's blood ye brats are afther, be here on Frida' week at half-four. I'm goin' to theach tha' little gobshite a lesson he won' forget in a hurry. He'll think thwice before feckin' off wi' an'thin' of mine again."

He snatched the bike from the grass and dusted it down. "Remember, Dwyer, the reply in wrihin'." Then he picked up the two schoolbags and wheeled the bike to the roadway where the girl was putting blue make-up on her eyelids and examining her face in a pocket mirror.

"What reply're you talkin' about?" she asked.

"C'mon, for God's sake, or you can go home on yer own."

As the pair cycled off, Mouse Morrissey turned to Eddie. "You're in it now, Dwyer, right up to your bollix. You're good, but not tha' good. I'd get a dose of the flu, if I was you; or emigrate t'Austhralia."

With similar suggestions for his well-being the gang slid from the wall and peeled away in the direction of town. Eddie waited till they were out of sight: then he picked up the handball and belted it as hard as he could against the alley wall.

As he was closing the halldoor Eleanor flew at him and started shaking him by the arm.

"Where the hell were you, you little creep? Didn't I tell you to come straight home after school?"

"I forgot."

"I suppose you forgot that Mam's in havin' a baby and you're meant to be helpin' me with the twins."

"I forgot." Eddie shook himself free of her grip and dumped his schoolbag on the hall floor.

"You forgot, you forgot. Well, you can forget about me gettin' you your tea. You can forget about me stayin' in to babysit night after night." She checked her face in the mirror on the wall, tucking her great blonde mane behind her ears. "I'm goin' round to Carol's for the night. There's a bottle in the kitchen if the baby wakes up. Let's see how you like bein' left high and dry."

Eddie looked at her. Egan was right: she was well developed in the upstairs department, better than most girls her age. She snatched her coat from the stairpost and stormed out, slamming the front door.

After a moment he opened it and shouted: "I'll tell on you so I will." But who would he tell? His Da, if he ever showed up. Or Auntie Josie. She was over from England, staying with a friend while Mam was in hospital. His arm was still sore where Eleanor had grabbed him. "Fuckin' bitch!" he yelled after her.

Eleanor stopped dead in the gateway. Then she turned and began to walk back towards the house, her hair on fire in the yellow light from the street. Eddie backed into the hall.

"I didn't mean it."

"What did you call me?"

"I didn't mean it. Honest."

She closed the door behind her and pulled the belt out of her coat. "You opened the door of this house and shouted down the street so's everyone could hear. What did you call me? Say it to my face."

"I swear I didn't mean it."

"You little brat. Come over here. When I'm finished with you you'll never say that about me again. Never, d'you hear?"

He picked up his schoolbag and threw it at her; she brushed it aside and books fell everywhere. That gave him a second to make a quick run for the staircase; but he could hear her pounding the bare boards on his heels before he reached the landing.

In panic he dived for the bathroom and tried to lock himself

in; he'd forgotten the bolt was broken. He put his back to the door, but Eleanor was stronger: he couldn't get a grip on the lino so he slid to the ground and wedged himself in between the lavatory and the door.

"You little creep. I'm goin' to put an end to your foul mouth for once and for all." She hammered the door with her fist and lashed at it with her belt.

Suddenly the house sounded like the abattoir: the baby was screaming in Mam's room; the twins were out in the hall bawling at Eleanor and trying to pull her away from the bathroom door; Philomena was howling in the background, probably too scared to get out of bed. And, all the while, Eleanor kept roaring and kicking the door, deaf to the bedlam around her. "I'll kill you. I'll kill you if you ever use that word about me again. D'you hear?"

After a while he heard her slump to the floor, sobbing and catching her breath. The twins, Philly and the baby were still yelling, but Eleanor's crying was different: it was steadier, deeper.

"Elly!"

There was no reply, only more of the sobbing. It sounded like Mam's voice, not Eleanor's. He'd heard his mother crying like that once, when she found out she was pregnant again. She got sick in the kitchen sink one morning and sat on a chair, whispering: *Oh no, Lord. Not again, not again.*

"Eleanor?" he asked quietly. "Elly? Is that you cryin'?"

There was silence. Something sharp hit the door – the belt buckle probably. "Of course it's me. Who the hell d'you think it is, you silly eejit?"

There was a strange shriek; she was laughing, not crying. Or was it both? He listened for a while. There was giggling all right, and a lot of sniffling at the same time.

Philly and the twins had quietened down too. He heard Eleanor ordering them back to bed. "It's all right. Get into bed and stop whimperin'. I'll tuck you in and tell you a story in a minute. Jus' give me a chance to catch me breath, will ye?"

Silence again.

"Eleanor?"

"What?"

"I'm sorry."

She said nothing.

"Can I come out now?"

"I s'pose."

"Will you hit me?"

Silence.

"Well, will you?"

"No."

"Promise?"

An impatient sigh.

"Swear to God?"

"Don't use that expression." Ice in her voice.

"You used it yourself."

"Then I shouldn't have. *He's* forever sayin' it."

"Who?"

"Your father."

"What's wrong with swearin' to God?"

"It's takin' the Lord's name in vain, that's what."

"Promise you won't hit me?"

"Oh shut up and come out, you stupid eejit."

Eddie stood up and opened the door – but only an inch or so, ready to resume his wedge if he was being tricked. "I'm sorry I called you a bitch," he muttered as a kind of insurance.

Eleanor was sitting on the bare wooden floor, leaning against the wall. Sprays of golden hair were sticking to her face. She looked at him and laughed. "Come out, you silly creep. You look like one of them Swiss weather people on a bad day."

"What Swiss weather people?"

"Never mind. Come over here."

He walked over and put his arms around her. She pulled him down beside her. "You're an awful eejit, d'you know that?" She pressed his head against her chest. "An awful eejit. That's what you are."

"I'm sorry I called you a bitch," he mumbled into her school

jumper. "I didn't know it was such a bad thing. A bitch's only a dog's mother, isn't it?"

"Aye. Or a dog's sister." He could feel her chest shaking; then she stopped laughing and held him away from her so she could look into his face. "It's not bitch I mind. You can call me a bitch any time you want. You can yell that up and down the street from mornin' till night for all I care. It's the other word."

"Fuckin'? Sure everyone says that, except Mam and Brother Meehan."

"I don't like it said about *me*. Especially by anyone in this house. It's somethin' that's never to be said about me, OK? By you or anyone. Is that a promise?"

"OK."

"Cross your heart?"

"I cross my heart."

"Swear to die?"

Eddie sighed. "I swear to die."

He went to the bedroom that night, the room he shared with Philly and the twins, and looked at his birthday cards on the wall. The baby slept in Mam's room, even when Mam was in hospital. Da slept in there too, the odd night he spent at home. Most nights he was on sentry duty and stayed over in the barracks.

Eleanor had a room of her own, because she was older than Eddie and more developed. Mam didn't want her undressing in front of him: she said it wasn't right. But Eddie was older than Philly and the twins, and all he had was a corner to himself. So he had to turn his back to the girls when he took off his clothes, whether he was developed or not.

At least he could lie in his corner and look at the card Auntie Josie had sent him from England a few weeks before. Eleven meant you had two numbers: you were grown up really – except there were no more rooms in the house. But that wasn't his fault. Tonight he didn't feel eleven, or even ten for that matter.

He still had a tenth birthday card on the wall, the one he got

from Mam. It was a brilliant card, Roy Rogers and his horse Trigger, all red and silver, so he had kept it pinned on the wall to hide the black stain that Mam said was mould. The nought was a giant's eye and the one was like his nose, or half of it anyway; it was like a giant looking around a corner or a door.

Or Tom Egan peering over the parapet of the bridge. Eddie pulled the blanket over his head.

If you had two tenth birthday cards you'd have a whole giant's face. Two tens are twenty. Eleanor wasn't even twenty. Twenty meant you could own a motorbike and smoke cigarettes without getting sick. You could go to the handball alley after dark for coorting and then everyone would know you weren't a kid any more.

The twins were asleep when Eleanor came into the room. Philly was talking to her invisible friend, putting her asleep. Eleanor tucked her in and Philly said: "Tuck in my friend Molly as well."

Eleanor did as she was asked and smiled at Eddie. "It's all right, I gave the baby the bottle. She'll probably sleep till your father gets home – *if* he gets home." She always called him "your father", even though he was her father too.

She tucked him in so tight he could hardly breathe; still he was cold, shaking from head to toe. "What're you shiverin' about? It's all right, I told you."

"Don't go yet. You're always runnin' out of the house when Mam's not here."

"I told you. I'm goin' to Carol's. I promised I'd help her with her homework. Did you do yours?"

"We didn't get any."

"Like hell you didn't. Did you eat the bread and jam I left out for you?" He nodded. "Then close your eyes and go to sleep. Auntie Josie'll be here in the mornin' before you go to school. She'll help you with your sums."

"Why doesn't she stay in our house when she's over from England?"

"I don't know. I think she's afraid of your father – especially when he's drink taken."

"Why do grown-ups get drunk?"

"Stop askin' questions."

"Tell us a story before you go."

"You and your stories. Have you no comics at all?"

"I've read them all."

"Then I'll lend you one of my Elvis magazines, but don't bend the pages, OK?"

Later he heard her going downstairs, opening the hall door and closing it firmly behind her. Even though the house was full of children, it felt cold and empty.

Elvis had his collar turned up and was looking over his shoulder. Eddie propped his head on the pillow and tried to smirk Elvis-style. Philly was staring at him, munching away at her dummy; she didn't look very impressed. Her eyes were flickering with tiredness – presumably Molly had already conked out.

His Elvis smirk wouldn't impress a sourpuss like Tom Egan either.

Maybe he should have read one of his cowboy comics again; he closed his eyes and tried to imagine Kit Carson instead of Elvis. Kit Carson and a posse riding out to attack the hump-back bridge. *OK men, we'll split into two groups. You take the abattoir and we'll head him off at the alley. And remember, we want this Egan crittur, dead or alive . . .*

* * *

Brother Meehan said the Men of 1916 died so that Irish people would be free to go to Mass. They were holy men really, saints in their own way, even though some of them were Protestants. That was the queer thing: it was why the English could never understand Ireland.

The biggest mistake the English ever made was shooting the Men of 1916 after the Easter Rising. They shot them one by one and that's what made Ireland free. The class had to learn their

names by heart and sing them out when Brother Meehan pointed his leather at their pictures.

"Patrick Pearse and James Connolly,
Thomas MacDonagh and Sean Mac Diarmida,
Joseph Plunkett, Thomas Clarke,
And, last but not least, Eamonn Ceannt."

Eddie found that list hard to remember because it didn't rhyme. The first time you said a name wrong Brother Meehan pounded his leather on your desk and pulled you by the ear to the front of the class; the second time, he gave you six of the best, three on each hand, and made you stand in the corner with your palms on fire. Nobody dared look at you then, let alone speak.

That was history. History taught you to love your country. Then it was time for catechism. Catechism taught you to love God and his Holy Roman Church.

Auntie Josie loved God but she had mixed feelings about Ireland. At least that's what she said, shaking her head and hammering a sticky ball of dough on the kitchen table.

"When you're ol' enough, Eddie, I'll give you money to get to Birmin'ham and you can live with your cousins. You'll get work over there and you won't be hangin' aroun' on the dole like halfa the young fellas in this town."

"I don't want to go to Birmin'ham. I want to join up and be a soldier like my Da."

The thought of leaving Drumaan held no appeal. If he got into trouble in England, who would he turn to? The English didn't understand Ireland and shot the Men of 1916 one at a time. But he didn't want to talk about that to Auntie Josie: her husband was English – and a soldier into the bargain. He probably went around shooting Irishmen all the time.

Eddie tried to think of a better reason for joining the army. "I want to fight for Ireland and be famous."

Auntie Josie stopped hammering the dough and wiped the

flour from her hands in her apron. "There's no fightin' for Irelan' any more. Them days is over, thanks be to the sufferin' Jesus."

She sounded very cross, so Eddie said nothing more about his ambitions. He watched her sprinkle the ball of dough with some flour, put it on a tin tray and slide it into the oven. Soon there would be a smell of hot soda bread all over the house and cramps in your belly till it was cool enough to eat with melted margarine and red jam.

But Auntie Josie had more than soda bread on her mind. "Your cousins are both workin' men and they've got very nice girl-friends. Jimmy's afther puttin' money on a house and he's gettin' married next year. Mike's not goin' to get married yet 'cause he wants to do further studies; but he's got a lovely girl and she's backin' him up in his plans."

She started carrying things to the sink. "I'm puttin' a few shillin's aside every week to get you and Eleanor over to Birmin'ham as soon as I can. Especially Eleanor: I'm worried about her here. There's no future for young people in this town. If ye want to break the mould, ye've got to move on, that's what I say."

Eddie went to his room. Sometimes he couldn't figure Auntie Josie out. What did she mean by breaking the mould? Mould was a black stain on a wall and you could hide it with a birthday card. And what was all that stuff about Jimmy putting money on a house? Eddie's Da sometimes sent him to put money on horses, but how could you back a house?

Maybe she'd lived too long in England and was going soft in the head.

It was Wednesday, the half-day, so he had longer than usual to practise in the alley. He took Eleanor's bike and rode the long way round the town to avoid Tom Egan's bridge.

When he reached the alley he found the grass around it littered with bikes and schoolbags. There seemed to be some sort of a tournament on and the place was thick with onlookers. They were squatting on the walls and bunched around the open end of the alley, engrossed in the action.

He burrowed through the crowd only to find it was Tom Egan they were watching. His grey-white shirt was drenched with sweat and half-hanging out over the top of his trousers. He was bounding about, making the ground tremble and wiping his forehead in his rolled sleeves after each rally. The other player was someone Eddie had never seen before, a small, powerful man with lightning movements.

Mouse Morrissey, seeing Eddie in the crowd, sneaked over and whispered: "He's a cousin of Egan's. He plays for the Newbridge club. Tom brought him over to pick up a few tips." Then he squinted at Eddie and shook his head. "I hope that sisther of yours is a good ride."

Eddie turned away to contain his rage and edged through the onlookers to another corner of the alley. He hadn't forgotten his pledge to Eleanor: Morrissey was in for it when this challenge match was over.

So, Egan had broken his word. How else did Morrissey know about Eleanor? And how long would it be before word got back to Elly herself? Worse still, his Da might hear of it and Eddie would be in dire trouble.

His father could get very ratty where the family honour was concerned. One night Eddie had heard him hauling Eleanor back into the house, slapping her across the face and calling her "a little slut and a hoor" because she was going to a dance with the top of her blouse open. Didn't she realise she was dragging the family's good name into the gutter? Elly spent the rest of that night crying in her room and nobody dared to go near her.

Eddie tried to focus on the game. As he watched Egan charging about, thumping the ball deep into the alley, he had a sick feeling in the pit of his stomach. Egan was not a skilful player, but he was powerful and determined. He would take some beating.

The Masters kids saw Eddie and nudged one another. Egan, walking back to launch one of his rocket serves, noticed him too and gave him a long, cold stare. Eddie felt the blood rising to his cheeks.

He stayed watching for a few minutes more and then pushed his way out through the spectators. As he left the alley, he heard Egan growling after him: "I hope for your own sake, Dwyer, you got the sisther t'agree." There was a burst of derisive laughter and wolf whistling from the crowd.

When he was leaving the field with Eleanor's bike, a hand landed on Eddie's shoulder.

"Where are you runnin', son?"

It was his father.

"You could learn from that pair so you could, I swear to God."

He was wearing his army uniform and rolling a cigarette between his quick, brown fingers.

"Da! I didn't see you back there."

"What's this I hear about you an' young Egan? I hear you fecked his bike an' now you've got to play him in a match."

"It's on'y a bit of a game, nothin' much really. I'll prob'ly get out of it somehow."

His Da looked smart and assured in his corporal's uniform, and, even though Eddie dreaded the questions that were bound to follow, he felt safe wheeling Eleanor's bike along the road beside him.

"What d'you mean get out of it?"

"I mean I'll think up some excuse not to play. Maybe I'll pay him for the lend of his bike, somethin' like that."

His father frowned and spat on the road. Then he put the rolled cigarette between his lips, cupped his hands and lit it in one movement.

"So, what did you want suggestin' a game for then? I hear tell it was your idea."

"I was tryin' to get out of a fight. He had me by the throat. It was the on'y thing I could think of."

"You'd no right nickin' his bike in the first place, sure you didn't?"

"I suppose . . ."

"Did you or didn't you?"

"I didn't."

"You could always wait back there and say you're sorry. He might buy that: he's stupid enough, God knows."

Eddie was surprised: Mam always said "sorry" was a word his father didn't know the meaning of. He said nothing.

"What did he mean by that remark about your sister?"

"I don't know." Eddie kept his eyes fixed on the road. "I must've said Eleanor mightn't agree to let me out on Friday after school or somethin' like that . . . Because Mam's in hospital. But she won't be in hospital by then, I suppose . . . But he doesn't know that. I don't know what he knows . . . I mean, I don't know what he means."

His father spat on the road again. "I s'pose they think you're a sissy havin' to get your sister's permission."

"Yeah, that must be it."

"The blaggards. I'd like to go back and belt the lot of 'em."

They walked in silence then, his Da spitting out particles of tobacco from time to time, past the abattoir and on towards the railway. When they were crossing the bridge, his father stopped and leaned over the parapet, staring down at the line. Eddie stood beside him, unsure whether to stay or ride on home. He could never figure out what people saw in those tracks, so much time was spent gazing at them.

"I'll tell you somethin' Ed," his father said in a quiet voice. "You're the firs'-born son and that carries a heavy load. It's up to you to set the pace, d'you know what I'm sayin'? The others'll be lookin' up to you so they will."

Eddie said nothing.

"If you make a mistake the likesa that, feckin' some gobshite's bike an' then challengin' him to a match, you're better off goin' through with it rather than crawlin' back an' apologisin'. It's no disgrace to be bet so it isn't, especially be a fella that's older an' bigger than yourself. But to go lookin' for pardon's on'y a sissy's way out. That's what I b'lieve anyway, an' you can take it or lave it."

His gaze had wandered down the tracks towards the Sidings, a cluster of old depots and derelict warehouses near the station. Eddie knew that drunks and tinkers congregated there, especially

on winter nights, and when they lit bonfires they could be seen staggering about in the light from the flames. People would stop on the bridge and stare, waiting for a fight to start or for the guards to raid the place with hailers and flashing lights. Some elderly people referred to the place as Purgatory and blessed themselves when they crossed the bridge.

Suddenly his Da snapped out of his trance; he spat over the parapet and jabbed Eddie in the arm. "You know wha' I think, son?"

"What?"

"I think you can bate the be-jaysus out of that bollix so I do. I think he's nothin' but a big awkward bear and you have twice his skill for the game, I swear to God."

"Do you really think that?"

"I feckin' well know it. When's the match anyway?"

"Friday week."

"A pity it's that soon, but no matter." He checked his watch. "Meet me at th'alley in an hour – they should be out of it be then – and I'll show you a trick or two that'll floor the galoot."

"Deadly! Thanks, Da."

"In the meantime, pick an armful of flowers from the Parochial Gardens there – without gettin' caught, min' – an' call into the hospital to see your new brother. Your Mam done us proud again this mornin', like she always does. A gran' little lad he is, an' not a blemish or a stain on him from head to toe; as bright as a new button he is. He'll play for the county some day, I swear to God."

Later that day Eddie waited for nearly two hours in the alley, looking up the road for his father. After the earlier activity of the place it seemed deserted and spooky.

From time to time he practised on his own till his arm began to ache. Still there was no sign of his Da on the road.

Then, as the evening light started to fade, he picked up Eleanor's bike from the grass and, to avoid the railway bridge, cycled home the long way around the town.

There was a great hullabaloo in the school the next day after a new first-year was driven right up to the gate. The lads said the car was a limo. "He's a right hick," they told Eddie. "A dooley if ever you seen one. Wait'll you see him."

Sure enough, the newcomer looked out of place: he acted dazed, like he'd just fallen out of a train or got off by mistake at the wrong station. Brother Meehan sent him out on a message and, when he was gone, told the class not to be slagging him. His mother had died a few months before and he had been sent to live with his uncle and auntie in Drumaan. If he caught anyone shoving or jostling the new kid, he'd give the offender six of the best.

Cormac Mannion was the newcomer's name. To look at him you knew by rights he was one of the Boarding School Brigade. This was what Brother Meehan called the lads who "couldn't wait to be whisked off to posh schools" – just so they could swagger around the town with long scarves during the holidays and look down their noses on the rest of the human race. Brother Meehan had it in for the Boarding School Brigade and he liked parading up and down the classroom imitating their ways.

The new kid talked posh combined with a queer country twang that made the Drumaan guys snigger. They fussed around him, asking him questions and trying to mimic him. When Brother Meehan wasn't looking some of them jostled him, but he seemed well able to stand his ground. Eddie decided to leave him alone – for the time being at any rate.

During their break times Eddie saw the new boy watching him, but he pretended not to notice. He just kept on hammering his handball against the gable wall of the school and, when the bell rang, he joined the others and filed silently back into the classroom.

After a day or two the newcomer worked up enough courage to break the silence. "You're pretty good at that," he said as he watched Eddie volley the ball without letting it touch the ground.

"Thanks."

"But you could work a bit harder on your top spin."

Eddie stopped volleying and looked at him. "That's what my Da says. I don't suppose you play yourself."

"A bit. There's an alley not far from our house in Westmeath."

"Want a game?"

"Here?"

"Yeah."

"OK."

Cormac turned out to be better than Eddie expected and it took a lot of concentration to beat him. After the game they were both out of breath. Cormac explained that he used to play a fair bit with his sister when they were younger.

"With your sister! I never heard of a girl playin' han'ball."

"That's 'cause you don't know Angie. She's great at all sports. She swims and plays tennis for her school. She can beat fellas her own age at most games. She's a brilliant coach."

"I wish she was here to give me a few tips. I've a big game comin' up."

"We could play each other after school and that way we might both improve."

"All right."

That afternoon they raced down to the alley the minute school ended and played till the sweat ran down their backs. Afterwards Eddie skipped home in high spirits; there was something he liked about his new pal – even if he was a hick or a dooley.

Before falling asleep he went over everything they'd said and done, and he forgot about Tom Egan for the first time since the bike incident.

They played again the next day, and the day after as well, and Eddie began to notice a definite improvement in his game. For the first time ever he was getting the hang of position play and other aspects of handball he'd hoped to learn from his father.

Cormac brought food to school and told Eddie that the maid in his auntie's house had given him extra sandwiches and apples when she heard he had a new friend. Eddie asked him what a maid was and Cormac told him. He said his auntie's maid was always nicking food from the kitchen and giving it to the gardener.

During school breaks they knocked up with the handball or, if it was raining, stayed in the bike shelter. They talked about cowboy books and films, or about Eddie's big match.

When Eddie admitted he wasn't sure if he could beat Tom Egan, Cormac said: "Sure you can. He's only a half-tamed gorilla." And he made ape grunts and hammered his chest.

As they were crossing the bridge on their way home one evening Cormac had a brainwave. "I know what, Eddie. Let's get the game put back. What do you think?"

"I don't know. It might only lead to . . . problems." Eddie was thinking of Eleanor finding out, but he hadn't said anything to his new friend about that.

"I bet I can get Egan to put it back. Here, give us a loan of your bike."

Eddie hung back, hoping it wouldn't look like he was chickening out. Then, as he walked past the school Cormac met him. "Tomorrow fortnight. And you know what: the gorilla was just as happy. I left him swinging from branch to branch in the bike yard."

"Brilliant!"

"See you tomorrow, Eddie."

"OK. Bye."

Cormac was a strange guy: one minute he would be standing in the alley, nattering on about the finer points of handball like a fully grown coach; the next, he would be charging across the Curragh playing cowboys and Indians or acting out ghost stories in some old ruin on the outskirts of town. But as long as no one from school could see them, Eddie didn't mind; in fact he liked showing his new pal around the place and switching suddenly from being all grown up and responsible to acting like a kid.

Cormac was a good storyteller too and he knew a lot about

books. One day he said they should go to the town library and get out books about handball.

"Who ever heard of books about han'ball?"

"There's books about everything there. Wait till I tell you: one day I found a book about the Brothers."

"The Brothers? Jeez! Who'd want to read the likesa that?"

"I don't know. But if they've books about something as stupid as that, they must have books about handball."

"You look very chirpy," Eddie's Mam remarked, as he skipped in the door late one afternoon. It was her first day home from the hospital and he hadn't expected to find her in the house. He rushed into the kitchen and put his arms around her.

She laughed over his shoulder. "Go easy, son. I'm not that long on my feet, you know."

Eddie had heard Eleanor and Auntie Josie whispering something about a complication. "Are you alright, Mam?"

"Sure I am. Right as rain."

The house was full of the warm smell of her cooking: brown stew, scones and home-made soda bread. The windows were clean and there were flowers on the table. Philly and the twins were playing in the back yard, running in and out of the bike-shed after the cats.

"Are you glad to see me back?"

He just held onto her and pressed his face against her chest. After a while she took his arms gently from around her. "You poor little skitter, didn't Eleanor look after you at all when I was away?"

"She did all right."

"An' Auntie Josie. I hear she came by the odd time."

"Yeah."

"I suppose she was fillin' your head with notions about goin' t'England." She looked into his eyes and he nodded. "An', needless to say, you didn't see much of himself."

Eddie looked around the room. "Where's the new baby? What are we goin' to call him?"

"He's up in my room. Don't go disturbin' him now. I jus' got

him to nod off. I'm thinkin' of christenin' him Patrick Joseph after my own father. Let me look at you, Eddie. It was grand when you came to the hospital that day, even if you needed a real good scrub. I felt that proud in front of the other women so I did. But I can't think where you got all them huge daisies."

"That was Da's idea."

"Was it?"

Mam seemed happy in one way, sad in another. She sat at the table peeling apples and popping them into a bowl of cold water. "I'm makin' a pie for the homecomin'. I wonder is it fair bringin' another child into this house? I jus' don't know: there's rich people without a wain of their own an' the likes of us trippin' over them at every turn. The Lord works in mysterious ways all right, there's no doubt about it."

"Does that mean Nuala will be movin' into my room now? It's gettin' a bit crowded you know."

"Oh everythin' may change one of these days. The way things are lookin' you might even en' up havin' a room of your own."

"What do you mean? Are we movin' to a bigger house?"

His mother laughed. "That'll be the day! No. Josie's offered to take Eleanor back to Birmin'ham an' put her in a good school over there. What do you think? I'm demented frettin' about it all week. I wan' to do what's best for the girl, but I don't wan' to lose her. God forgive me, is that jus' plain selfish?"

Eddie and his mother sat in silence then for a long time, Mam staring at the apples she was peeling while he wrestled with the idea of Eleanor leaving home. He felt a great emptiness at the thought of the house without her. God knows, she could be fiery-tempered, but the way she put her arms around you and laughed, and the bright way she flicked her hair over her shoulder, they were things that made up for it all.

His mother looked across the table at him. "You're gone awful quiet all of a sudden,"

"I was thinkin'."

"Well, don't strain yourself: you're probably out of practice."

"If Eleanor leaves, will she be goin' before Friday week?"

His mother stopped peeling and looked at him. "What kin' of a nonsense question is that in the name of all that's holy? Sometimes I wonder about you, Eddie Dwyer. Will she be goin' before Frida' week? What's happenin' on Frida' week that's so importan', would you min' tellin' me?"

"Oh, nothin' really," he said, snatching an apple from the table and skipping out of the room. "I'll tell you another time."

Cormac said Tom Egan was relieved that the match was put back. Eddie wondered about that. Perhaps Egan thought Eddie needed more time to work on Eleanor; or maybe he just wanted to improve his own game. Could it be that he was scared too?

Cormac made gorilla noises whenever Eddie mentioned Egan. "Don't worry," he said one day. "When he's just going to take a serve I'll throw him a banana."

The whole Brothers school seemed to be geared up for the match – and most of the older kids from the Masters school too. Egan was still favourite to win, but the odds on a surprise outcome were getting shorter by the day.

Eddie and Cormac had the alley for the first hour after school; Egan took over then and practised till nightfall. There were spies now relaying information between the two camps and once or twice Cormac made wild tactical suggestions in a loud voice – in the knowledge that Mouse Morrissey or one of his cohorts would carry the game plan back to the Egan side. "That should scare the shit out of the gorilla," Cormac said, winking at Eddie when Morrissey had slunk away.

By the Wednesday before the match Eddie felt certain his game had improved. He and Cormac had borrowed books and manuals from the town library and these had shown them how to distribute their body weight evenly while waiting for a spinning ball, how to read the outcome of a ricochet and how to mislead an opponent with a last-second switch of direction. The secret was to play the full court, not to lie back waiting for your ace shot; and, as one of the manuals put it, strength was "secondary to skill and concentration".

But how was Eddie going to concentrate and remember these things in front of half the town? There would be jeering and heckling and everyone would know he had been bullied into promising Egan a date with his sister. Eddie hadn't even told Cormac about that.

Eleanor would hear of it too – it was a miracle she hadn't heard already – and there would be hell to pay. And then, to add to his shame, girls would be giggling at his pale skinny arms and legs.

"Beside Egan I'll look like one of the white statues at the church gate," he told Cormac. "The one of Jesus lying in the lap of his mother."

"Don't worry. I'll light a candle for you."

"How would you feel if you'd to get up in front of the whole school and play the likes of Tom Egan? I stand to make a woeful eejit of myself. I'll be the right laughin' stock – if I'm not that already."

"I don't think anyone's laughin' at you, Eddie. In fact, I think they look up to you for takin' on Egan."

"That little shite Morrissey doesn't look up to me. He said somethin' about my sister that I've yet to pay him for. He has some thrashin' comin', I swear – as soon as I get this business out of the way."

"Never mind Morrissey. You've more than a fifty-fifty chance of beatin' Egan. The match'll go to whoever has the most stomach for the occasion." Cormac was beginning to sound like one of the handball manuals.

"At this minute I've no stomach for anything. I can't eat and I can barely sleep at night with the belly cramps."

"And how do you think Egan feels? If you lose, everyone will put it down to the fact that he's bigger than you. But if he loses, they'll say he was beaten by a kid and he won't be able to show his horrible face for weeks."

"I wish it was over, one way or the other."

"C'mon, let's go to the mill pond. It'll take your mind off the match. Do you remember that perch we saw looking out at us from the reeds?"

"The massive red-and-gold fella?"

"Yeah. Wait till I tell you: I know how we could catch him. We can make a rod: I've got some string and a hook. Then, if we cross the river at the weir and crawl along the far bank on our bellies – like Apache scouts spyin' on a herd of buffaloes . . ."

It was getting dark and the perch was still safe in the reeds when Eddie finally persuaded Cormac to abandon the enterprise. Cormac blathered on about strategies they could adopt to catch the fish on their next outing.

"Maybe you should see if the library has books about catchin' perch," Eddie suggested.

"Hey, that's a good idea."

As they drew near the weir, a black car pulled up on the opposite bank and a tall woman got out and waved in their direction. She was wearing a long silvery-grey fur coat and a hat that matched. At first Eddie thought she must be a film star or some kind of millionaire. Then he realised she was shouting something urgent, but across the millstream it was impossible to make out what she was saying.

"Look at your one: she's in a wild fret, whoever she is."

Cormac saw her and waved back. "That's my aunt. What's she doing here?"

"You better go on over and find out. I'll look after the rod."

Cormac crossed the weir and ran along the far bank. Eddie watched him talking to his Aunt Maeve and then going to pick up his schoolbag from the millhouse. He waved back across the weir, shrugging his shoulders as if to say he'd no choice. Eddie returned the wave and stood watching them drive away: the car engine made no sound over the rush of the water.

Eddie crossed the millstream and hid the rod in a corner of the deserted mill. He had to go back by the alley on his way home to pick up his schoolbag, but he didn't mind: it was a warm night; besides, the longer he stayed out of the house, the less time he'd have to lie in bed brooding about the match.

As he drew near the field he thought he heard voices from

the alley. Could Egan possibly be practising by moonlight? He slowed down and left Eleanor's bike on the grass near the road. Then he crept slowly – not quite Apache-style – towards the shadowy structure.

If it was Egan he could hear, he had a girl with him, probably the one he was forever carrying on with under the railway bridge; they were in a corner of the alley and he had his back to where Eddie crouched on the grass. He stayed still and watched. Egan had one hand against the wall to make it hard for the girl to get away and he was holding her by the shoulder with the other. Occasionally she tried to shake herself free.

Suddenly she yelled at him: "No, I will not do it here. Or anywhere else, for that matter. It's over, d'you hear? You're a liar so y'are. Let me go. I should never 've came here in the firs' place."

Her voice sounded different somehow, not as flat as the day Eddie had snatched Egan's bike. The wind was rustling the trees all around. Eddie huddled low. He shouldn't have got himself into this position: he would have to wait now till they left the alley before he could make a move.

Slowly, as his eyes got used to the darkness, he realised it was a man he was watching, not Egan: a dark-haired man wearing an army uniform. His trousers were tucked in just above the boots and there was a beret in his tunic epaulette. He was talking in a low voice and it was hard to tell what he was saying.

"Don't give me that . . . I didn't have to shaggin' carry you there . . . I swear . . ."

"You're drunk, Bill. Let me go."

"Come on . . . Take it easy."

"Leave go. An' take your arm out of my way."

"Come on . . . you know how you feel . . . Stop fuckin' arguin'."

He leaned closer to the woman but she pushed him aside and yelled: "Take your filthy hands off me! It's over between us, Bill Dwyer, d'you hear? That's all I came out to tell you, so now you know."

Eddie could hear that she was crying as she ran out of the alley. There was a gust of wind and the trees rustled and sighed.

"Da," he whispered when the woman was well out of range. "Da, is that you?"

But the dejected figure just slumped against the wall and spat on the ground, cursing to himself. And the trees drowned out Eddie's half-hearted whispers.

When he got home he took Eleanor's bike around the side of the house and went straight to the shed. From the kitchen he could hear his mother, the kids and the usual sounds of his home – childish arguments, pots and pans being scraped, babies crying and the range being scuttled over and over again.

The back yard was lit by shafts of light from the kitchen and from Eleanor's bedroom above it: he could see her golden head bent over the table where she usually did her homework. He heard Mam calling her down for her tea and asking her if she knew where he was. Eleanor said she hadn't a clue.

He sat on damp sacks in the shed and listened to the faint voices of his mother and sister talking about England. They said something about an ambush in the Congo. It had been on the news: some Irish soldiers had been killed; but their names were not being announced until their families were told.

The twins started arguing about jam. Philomena was singing quietly to herself even after she was told to eat up. The new baby began to cry in the background and Eleanor said: "It's all right, Mam. I'll pick him up."

"Did they say how many was killed?" his mother asked when Eleanor came back to the room.

"No one knew for sure. Some say ten. Maybe more."

"God bless the poor families. An' what were they doin' out there but keepin' the peace?"

"How come Da never went?"

"Are you askin' me? Sure I don't know the halfa what goes through that man's head. He's a law unto himself: always was an' always will be. An' Eddie's turnin' out the same if you wan' my

opinion. Where d'you think he might be at this hour an' it black dark outside?"

"Don't ask me."

When the meal was over Eleanor took the baby back upstairs and Mam came to the back door to shake out the tablecloth. Then Eddie saw her at the window washing the dishes in the sink. She issued commands over her shoulder, breaking up disputes, encouraging the kids to share their toys and promising treats if they were good. When Philomena let out a roar at someone, she said: "Don't screech like that, Philly pet. It isn't the end of the world y'know. Be good now, or your Da'll be cross when he gets home."

After the baby had quietened down, Eleanor came back. "What in God's name is keepin' Eddie? He's gone off gallivantin' somewhere with my bike and I haven't seen him all day. I wanted it to go to the pictures with Carol, but we'll never make it walkin' at this hour."

"What picture's that?" Mam asked.

"It's a Brando picture. I got the money from Auntie Josie."

"Well, why don't you go out and see if your bike's in the shed? Sometimes he comes home and goes away again without sayin' a word to anyone. All he's livin' for these days is han'ball and comics. He's even readin' books about han'ball, whatever's got into him at all."

The back door opened and Eddie cowered as low as he could on the sacks: they smelled of cats and the bitter stench almost made him throw up.

Eleanor came out, looked into the shed and called back: "Hey, Mam, you're right. The bike's here. He must've come home and left again earlier without comin' inside. What's got into that fella lately, I'd love to know."

She shook the bike a few times to see if it was intact; then, satisfied that the rattles were the familiar ones, she put it down, closed the shed door and went back into the house.

He heard her and Mam talking, but he could no longer make out their words: something about the terrible business in the

Congo. *May the Lord have mercy on their souls*, his mother kept saying over and over again.

He stayed as still as he could and wondered why the cat smell was fading: he felt too tired to figure out how the shed smelled less putrid with the door closed than when it was open . . . He closed his eyes . . .

When he woke up the bike was gone. The back yard was darker now: there was no light from Eleanor's room and less than before from the kitchen window.

He crept to the kitchen door and turned the handle: then he took off his shoes and tiptoed across the concrete floor. From the hall he could hear his mother and some neighbour women talking quietly in the front room. There was a new pair of baby socks tied in a pink ribbon lying on the hall table beside a card and another unopened present.

When he reached the landing he went straight to Eleanor's room and, fully dressed, slipped in between the sheets. They were cool and dry, and there was a faint scent of the green soap she used and kept in her room. It reminded him of the smell of grass at the alley.

He tried to put everything out of his mind – the match, the car driving silently away from the weir, the shadowy figure in the corner of the alley, the woman yelling, the sickening smell in the cat shed . . . But he couldn't sleep.

In the moonlight he gazed at the posters of Elvis with his queer smirk. Then he tried to think of the perch in the reeds. Even that was no good. He was back at the alley and his head was full of the sounds of the trees rustling. They seemed to be sighing, whispering to him, warning him away.

If only he could close his eyes and wipe his mind clean – the way Brother Meehan cleaned the blackboard between each different lesson . . . rubbing out the chalkmarks . . . starting all over . . .

Suddenly Eleanor was in the doorway, silhouetted in the light

from the landing. "Jesus Christ!" she gasped, backing out of the room.

Eddie sat up in bed and put his finger over his mouth. "Shh, Elly. It's on'y me."

"Ed!" She stepped inside and closed the door. The only light in the room was a strip of moonlight on the wall near her desk. "Holy Moses! You near put the heart across me. What the hell do you think you're doin' in here? I thought for one minute . . ." She sat on the side of the bed. "Never mind what I thought. Jesus in Heaven! The smell in this room would choke a rat."

She went to the window and raised it till he felt the night breeze on his face.

"Where in the name of God have you been hidin'? Mam's goin' mental downstairs, convincin' herself you're after fallin' under a train or somethin'."

"Go down and tell her you found me asleep in your bed. Then come back up: I want to talk to you."

"Go down yourself. I'm not some feckin' skivvy. It's one thing havin' your father orderin' me about: don't you start."

"Please. I don't want to talk to her now."

"What's up with you anyway? You're carryin' on mighty queer these days. I hope you're not after gettin' yourself in . . . Mother of Jesus! The smell in here! Were the cats in the house or what?"

"No, I'll explain later. Go on. Please."

Eleanor stood and stared at him for a moment. "My trouble is I don't know when to say no. I'm just as big an eejit as Mam when it all boils down."

"I just want to talk to you for a few minutes. Then I'll go to my own room."

She opened the door and set off down the stairs mumbling to herself. Then Eddie listened to his mother exclaiming: "Merciful Jesus! I'll have to offer up a novena to St Anth'ny." And if she said it once, she said it five times.

Eleanor started back up the stairs. "Anyway he's asleep now. I'll go into the other room with the kids."

When she reached the landing she called back in a loud

whisper: "Oh Mam, the picture was great. You'll have to go and see it. I cried the whole way through."

"I've more to be doin' than watchin' that madman actin' like his pants was on fire."

"It wasn't Elvis, Mam. It was Brando. I told you."

"They're all the one to me, them rock 'n rollers. One's as bad as the nex' . . ."

Eleanor was back in the bedroom and the light snapped on. "Now listen here you. I want you out of this room in three minutes flat. I'm not takin' any more of your carry-on, do you hear? What's so important that you want to talk about anyway?"

Eddie blinked up at her.

"Well, come on. Out with it, whatever it is."

He ducked his head under the blankets. She pulled them off him and threw them over the foot of the bed.

"My God! You're in my bed with all your clothes on."

"I took off my shoes."

"Well, that's somethin'. Eddie, what's eatin' you? You're actin' mighty weird this last while."

"Mam told me you were thinkin' of goin' to live with Auntie Josie. Is that true?"

"Well, well! She told me that all you were worried about was if you were gettin' this room. And somethin' about Friday. What's happenin' on Friday?"

"I don't give a curse about this room. Just promise me you won't go." The words burst out of him in a tearful rush and he turned to the wall and buried his face in her pillow.

Eleanor sat on the bed beside him and put her hands on his shoulders. "Eddie, come on. What's got into you at all?"

He couldn't speak.

"Is it school? Are you in trouble with the Brothers, is that it?"

He shook his head.

"Then it's your father. Has he done somethin' to hurt you?"

He looked up at her and wiped his nose in his sleeve. "How'd you know?"

"Shh! I know more than you think. You worship him and that's OK. But be . . . careful. That's all I'll say."

"Well, you're wrong. I don't worship him. He's a bastard and I hate him, just like you do. I really hate him."

She held him in her arms and patted his back. "So, what did he do to deserve this? Why don't you tell me about it?"

Eddie shook his head. "It's not important. Nothing's important. I don't care what he does. I jus' don't want you goin' to live in England, that's all."

"I might be sent."

"You don't have to go if you don't want to. You don't have to do an'thin' in this life if you don't want to do it. That's what I believe and you can take it or leave it."

Eleanor smiled. "So, what did he do to you? Tell me."

He thought of the slouched figure in the alley and the trees rustling all around the field. "I saw him . . . in the alley . . ."

"Go on," Eleanor prompted. The leaves grew louder and more agitated. "You saw him in the alley. When was this?"

He looked away. It was dark at the alley: maybe his eyes had tricked him.

"Eddie, what are you tellin' me?"

"It was a good while ago. I met him there and we walked to the bridge."

"And?"

"He told me he'd come back to the alley and give me some tips, you know, a kind of a coachin' for the match. But he never showed up. I waited for hours, till it was black dark."

"You poor sod. Is this what has you in this state?"

"I s'pose so."

"My, oh my! Aren't boys the weak creatures? You're stood up once by your father and now you hate him."

"He's a liar, so he is. An' a cheat."

"Eddie, let me tell you somethin'." She sounded serious and grown-up. "Sometimes it's better not to tell people all you see and hear. Do you know what I'm sayin'?"

"No."

"Well, think about it. Take Mam, for instance: she's got enough to put up with as it is. Don't go tellin' her that your father let you down like that."

"I s'pose . . ."

"Listen, there's some bridges in life you've to cross on your own: ones that are too narrow or shaky for others to cross with you, do you know what I mean? Your father lettin' you down: that's one of them. Do you understand?"

He nodded.

"Sometimes it helps to talk; other times it doesn't help at all. And the trouble is to know . . . which at the time."

She went quiet for a few minutes, arguing something in her head. Eddie said nothing. Then she stood up and went to the mirror. There she began examining the whites of her eyes, pulling her face into scary expressions, and when she caught him staring at her, they both laughed.

"So, then: what's all this about a match? Handball, is it?" she asked.

"Oh yeah, didn't I tell you? I must've forgot. I'm playin' Tom Egan on Friday."

"Tom Egan? Why?"

"He tried to strangle me jus' 'cause I took a lend of his bike. So I challenged him to a game of han'ball if he let me go. It's on Friday after school."

She was combing her hair and wiping her cheeks in front of the mirror. "I must go to that. You'll need all the support you can get."

"Yeah."

"So, if you win, he lets you go without stranglin' you."

"Yeah."

"And if *he* wins?"

"He strangles me, or . . ."

"Or what?"

Eddie took a deep breath. "Well . . . I promised I'd ask you to go out with him."

She stopped combing and stared at him. "You promised what?"

"He's not that bad-lookin' really. And he's about your age."

"Tom Egan! Are you out of your mind? You bartered me to

66

save your skin. He's a bear. An' he's at least twice your size. What did you want havin' a run-in with the likes of him for?"

"Well, all you have to do is *say* you'll go out with him. You can kick him in the shins an' come home early for all I care – as long as you agree to go out with him. An' you've to put it in writing: he insisted you put it in writing before the match."

Eleanor sat down in a chair away from the bed. "Oh, he insisted, did he? I don't believe this."

"You were the on'y person I could think of at the time. Besides, he fancies you."

"An' what gave you that impression, might I ask?"

"Jus' somethin' he said."

"An' what was that?"

"He said you've got great . . . brains."

"Uh huh!" She didn't sound convinced.

"And he likes you in other ways too."

"I bet he does. He likes anythin' in a skirt, anythin' willin' to descend to his own level, under the railway bridge. Have you any idea what kind of a reputation that animal has?"

"You don't have to do it if you don't want to. I on'y said I'd ask, that's all. 'Cept, if you don't and I lose the match, he'll smash my face in – an' you'll have that on your conscience for the rest of your life."

"An' if I agree and you lose, what happens to your conscience? No self-respectin' fella in this town would look at me again, ever. No, Eddie. You stole the bike; you better get out there an' win. An' if you don't, you can plead with Tom Egan for mercy, not with me."

"You mean, you won't . . ."

"No, I won't. I'll be there to cheer you on an' nurse your wounds, if there are any. But I'm not swoppin' my reputation for yours or anyone else's. An' that's the end of it."

"But it's on'y a date. I didn't promise anythin' else."

"Well, that's a relief! I suppose it's all over town that I'm the prize."

"Well, he promised he'd keep it quiet but . . . I think . . . he forgot."

"Listen, Eddie: do you hear yourself? You're apologisin' for that gobshite now."

She went quiet then and paced around the room for a while. "Listen here, Ed. If I don't have to do what I don't want to do, has it not dawned on you yet?"

"What?"

"You don't have to either."

"What do you mean?"

"I mean, meet Tom Egan tomorra an' tell him I don't agree to go out with him. Then, as far as you're concerned, you honoured the agreement from your end an' the match is off."

"And what if he clobbers me there an' then?"

"You clobber him back. Or turn the other cheek, whichever."

"So I get beaten up?"

"Yeah, that's possible. But when you're lyin' there in a pool of blood, spittin' out teeth, you can say: 'Strange as it mus' look, Eddie Dwyer has just learned to stan' on his own two feet. He's come out from under his mother's skirts an' his sister's gym frock. He's a fully-fledged human bein'. Praise the Lord, halleluia!'"

Her words reminded him of a statue near the church gate: not the one of Jesus lying in his mother's lap; but one that showed him rising up behind a group of people who were mourning his death. But then he remembered the slouched figure of his father in the alley and his heart sank again.

"Well, don't look so miserable. It's just another one of those narrow bridges I was talkin' about."

"OK," Eddie said, getting off the bed. "Goodnight, Elly. An' thanks for the advice."

"Don't worry, Ed. He'll play alright. His reputation's at stake by now."

"I s'pose."

She looked unsure for a moment, her eyes fixed on his. "Maybe I'm bein' mean . . . I s'pose I could pretend . . . Is that what you want?"

Eddie shook his head.

"Then you're goin' to tell him I said no."

"Yeah."

"And what then?"

"If he still agrees to play, I'll jus' have to beat him, that's all."

"Are you sure you don't want me to say I'll go out with him? I could always get out of it later I suppose."

"No. I'm glad you decided not to. To tell you the truth I never thought you would. I was plannin' on forgin' the note."

"Were you now? So you're a forger as well as a bike robber."

"I s'pose so. Goodnight."

She hugged him and patted his back again. "My God, it's you! You stink to the high heavens. Were you in a cat fight or what?"

"No, I . . . I . . ."

"You what?"

"It's too hard to explain."

"I'll have to fumigate the room and change the sheets. Go an' have a bath before you go to bed."

As he closed her door and stood in the landing outside his own room, Eddie knew he had crossed one of Eleanor's narrow bridges, but he was only half way across the second. Beneath his feet the millstream roared. There was nothing she could say or do to help him blot out the sounds and images that would trouble his sleep that night and for many nights to come, so why should he inflict his trials on her? It was surely enough that he'd filled her room with the stench of cats.

But, with or without Eleanor's help, he finally felt ready to face Egan – even if he was a gorilla or a bear or a troll, and more than twice his own size.

1965

Chapter Three

THE COMMANDANT WAS studying one of his palms, like a map of some difficult terrain he had orders to capture. He was sitting in his wheelchair, slouched a little to one side. Aunt Maeve glared at him. Then she sighed, blessed herself and looked at Cormac to recite the grace.

"Bless us, O Lord, and these thy gifts, which through thy bounty we're about to receive through Christ Our Lord, amen."

He thought of the refectory in school and the roar of boyish voices that always followed the prayer. Leonie made the sign of the cross before leaving the room.

The meal began in silence, the Commandant fiddling with a napkin tucked under his chin, his wife at the head of the table frowning every time he spilled soup back into his plate. In front of her, around a floral island, a flotilla of vessels stood waiting for starting orders: dishes of steaming vegetables, a covered platter of ribs of lamb, a silver gravy boat and large serving spoons.

When the Commandant leaned forward to examine a silver spoon, Aunt Maeve moved it out of his reach. *"Really, Frank, be careful,"* she said in the sharp voice she now used to address him. *"We don't want you falling and knocking everything on the floor."*

The silence returned. Cormac's thoughts fled to the refectory in school and the mêlée whenever the priest in charge nodded off. One day a potato fight had broken out and someone had nearly lost an eye. Another time a first-year was locked in a fridge: the boy was so traumatised that his family threatened to

sue the school. Then the bowed heads and fearful hearts – and his Belfast friend, McEldowney, chanting during Benediction: *From scandal and litigation, O Lord deliver us.*

"*Really, Frank,*" Aunt Maeve demanded. "*Don't jog about like that. You might damage the carpet.*"

The Commandant leaned over his soup – as if seriously contemplating diving into it to put an end to his misery.

Even though it was less than a week since the school broke for holidays, Cormac had already written to McEldowney:

> I can't tell you how insufferable meals are in this household. Every grain of resentment seems to come to the surface at the dinner table. I use any excuse to avoid eating with them. I have even found myself dreaming nostalgically of the school refectory: is this not the onset of severe dementia?
>
> Every summer I say the same thing: this time I'll do something to lift them out of their despair. But after a day or two I feel the weight pulling me down. It's as if neither of them has ever forgiven life for what happened in 1960.
>
> The fact that he was injured in an absurd accident seems to have undermined them both. Sometimes when I read to him, his face lightens a little and I think there must be some spirit there. But she seems determined to crush the few sparks, rather than nourish them – as if the last thing she wants is to have her hopes and dreams rekindled.
>
> Anyway, enough of that. I've decided to take your advice and try to re-establish contact with Eddie Dwyer. I don't know why I've shied away from tracking him down – ever since the first Christmas holidays I spent in Drumaan.
>
> I suppose I do resent the way Leonie came between Eddie and me. But then we've been through all that and I still await the enlightenment of your meditations . . .

Leonie was back in the room, clearing away soup plates and setting the main course within reach of Aunt Maeve. Cormac slowly became aware that his aunt had turned her attention to him.

"I'm talking about Maurice and Imelda Lindeman. I really don't see why you refuse to make friends with them. They're

always asking if you'd like to play tennis. It would be much better, I assure you, than moping about peering at them over the garden wall."

Cormac lowered his head towards his plate. Could she really be nattering on again about the wretched Lindeman kids?

"Up straight," the Commandant demanded. It was one of the few phrases he could articulate clearly since his Congo injury, so he seized every opportunity to say it.

"Imelda and Maurice might like to go riding," Aunt Maeve went on. "They could help you improve your tennis and you could show them how to handle a horse. I've recently had business dealings with their father and he's very anxious for you to become friends. They'd make most suitable companions in my view. It's not as if your social calendar is bursting at the seams."

From behind Aunt Maeve, Leonie caught his eye.

"I'm going to go around and see Eddie Dwyer today," Cormac blurted. "That's the first item on my summer agenda."

"I see."

"That's assuming he still lives in Drumaan." He looked at Leonie; her wry smile had quickly evaporated. "It's four years since I've seen him. More than four in fact."

Aunt Maeve sighed and withdrew into herself again. Silently she served out the main course and passed the plates to Leonie.

Cormac recalled his first-year visit to the Pearse Estate. Leonie had put him up to it. There was a flu epidemic in town and almost the entire Brothers school had been laid low. She'd heard that Eddie was confined to bed over Christmas: Cormac should bring him some comics and food and try to cheer him up.

Cormac's heart had sunk at the poverty of the place: it was a cluster of drab houses erected like a barricade against the wilderness at the edge of town. The small front gardens were little more than dumping grounds for broken bikes and prams. Some windows had been boarded up and walls daubed with graffiti. Children were playing on an icy roadway strewn with glass and scraps of metal.

A girl of about seven opened the door of Eddie's house, two younger kids, identical twins, cowering behind her. From the kitchen at the end of the hall a woman called out: "Philly, if it's someone for Eddie tell them he's sick."

There were footsteps behind him, Cormac remembered, and he turned as a girl of about fifteen brushed past him into the house and dumped a schoolbag on the hall floor; then she pulled a band out of her blonde hair and ran up the bare wooden staircase. "Elly, Elly!" the two little ones shouted after her, but the only response was a door slamming upstairs.

The child holding the halldoor open rolled her eyes and remarked in a surprisingly grown-up voice: "Boy problems, don't you know?"

"Philly," the woman shouted down the hall again. "Did you tell him Eddie's sick?"

"Just a minute, Mam," Philly said, turning to Cormac again. "I'm sorry but my brother Edward's in bed with th'influenzie." The twins covered their mouths and giggled.

"I know Eddie's sick, Mrs Dwyer," Cormac called out over the children's heads. "I brought him some comics and a few apples. I'm his friend, Cormac Mannion."

The woman came from the kitchen, wiping her hands in her apron. "That's very kin', Cormac. Eddie's asleep at the minute, but I'll tell him you came over to see him."

"He's not very sick, is he?"

"No. Maybe you could run up an' say hello." Then she seemed to have second thoughts. "The room's in a wil' state, though, and you don't want catchin' the bug. Here's his Da now: I'll see what he says."

The three children suddenly ran down the hallway towards the kitchen, Philly abruptly abandoning her halldoor demeanour. Cormac turned in response to the heavy footsteps on the path.

"Bill, this is Eddie's pal, Cormac. He brought over some comics and apples. Isn't that very decen'?"

The Corporal stopped at the garden gate and stared at

Cormac. Then he stepped forward and punched him lightly on the upper arm.

"I didn't . . . know . . . " Cormac began. "I never . . . knew . . . "

"What didn't you know?" Mrs Dwyer asked.

"He didn't know I was Eddie's ol' man. Is that what you're tryin' to tell us, son?"

Mrs Dwyer placed a hand on Cormac's shoulder. "Are you all right, Cormac? Do you want to come inside? You don't look the best . . . "

The Corporal laughed. "Yerra, lave him be an' stop fussin', woman." As he spoke some impulse made him straighten his army tunic. "The Comma'dan' is Cormac's uncle so he is: did I never tell you that, Biddy?"

"You never did."

He put out his hand and gripped Cormac by the back of the neck.

"A great young lad, he is too, but always a bit white in the gills. So, how're you gettin' on in the boardin' school, tell us?"

"OK, thanks."

"Keepin' your nose outa throuble, I hope. Eh?"

"Yeah, for the most part."

The corporal released his grip.

"Good. Very good. I drove him there meself, Biddy, the mornin' after the Congo ambush, would you b'lieve? An' the poor skitter was shakin' that much I thought he'd pass out cold waitin' at the fron' door. A mighty place it is, a mansion, you could call it. It near put the heart across meself as well."

"God bless us all."

"So, how's himself these days? Poor Comma'dan' Conn'lly."

"Oh, he's just the same."

"An' to think he wasn't even on the pathrol that got ambushed. He on'y banged his head gettin' out of a milit'ry plane, y'know Biddy. An' that left him the way he is."

"Heaven help us."

"But it's good he has you there to keep him company, Cormac."

"Yeah, me and Aunt Maeve. And Leonie too. She's still . . . around . . . "

He had said her name before he could stop himself. The Corporal shifted uneasily, looking at the ground and scuffling it with one of his army boots.

"I didn't . . . I mean . . . Here, you take these," Cormac said, thrusting the comics and apples into Mrs Dwyer's arms. "I've got to go. Tell Eddie I'll see him when he's better."

"He'll be ragin' he missed you. Maybe I should've woke him up, what d'you think, Bill?"

"Yerra, lave him be," the Corporal snapped. "Let sleepin' dogs lie. Isn't that what they say, Cormac? Let sleepin' dogs lie."

"I suppose so. Goodbye."

"Goodbye, Cormac. An' come again," Mrs Dwyer shouted after him as he closed the metal gate and made his way out of the housing estate.

* * *

Leonie picked up a pile of unwashed clothes and carried them out to the scullery.

"I thought you were goin' to Belfas' again this summer."

"I was thinking of going."

"An' what about Wes'meath?"

"That's as bad as here. I'll stay a week or two there at the outside."

"Imagine, three months free an' all you're doin' is moanin' about your family."

"Two and a half months," Cormac corrected her.

"Aw, is that all? Isn't that a fret! Is it a boarding school you're at or a holiday camp?"

He heard the wheels of the washing machine screeching on the scullery tiles. Soon the mesmerising swish-swosh would pulsate through the house and she would spend the rest of the day with her sleeves rolled up, pulling clothes from the soapy water and mangling them back and forth.

They used to have suds fights on wash days – chasing each other around the garden with soaking rags and falling around in hysterics as they got more and more drenched; but not any longer. It was as if his resentment of her had grown slowly, years after the events that occasioned it.

Leonie was back in the kitchen, humming to herself while she rummaged in a press for some washing powder. "I s'pose you'll spen' most of the summer readin' books or writin' long letters to that Belfas' fella, what's his name?" She slammed the press door.

"McEldowney."

"Does he have no Christian name?" She breezed out of the room again. Before he could answer, her humming had started up again.

"I was serious about what I said: I'm going to look up Eddie Dwyer again. I'm not going to be told who I can pal around with and who I can't."

Leonie's humming stopped: apart from the sound of the tub filling, there was silence from the scullery.

"What are you in such a sulk about?" he asked.

"Who's in a sulk?"

"Everybody's in a sulk. As soon as I mention Eddie Dwyer, everyone in this house sulks. It was you sent me to his house the time he had the flu: don't forget that." Leonie left the tub filling and came into the kitchen. She stood still for a moment, smoothing a pillowcase with the palm of her hand. "What are you shoutin' at me for? If you didn't go lookin' for Eddie all these years, that was your decision, no one else's. So, if you're goin', go. You know where he lives."

"Right."

"An' if you don't fin' him there, call up to Dr Donovan's. I hear he goes there a lot lately. So I'm told anyway."

"Dr Donovan's? What's that meant to . . . ?"

There was a splash in the scullery and the sound of the sink water pouring on the tiles.

Leonie spun around. "Feck that hose anyway. It never stays

on the friggin' tap. Go on with you. I've no time to stan' about natterin'."

On his way to the Pearse Estate Cormac passed some lads he had known in the Brothers school. Their eyes followed him closely. He was one of the Boarding School Brigade now – except there was no brigade: probably just a few banished souls like himself, forever watched and resented.

The estate was as ramshackle as the first time he had visited it. Children were playing with makeshift go-carts on the streets and even they stared at him: some of the younger ones roared up to him and swerved away at the last second, cautioning him and his kind to steer clear of their world.

Philly opened the door to Cormac again. She was quite changed now, almost a teenager, and she blushed when she saw him.

"Eddie's above at the Clearin', playin' football with the lads. He'll be glad to see you."

"Do you think so?"

"Sure. He's in the dumps since Ann Marie went away."

"Who?"

"Ann Marie Donovan. Didn't you hear they're doin' a line?" Her colour deepened.

"No. I didn't hear that."

"If you don't fin' him there, you'll prob'ly catch him mopin' about the town. You could try the lib'ry. He goes there a lot."

"Thanks, Philly. See you."

Cormac found Eddie's gang on a stretch of scrubland near the GAA grounds. They had thrown down their jackets to act as goalposts and were playing a seven-a-side version of Gaelic football. Eddie was in one of the goals and showed no sign of noticing the new arrival.

He had changed since Cormac had seen him last – the day Aunt Maeve had driven to the weir to tell Cormac he had got a place at last in boarding school. He was still small and sturdy in

80

build, but his eyes were more deep-set now, not unlike his father's. He skipped about in the goalmouth, just like he used to in the alley, anticipating dangerous shots and using his speed to compensate for his small stature. Once or twice he dived to save a goal, but he was back on his feet in a second or two, punting the ball far down the pitch.

"Eddie! Eddie! Over here. Quick!"

"Get it up the friggin' field."

Cormac sat on the grass and watched the game. Much of it was taken up with disputes about rules. "Foul! That's a penalty for us." "Don't be a stupid bollix." "Come on, will ye! Stop fuckin' wastin' time". After a while, when the action and arguing were concentrated at the other end of the pitch, he strolled up behind Eddie's goal.

Eddie glanced in his direction. "Ah, Cormac. Howya."

"I've been looking for you all over. Philly told me I'd probably find you here."

"Did she?"

"Who's winning anyway?"

"We are . . . I think. It's hard to tell."

"How long more is left?"

"Not very long."

"Will I wait so?"

"That's up to you."

Cormac went back to the side of the playing area and sat on the grass. One of the players noticed him and there were some glances.

"Time up!" one of the team captains shouted triumphantly as the townhall clock rang out the hour.

"What about extra time?" another player protested – but he was reminded emphatically that there had been no injuries.

As they gathered up their belongings, one of the lads whose face Cormac remembered from the Brothers muttered something about "boarding-school swanks" and "horsemen in the sky". Cormac sat waiting for Eddie, staring at the ground in front of him.

Eddie was the last to reach the changing area and, as he drew near, the joker said: "Your frien's here to collec' you, Eddie. You're invited to a gawrden pawrty at the Comma'dan's."

"Or is it a croquet match with Anne of Green Gables?"

"I say, let's all play tennis!"

There was general laughter and Eddie scuffed the ground with his toe. After they had all picked up their bikes and left, he stayed behind. "So, how's the boardin' school?" he asked.

"It's OK, only it can get boring sometimes. How's the Brothers?"

"Oh, the same as ever."

"Playing any handball lately?"

"Not too much. Just keepin' the hand in."

"We could go for a swim if you like. In the millpool."

"I can't. I've got to go home."

"Is it true you're going with Ann Marie Donovan?"

"Who tol' you that?"

"Your sister, for one. It seems to be common knowledge."

"Yeah, I s'pose." He looked uneasy. "Was anyone sayin' an'thin' about it?"

"What do you mean?"

"You know the way they talk aroun' here. Or maybe you don't."

"I haven't been around that much. I don't hear a lot of gossip."

"No. You're lucky: you're jus' passin' through. If you want my advice, keep it that way."

"Do you want to come out for a canter tomorrow?"

"I don't think so, thanks all the same."

"We could take the mare over to the mill. I could show you how to"

"It's OK, I know already. I prefer football."

"Will I see you later then? The day after tomorrow maybe?"

"I'm going to the country to spen' a few weeks at my gran'parents' place. I'll be helpin' them save the hay."

"Not to worry: I'm going to Belfast myself."

There was an impatient call from the last of the departing players and Eddie looked in their direction. Then he started to back away. "I'll see you aroun' – that's if you're still here when I get back."

"I'll probably be gone," Cormac called after him, but Eddie didn't seem to hear. He was running along the edge of the Clearing to catch up with his friends.

Cormac sat on the grass for a while then, staring at the silent pitch. The townhall clock chimed again, once for the half-hour, and he set off on the solitary trek home.

* * *

The next morning, when he was dressed, Leonie knocked on his door and handed him a letter with a Belfast postmark.

"Are you comin' down for breakfas' today or not?"

"No thanks. I'm not hungry."

"What's up? Are you sick or what?"

"No."

He saw her looking at the case on his bed and the piles of folded clothes. "Well, what then?" she asked, coming into his room.

"If you've got any clothes of mine in the wash will you give them back to me? I'm going home to Westmeath."

"Home?"

"Yeah."

"This soon?"

He nodded.

Leonie sat on a chair beside the bed. It was a while before she spoke. "For good, d'you mean?"

"Yeah. One less mouth to feed: look at it that way."

There was another silence.

"An' what about the mare?"

"What about her?"

"They're bringin' her in today, didn't your Aunt Maeve tell you?"

Cormac said nothing.

"She'll be right annoyed so she will. She kep' her out on grass the whole year, jus' so's you could go ridin' this summer." She rummaged in her pocket and produced a packet of cigarettes. "You're wil' contrary so y'are. You're near as bad as herself."

"I'm fed up always being on my own."

"I thought you were goin' to see Eddie Dwyer."

"I did but he's going away. At least that's what he told me."

"It soun's like you don't believe him."

"I'm not sure I do."

"Why wouldn't he want to see you? Weren't ye the besta pals back in first year?"

Cormac turned and looked at her. "Yeah, for a while we were. But that's all . . . water under the bridge, as they say."

Leonie stubbed out her cigarette and stood up. "So, what'll you be doin' in Wes'meath? Yesterda' you didn't soun' too keen on goin' there, even for a couple of weeks."

"I don't know. I'll try starting again."

"Goin' back to your old school, d'you mean?"

"I suppose so."

"An' how d'you think you'll get on, livin' with your father?"

Cormac shrugged. "It couldn't be much worse than this morgue."

Leonie laughed. "Oh, it's quiet here all right, but there's worse places in the world, believe me. Maybe you should heed your auntie and get to know the Lindemans. They mightn't be as bad as you think."

"I told you I'm leaving."

Later that morning Cormac lay thinking things over on the roof of the lawn-mower shed. At one stage he climbed into the branches of the large sycamore overlooking the Lindeman garden.

The Lindemans were the most pampered young people he had ever seen. While they made feeble attempts at playing tennis, their mother stood by to run for the ball and utter doting words of encouragement. Today was no exception.

"Wonderful shot, Maurice. Oh, hard luck, Imelda. But your swing is so much better, darling. Be a little gentler, Mel. Morr is only learning. And he is younger than you, remember."

Their games rarely reached a conclusion: one or other of the players usually stormed off in a huff, leaving Mummy to pick up the abandoned racquet and console the person left stranded on the court. Today was no exception and, when the game ended in the inevitable row, Mrs Lindeman reacted in her usual indulgent tones. "Well, maybe it's a bit hot for tennis today. I'll ask Kevin to take out the car and we'll drive to the pool by the mill. What do you say?"

"The millpool! Great idea, Mum."

"I bags the first dive off the wheel."

"That's not fair. You were first last time. Mummy, it's my turn, isn't it?"

"Come on, you two. Off you go and ask Bríd to get your things . . . "

Cormac lowered himself down on to the shed roof and sat for a while watching Seamus at work. He was down on his knees, crawling from drill to drill, his face and hands smeared with clay as he weeded the vegetable garden.

McEldowney had lent Cormac a H G Wells story last term in school. It was all about a future in which there were two distinct kinds of human: a dominant class who lay around in the sun, eating, drinking and issuing commands, and a mole-like underspecies who spent their time burrowing about in the earth for food and fuel.

But hadn't that future already arrived in Drumaan? And if it had, why did Cormac feel a stronger bond with the moles – Leonie banished to eat alone in the kitchen, Seamus crawling through drills on his hands and knees, Eddie living in a squalid council estate, his mother ashamed to let a visitor see his room?

"'Rise like lions after slumber'," he muttered aloud – and Seamus squinted up him, his face all question marks between the mud-stains. Cormac coughed. "I was just saying a poem, Seamus, that's all."

The gardener continued to gaze up at him, his eyes full of expectation. Cormac felt compelled to continue. He cleared his throat.

> "Rise like lions after slumber
> In unvanquishable number;
> Shake your chains to earth like dew
> Which in sleep hath fallen on you;
> Ye are many – they are few."

"Gran' pome," Seamus mused. "Gran' pome. D'ya know 'Fair Daffydils'? That's another good wan."

"Just a minute, Mummy," Imelda Lindeman called out. "I'm looking for the ball Maurice lost."

After another funereal lunch with his uncle and aunt, Cormac returned to the shed roof. There were no sounds from the Lindeman garden and Seamus was further down the rows of brassicas, well out of range. He lay back in the sun and read the letter from McEldowney for the second time.

He had confided in his Belfast friend only a few days before school broke up.

"So, what's the problem?" McEl D had asked. "She sounds like a healthy, hot-blooded wench to me. You should see the toothless harridan we have working in our place."

"What I can't understand is why she never told me Eddie was the Corporal's son. She must have known that all along. Instead, for some reason, she arranged it that I'd find out in the worst possible way."

> Troubled Comrade,
> First things first. At your request I've arranged for your stay with us to coincide with the marching season in July. I'm convinced that no weedy liberal, nurtured in the Papist sanctuary of the Free State, can ever fully grasp the Northern situation, no matter how long he lives. But I'll try nevertheless to slake your curiosity, even if we risk getting beaten into a green pulp in the process.

I want you to stand on the Shankill Road on the Twelfth and tell me in a loud, unwavering voice that you still believe in a united, independent and Gaelic-speaking Ireland – with or without Dev's comely maidens dancing at the crossroads. If you can do that without flinching, while the Lambeg drums pound your ears, I'll personally undertake to eat my Marxist-Leninist cloth cap on the steps of Leinster House.

Concerning the other matters we spoke about, I can only offer what you will no doubt regard as a "crude Marxist" analysis.

The boycotting of your pal Eddie all these years may have nothing to do with the fact that you caught his father up to his bollix in the lusty Leonie. The real reason is that you're up to your own balls in middle-class guilt and fear. Admit it: his poverty galls you. Why? Because you feel threatened by it. In fact, you nurture that fear and polish it – a bit like your aunt and her wretched porcelain.

As for Leonie, ask yourself: why have *you* never told *her* that you know the Corporal is Eddie's father? Isn't it because you're still playing games with her, games to shield yourself from the realities that are the real source of tension between you?

So, if you still want my advice, stop pussy-footing around and allowing resentment to build up. Perhaps you should think of reviving the washday water battles you used to tell me about. There's nothing like a good soaking for clearing the head and breaking down social barriers. As Trotsky said . . .

Leonie appeared in the garden carrying a basket towards the clothesline. Locks of hair hung loose over her face and as she walked she tried to flick them aside. Eventually she set down the basket and tucked the loose strands into the white headband of her uniform. She wiped her forehead with a bare arm, picked up her basket and continued towards the line.

"'Fair daffydils we weep ta see ya haste away so soon,'" Seamus chanted, looking up at her with a grin as she passed by.

"Eh?"

"'Rise like lions after supper . . .'"

Leonie glanced at Cormac. "D'you think we better call Doctor Donovan?"

"Too late for that," Seamus muttered and he wheezed with laughter.

She set down her laundry basket again and arched her back, looking up at Cormac. "My God, but you've the great life. I s'pose the nex' thing you'll be off playin' tennis with the Lindemans. More whites for me to scrub."

"Hurry up, Mel pet," Mrs Lindeman's voice rang out from over the wall. "What on earth is keeping you, darling?"

Cormac made a groaning sound: they were back from the millpool.

Leonie laughed. "I don't know what you're complainin' about." She picked up her basket and went on towards the line. "Most suitable companions!" she called back. "Most suitable in my view."

On visits to Dr Donovan Aunt Maeve usually left Cormac to the surgery door while she went around to the house to see Mrs Donovan. Hilda was her name and she was a jovial woman with a round Flemish face. She worshipped her husband and never tired of echoing his words in her guttural accent. "Charlick says he prefers my hair up. Yours is lovelick, Maeve. You always look so spruce. You're like a spruce tree."

Dr Donovan was jovial too, and a gossip into the bargain. Cormac enjoyed his company – even when that pleasure was punctuated by a sharp needle-jab in the arm. The doctor usually treated him to a string of locker-room jokes, daring Cormac to repeat the smuttiest of them to Aunt Maeve. Sometimes he laughed so heartily at his own yarns that he had to take off his glasses and wipe tears from his eyes. Then, at the end of each visit, he thanked his young patient for cheering him up.

At that stage Cormac was generally shown into Mrs Donovan's drawing-room for afternoon tea. The room had a warm, untidy atmosphere that reminded him of his old home in Westmeath: it was cluttered with books and there were paintings

everywhere, many signed by Hilda Donovan herself. (Dr Donovan once referred to her as his Old Flemish Mistress.) The walls were adorned with portraits of Ann Marie, each stage of her development recorded in a variety of artistic styles.

Above the fireplace there was a large oil painting of a young woman bathing naked in a stream. It was titled *La Jeune Fille de Servis* and, the first day Cormac met Ann Marie, she smiled when she saw the magnetic effect the canvas had on her guest. She offered to play him a game of chess – on condition that he sat with his back to the painting – and, while she waited for him to make his moves, she talked excitedly about her favorite novels and films.

He glanced around at the canvas and in a hushed voice she told him that sometimes art students posed nude for her mother, young men as well as women, and she had made a periscope out of shoebox and mirrors for spying on them. She wouldn't mind posing nude for an artist, she said: she believed that the human body, male as well as female, was the most beautiful thing on earth. Didn't he agree?

Cormac quickly changed the subject and asked her if she had any views on blood sports.

Meanwhile, his aunt and her hostess chatted away in another part of the room, Mrs Donovan repeating her husband's words over and over, and Aunt Maeve interjecting: "I said to Frank, 'Frank,' I said . . . "

When his aunt stood up to leave, Ann Marie pulled Cormac aside and whispered something about a mutual friend. But her mother offered him his coat at that moment, so there was no time to find out who she meant. He wondered why she was being so furtive at the time. The last person he would have guessed she was talking about was Eddie Dwyer.

The mare greeted him in her usual manner, nodding her head vigorously, agreeing that it was good they were back together. *Yes,* she seemed to say, *it's a perfect day for a ride-out.* He stroked her neck and chatted to her, slipping the bit into her mouth and

looping the bridle gently over her ears. Her chestnut coat shuddered when he slid the saddle into position and tightened the girth.

Out in the yard he swung himself into the saddle and trotted her down the laneway to the Lindemans' field. Familiar with his routine, she cantered till they reached the gateway that led to the main road. Before he dismounted two stable lads came by walking a pair of sleek black colts and they stopped to ask him what he thought of the mare's condition.

"She doesn't look too bad to me."

"Marty's been ridin' her out two or three times a week, so she should be in good fettle," the older of the two said.

"I know. My aunt told me."

"He fairly knows how to handle a horse, that young fella. He's near as good as yourself. He's kep' her from gettin' too slack anyway, you can see that."

"Is it still OK if I use the cinder track?"

"Sure it is. You'll have it all to yourself this mornin'. Here, stay where you are an' we'll get the gate."

"Thanks, fellas."

"Take it easy your first day out or you could en' up bent double."

"I will. Good luck."

When he reached the Curragh, Cormac trotted the mare at first, letting her build up a steady rhythm and allowing himself time to adapt to the motion. From the lightness of her step he knew she relished the firm track. The sun was high but the air had the sharpness of early morning.

Soon they were cantering again and the mare flicked her ears in response to his commands. The racecourse buildings, the barracks, even the town in the distance seemed to be standing back, allowing them the space they needed. In the rhythmic movements Cormac began to sense freedom again; he was in harmony with what mattered most in the world, its pulse, its heartbeat.

Later, as he walked the mare near the railway track, he thought again of Eddie. They had often played there and one time Cormac had pointed out his uncle's house and stables in the distance.

"My Da works somewhere around here," Eddie had said. "He's thinkin' of becomin' a horse-trainer and quittin' th' army."

"My uncle's in the army and he has a mare. He's got medals for riding."

"A mare's not as good as a stallion. Hey look! Over by the tracks. A rabbit. Let's sneak up on it, Apache-style . . . "

Cormac turned the mare and trotted her in the direction of the millpool. When he arrived at the weir he sat on the grass and watched the mare drinking, her long muscular neck siphoning the water while she brushed flies away with her tail.

It was here that Aunt Maeve had driven up and told him she'd just had a call from the boarding school: a first-year had dropped out and Cormac was being offered his place. That night, as he lay in bed shivering, it seemed the whole world around him was caving in: everyone was whispering about the dreadful ambush in the Congo; Aunt Maeve was pacing about, waiting to hear from the barracks; and, to crown it all, Leonie had gone missing. Not least of Cormac's worries was how Eddie would face the handball match without him; he thought of him lying awake in his bed, counting the few remaining hours.

Late in the night he heard Leonie going to the bathroom; when she came back he got up and went over to her room. After a moment's hesitation she took him into the bed beside her and they lay for the night curled up in each other's misery.

By the time the Corporal turned up the next morning to drive him to the boarding school, Leonie had Cormac's clothes packed and name tags sewn on all his shirts and underclothes.

On his way back home he left the Curragh and directed the mare up the roadway leading to Ann Marie's house. It was a large stone farmhouse, restored and converted, the outhouses used for Dr Donovan's surgery and his wife's studio.

As he approached the house Cormac wondered whether he was coming to find Eddie or to try to take his place. He remembered the disturbing effect Ann Marie had produced in him the first time they met and a wave of excitement shot through him. She must have felt the same about him: it was hardly a coincidence that she had spoken so much about nakedness and the beauty of the human body.

Maybe, if there was no one home, she'd show him around her mother's studio, where the art students posed nude . . .

When he arrived at the gate he found it padlocked. He rattled it once or twice but there was no sign of life; the downstairs windows were all shuttered. He turned the mare towards home and urged her into a trot.

Leonie was waiting for him when he got back to the stable yard. She smirked at him as if she knew about his trip to Ann Marie's house. "I was tol' to get you to hurry up."

"I'll have to have a bath. My legs are aching."

She stood watching him as he unsaddled the mare and brushed down her coat. Then he clambered up on the manger and filled it with hay from the loft.

"You're pretty nifty on them bars," she commented. "But then I s'pose you got plenty of practice in days gone by."

He said nothing.

"Tell us, did you ever let on t'anyone what you seen that night? Eddie, for example? Or your frien' from Belfas'?"

"No."

"Are you sure?"

"I told you, no."

"OK, keep your hair on. I on'y asked."

They walked towards the house together and Cormac complained again at the stiffness in his calves and thighs.

"Serves you right for stayin' out that long your firs' day in the saddle."

She hummed to herself and laughed as they passed the vegetable garden and the sounds of Maurice and Imelda

beginning another round of arguments on the other side of the wall. Then, at the kitchen door she stopped and held on to his arm. "You'd want to be more careful so you would, with things that's private an' personal."

"What do you mean?"

"I foun' this on the grass on my way down to the stable. It's yours, isn't it?" She handed him a crumpled letter and he recognised McEl D's spidery writing. Then she shook her head disapprovingly and smiled, before going ahead of him into the house.

He lay back in the warm bath water and tried to soak Leonie and McEldowney's letter out of his head. He was sure she'd read it. She'd smiled mischievously before handing it over – but then she often smiled like that for no obvious reason.

What was it McEl D had written about her? He had referred to her as a "lecherous maid". Or was it a "lascivious maid"? It was one of those l-words anyway: he would check which after his bath. *The Corporal up to his bollix in the something maid.* He ducked his head under the water.

Maybe she wouldn't have got that far in McEl D's knotty prose: all she was used to reading was trashy love comics. He tried to imagine what she would make of his friend's theories about class antagonism. Or his comparison between middle-class guilt and Aunt Maeve's porcelain. She'd probably write him off as some kind of a nutcase and leave it at that – and maybe she wouldn't be too far wrong either.

He allowed himself to float lifelessly for a moment. Then he plunged his head under the water again and held his breath. If he died now, Leonie would find him naked. Ann Marie had said there was nothing in the world more beautiful than the human body, male as well as female. When he came up for air he checked to see if she was right.

The Corporal's son and the Doctor's daughter. It was hard to imagine. But if Eddie was doing a line with her why had he been so sulky when he talked to Cormac after the football match?

Maybe Ann Marie had broken it off. Maybe they'd come to realise there was too great a chasm between them.

Wasn't that what Cormac's own parents had discovered after all their years together? His father was not "top drawer", Aunt Maeve had told her bridge friends one evening; she and Frank had never approved of the marriage. "But Rosemary was a mule. I said to Frank, 'Frank,' I said. 'She might have been my young sister, but . . . '"

The bath water was cooling so he ran the hot tap. It was "lusty" McEl D had written about Leonie. *Up to his bollix in the lusty maid*. Merciful Jesus! Head under water.

When he resurfaced he decided that maybe it wasn't so bad after all. It sounded a bit like a John MacCormack ballad.

> "Oh, come ye lusty maids and corp'rals
> And listen to me awhile . . . "

But all he could think of to rhyme with bollix was rollocks and that wasn't much use.

As he dried himself the bath-water swirled down the drain. *Let by-gones be by-gones*, it said as it spiralled into oblivion. *And people who read other people's letters deserve whatever sticks in their throats*, the drain added, gulping the last dregs.

Checking the coast was clear, he darted up the narrow staircase wrapped in an assortment of white towels. It was only when he reached his room that he realised he had lost one or two of his wrappings en route.

He was lying on the bed and massaging his calves and thighs with muscle relaxant cream when he noticed that Leonie had unpacked his clothes and put them in drawers; the suitcase was back on its perch above the wardrobe, mocking his indecision.

The sharp ointment tang brought back images of the changing room in school: mud-stained football shorts and white limbs; thick woollen socks folded just below the knee; elbows and heads disappearing into striped jerseys; and, as the teams jogged out to the playing fields, the clack-clack-clack of studs on parquet.

There was a knock on the door and he leapt off the bed. He snatched a towel and wrapped it around himself.

Leonie came in and glanced around the room. "Are you not dressed yet? What's keepin' you?"

"I had a bath, that's all."

"Don't I know you had a bath? You drew off all the hot water so's I can't do the washin' now till th'evenin'. An' then you left wet towels strewed all over the house for me to pick up."

"Strewn, not strewed."

"What's that queer smell in here? It's like a hospital so it is."

"Deep Heat. It's for stiff muscles."

She laughed. "Now I've heard all. Have you got any clothes that need launderin'?"

"Have you got a cigarette?"

"Don't tell me you're smokin' at your age."

"You smoked when you were my age. And probably other things besides."

She looked at him hard and he tightened the towel around his waist. "You're gettin' mighty big alright. There's no doubt about it. Tell us, what do you be thinkin' about when you're ridin' aroun' the Curragh on the mare?"

"Oh, you know: maths and science, that kind of stuff."

"Is that what fellas like you do think about? I often wondered."

"That kind of thing. And deep philosophical problems: like why we don't get on like we used to, you and me. Why we never have water fights any more. Or curl up beside each other like we did in the old days."

She took out two cigarettes and offered him one. When she had lit them, she stood in front of him. "An' why d'you think that might be?"

"I don't know." He puffed smoke in her face. "Maybe there isn't the same . . . trust. Maybe something came between us, how do I know?"

"D'you know what I think came between us?"

"What?"

"I'll show you what . . . "

She reached out and whipped the towel from around him. "That lad there. You're afraid of that little fella, an' not without good cause. That's a stick of dynamite you're carryin' aroun' an' your livin' in dread of a mighty explosion."

He grabbed the towel and covered himself. "I suppose that's your way of saying you read that letter." His voice was shaking.

"You needn't soun' so cross. At least I do it out in the open, not peepin' through keyholes an' trapdoors."

"Well, did you?"

"Did I what?"

"Did you read the letter?"

"I tol' you I'm no spy. I mind on'y what's put in front of me, starin' me in the face. An' I don't go lookin' for trouble either: it has its own way of findin' me, that's for sure."

"What's that supposed to . . . "

"Shh!" She was listening at the door and Cormac heard Aunt Maeve's footsteps on the landing below. "I better be goin' before she comes up an' catches me in your room an' you in that state." She pocketed the cigarette packet, swept some shirts and underclothes from a chair and made for the door.

Before leaving she looked back at him and winked. "It's OK," she whispered. "Stop frettin' about nothin'. An' for Jesus' sake don't set the house on fire."

* * *

One of the gestures Uncle Frank liked to make after his injury in the Congo was a kind of lobbing action with his right arm. Occasionally after tea in the garden or on the verandah he shook himself out of the inertia of his partial paralysis, muttered something about someone called Leslie Dennis and swung his right arm back and forth like a pendulum.

Aunt Maeve, fearing that his movements would propel him out of his wheelchair and cause him to break some of her best porcelain – not to mention one or two of his own bones – would rush to his side and take a firm hold of the swinging arm. Then

she would bellow: *"It's all right, Frank dear. You mustn't get agitated. Remember what the doctor said."*

On such occasions she often glanced at Cormac and made a gesture with her head. This was his cue to go up to the Commandant's quarters and dig out a dusty account of the Crimean War or the Battle of the Bulge. By reading aloud to him from these volumes, Cormac was fast becoming a homespun expert on military history.

Once, during one of these missions to the Commandant's room, he noticed a photograph album on a bookshelf and sat at the desk flicking through the pages. There were pictures of his uncle and aunt in long swimwear on a beach, in suits with big shoulder pads at the Curragh racecourse, wearing fur coats in an open vintage sports car in the mountains somewhere and standing on the steps of a Georgian mansion in elegant evening clothes.

They were also photographed on riding treks and fox hunts and there was one cutting from *The Irish Times* showing the Commandant – then a Lieutenant Captain – in full military regalia being presented with a trophy by President Sean T O'Kelly in the showgrounds of the Royal Dublin Society.

In the photographs Aunt Maeve clung to her fiancé's arm like a loving daughter or a niece rather than an equal. It was hard to believe that this shy young woman was the same person who issued stern commands to Leonie and Cormac and seemed as brittle as the porcelain she lived in terror of finding chipped or broken.

The album also contained a series of photographs of the couple playing tennis. In one of the pictures, captioned *The Season's Most Elegant Champion*, Aunt Maeve was shown holding a silver plaque up to some admirers and waving her racquet in the air in triumph. With a shock Cormac realised that one of the young women applauding was a youthful version of his mother, her hair swept back from her face in a way he had never seen during her lifetime. Her eyes shone the way they used to when he and Angie ran in home and told her of their latest adventure

on the way from school. He stared at the photograph for a long time.

Leonie came in and jolted him out of his reveries. "She wants to know what's keepin' you." She came to the desk and peered over his shoulder. "God bless us all! Is that herself winnin' a prize?"

"Yeah. And that's my mother there."

"Lord above! But she was a good lookin' woman, God rest her soul."

He felt her place her hands on his shoulders and then her chin on the crown of his head, a quiet encouragement to go on showing her the photographs. "My God! Weren't they a han'some couple? An' jus' think what life's done to them now. God between us an' all harm, isn't that a fret? Look at the two o' them in swimsuits, I swear to God. Don't they look so bright an' cheery, like film stars you'd see in a magazine."

"Do you think I should show the album to my uncle? It might cheer him up more than another war book."

"Maybe. But wait till sometime she's outa the way. You can never tell how she's goin' to react, she's that contrary. Come on, you better go down an' show your face or she'll think . . . I don't know what she'll think."

When he stood up, Leonie looked into his eyes. "My God, but you're growin' up fast an' furious, there's no doubt about it. The food in that boardin' school mustn't be half as bad as you say it is." She straightened the collar of his shirt and patted his cheeks. "Here, don't forget the book. Go on, quick. I'll tidy up here."

Cormac read to the Commandant in the garden that afternoon, filling his head with accounts of Mujahadeen resistance to British imperial designs, and at moments the bewildered look that had become almost a permanent fixture seemed to leave his uncle's face. Aunt Maeve sat crocheting under the canopy of the garden swing seat and, when Cormac reached the end of a chapter, she declared: "Well, at least that school's done something for your diction. You don't sound any

more like you should be haggling over the price of ewes at a fair in Mullingar."

The Commandant swung his arm back and forth and muttered: "Leslie Dennis, Leslie Dennis."

"Who's Leslie Dennis?"

"I've no idea."

"Maybe an old girlfriend, do you think?"

"Don't be so cheeky. I was the one and only." And she sighed, as if regretting the lack of competition. "Besides," she mused, "Leslie's also a man's name."

"Maybe it's some friend from his school days. Or a colleague in the army."

"Possibly, though the name doesn't ring a bell. I can't imagine who it can be."

A gust of wind carried the sound of a tennis ball to Cormac's ears. He heard voices and laughter and someone shouting: "Out! Hard luck. Love forty." He cowered; it was the Lindemans having another stab at their wretched obsession. With any luck Aunt Maeve hadn't heard it.

"Up straight," his uncle ordered. Then, gesturing in the direction of the Lindeman garden, he repeated excitedly: "Leslie Dennis! Dennis! Dennis!"

Cormac sat up. "It's tennis. He wants to play tennis. 'Let's play tennis'. That's what he's saying."

Aunt Maeve put her knitting down. "Good Lord! You may be on to something."

There was no denying Cormac was right: the Commandant was hammering the arm of his wheelchair, grimacing and writhing the way he did whenever they interpreted him correctly.

"Run inside and get a couple of racquets. They're in the cloakroom press. And there should be a box of balls there too. You'll have to dig for them, it's so long since they were used. Go on. Hurry! Don't just stand there gaping."

When he returned some moments later the garden was all activity. Leonie was wrestling with a heavy black net that

Cormac had often seen folded in the lawnmower shed – she had stretched it out on the grass and was tying severed cords in the mesh; Aunt Maeve was oiling the winding-handle on one of the two green metal posts that had miraculously sprouted in the lawn; and Seamus was pottering about with an ancient cast iron machine for painting white lines on grass. In the middle of all this commotion the Commandant was waving his arms about as if conducting an open air concert, apparently convinced that his gestures were essential to the success of the enterprise.

There were no traces of the old markings in the grass so, using a measuring tape, string and garden pegs, Seamus had to measure out the distances and ensure that the lines were parallel. Aunt Maeve and Cormac held the cord taut as the gardener rattled over it with the line painter. Leonie stood to one side with her arms folded, clearly relishing this rare outburst of frivolity in her place of employment.

When everything was in place and the white lines had been allowed to dry, Aunt Maeve made one final inspection. "Perfect! Now, the only question now is who's going to play."

"Why don't you and uncle Frank play?" Cormac suggested. "I'll stay at his end and manoeuvre him about."

He handed his uncle a racquet and the Commandant began bouncing a ball expertly in the air, alternating between forehand and backhand.

"Hey! He's good," Cormac remarked.

Aunt Maeve glanced shyly at Leonie and Seamus. "Oh, I don't know. It's so long since I held a racquet. I don't think I'd be up to it."

"Come on, Aunt Maeve. It's not Wimbledon. You used to be good at tennis."

"That's right, Ma'm," Leonie chipped in. "You won prizes an' all. I seen . . . " Her sentence tapered off. "I mean . . . "

"Rubbish! Who told you that?"

"My mother told me," Cormac said quickly. "She said you once won a big silver plaque. I was telling Leonie about it . . . only today." Leonie glanced at him and smiled.

"Well, you'd no business making up fairytales like that."

The Commandant was still hopping the ball against his racquet. "Leslie Dennis. Leslie Dennis."

"Oh, all right then. I'll play. But no one's to laugh at me."

With that she kicked her shoes to one side, pinned her hair back behind her ears and accepted the racquet and balls that Leonie offered her. Cormac took up a position behind his uncle's wheelchair.

There had been no rain for days and the ground was hard – as Aunt Maeve demonstrated by bouncing the ball a few times. "We'll just knock up gently to see how he can manage. Are you ready, you two?"

"OK," Cormac shouted back and his aunt sent a soft forehand lob in the direction of the Commandant. The ball bounced about two feet in front of him, a little to the right, and, without needing to be repositioned, Uncle Frank replied with a fine shot that flew low over the net and touched down just inside Aunt Maeve's baseline.

Leonie let out a yelp of incredulity and clamped a palm over her mouth. Aunt Maeve was also impressed. "Good heavens! I can see he means business."

She sent down the second ball, making it bounce in the same place as the first, and again the Commandant answered with a fine volley, this time driving the ball deep into a corner of Aunt Maeve's court.

Seamus hobbled off to retrieve the balls and Aunt Maeve composed herself for a moment before sending down her third shot, this time more of a stroke than a lob – but the Commandant, with a little propulsion from Cormac, reached the ball and buried it deep in the other corner of her court. He waved his racquet in the air. "Leslie Dennis. Leslie Dennis."

"I think he wants to play a game," Cormac shouted, "and by the looks of it, you'd better play to win."

"I always play to win. And I always win," Aunt Maeve retorted. Then, to Cormac's surprise, she turned and winked at the gardener. "Well, nearly always."

The old man responded by shaking his right hand in the air as if he was about to throw a dice. "My money's on the Commo'dant." He spat on his palm and rubbed his two hands together. "What'd ya say to five bob evens, Ma'm?"

"You're on. You pay me five shillings if I beat my husband. And vice versa if he wins."

"Vice versa," Seamus wheezed. "Vice versa. 'Fair daffydils we weep to see ye haste . . .'"

Leonie elbowed him. "Whisht up, you oul' crackpot!"

"Just one set. That's all I could manage."

Leonie sat on a bank of the terraced lawn, staring open-mouthed at the scene, as if some miraculous transfiguration was taking place before her eyes. She glanced in Cormac's direction and, when their eyes met, she laughed and hunched her shoulders; he smiled and shrugged back at her.

Aunt Maeve noticed the exchange. "What about you, Leonie? Are you on for a bet?"

"Leslie Dennis!"

"I'll just sit and watch, Ma'm. I wouldn't know who's goin' to win. Me and Seamus'll be the referees and say if the balls are in or out."

"Th'umpires," Seamus corrected her. "Referees is for hurlin'."

"Right you be. Will we toss to serve, Frank?"

With an irritable gesture of his racquet the Commandant indicated that she should serve, so Cormac wheeled him into a position about halfway between the right-hand service court and the baseline.

Aunt Maeve had taken off her cardigan, hung it on one of the metal posts and tucked her white blouse inside her skirt. With her hair swept back, she looked more like the young woman in the photograph album than Cormac had thought possible. Her eyes were full of a new light and for the first time she reminded him of his mother.

The opening serve came to his uncle's backhand and, mainly because Cormac was slow manoeuvring the wheelchair into position, the Commandant failed to return it accurately.

"Fifteen love," Aunt Maeve sang out as the return fell wide of the mark.

"Aye, that's a fac'," Seamus confirmed and Leonie giggled.

Cormac took up the next position with more care, but his aunt served an ace that he barely saw crossing the net. Clearly she was intent on putting up a good display.

Seamus winked in Cormac's direction. "Tha' was out so it was. Be a mile."

"No, it was in," Leonie corrected him from a new vantage point higher on the bank. "I can see better up here."

Aunt Maeve pointed her racquet at the gardener. "You're disqualified as an umpire, Seamus Hogan. You've a vested interest in the outcome. You can keep the score, that's all."

The gardener chuckled and rubbed his hands together. "Vice versa! Vice versa!"

Between them, the Commandant and Cormac botched the next two returns and Seamus announced: "Wan game to Missus Connolly; nought to the Commo'dan'."

Cormac wheeled his uncle back to the baseline and handed him a ball. He stood behind the wheelchair, expecting him to serve underarm; instead, flicking the ball high with his stiff left wrist, the Commandant delivered a superb first serve which Aunt Maeve could only have reached by diving on the grass.

Seamus hopped from foot to foot, whistling and yahooing, and Leonie applaued. Then, remembering their roles, they ended the commotion.

The Commandant repeated the feat with his second serve and it was not till his third that the first rally of the game was played. Aunt Maeve returned his service ball, placing it so close to the net that there was no chance that the Commandant could reach it.

Cormac had guessed this would prove to be the trickiest position for his uncle – that was, assuming his aunt really wanted to exploit his mobility limitations and go all out for a win. By the time the Commandant reached the ball it had bounced twice and Aunt Maeve was taking up her next position. But Uncle

Frank's service was still sufficiently strong to allow him to take the game without further loss of points.

Aunt Maeve won the next game, but less easily than the first. The Commandant, with Cormac's help, was beginning to win points against his wife's serve. And, largely because Cormac worked hard getting him up to the net when he guessed a sneaky return was in the offing, he held his serve in the games that followed. But equally, Aunt Maeve held hers and for the next series of games neither player managed to break the other's service.

Leonie and Seamus had fallen very quiet and were following the match earnestly. Occasionally they applauded and threw in favourable comments, before remembering their roles; from time to time they glanced at each other and whispered. And all the while Leonie continued to give verdicts when there was any possibility of a line dispute, while Seamus echoed Aunt Maeve, calling out the score: "Vantage to the Commo'dant." "That's right, juice again." "Vantage to the Missus."

If Aunt Maeve was playing below her ability, there was certainly no evidence of it. As the match progressed she seemed to become more and more determined, running up to the net for close shots and doubling back if her husband sent over a lob. She tucked in her blouse when it became loose and kept her hair pinned back, crouching low to try to answer the Commandant's serves.

Everyone was so engrossed that there was no concern for Cormac's predicament: his legs and arms were aching now and his shirt drenched. Nobody even seemed aware of his contribution, least of all his uncle. In fact, the Commandant practised so vehemently between shots that once or twice he narrowly missed knocking out his exhausted helper.

Gradually Cormac began to resent his aunt's attitude. Could she be so hell-bent on winning that she was oblivious to everything else? Had she no thought for her incapacitated husband? Perhaps he should withdraw his services and bring the whole game to an end.

Aunt Maeve was preparing to serve. "Five games all," she announced. "Are you ready for the kill?"

"We'll break her this time," Cormac whispered in his uncle's ear as he wheeled him into position. "But be prepared: she's going all out for a win."

The Commandant swung his racket impatiently. "Leslie Dennis."

Whether it was the effect of Cormac's words on the injured brain or whether he had some other inspiration, the Commandant returned three of her best serves with such force that she could only stand and watch the balls flashing past. Seamus elbowed Leonie so hard in the ribs that she retaliated by pushing him angrily down the bank.

At love-forty Aunt Maeve delivered an ace but the Commandant, as cool as he was at the beginning of the match, returned the next shot perfectly and smiled up at his nephew. Aunt Maeve's serve had finally been broken.

With the score standing six games to five in his favour, he made no mistakes of service, but Aunt Maeve moved so fast about the court that nothing stayed on her side.

Cormac was in pain now from head to toe, pushing the wheelchair so fast that he half expected to toss his uncle out of it and end the match in disaster. But the scent of victory had taken possession of him and the exhaustion no longer mattered.

"Serve to her backhand," he urged his uncle. "That's her weak point."

The Commandant mumbled something and sent down a rasping service on the side Cormac had suggested. Aunt Maeve ran to meet it but botched the return.

"Dammit!" she exclaimed. It was clear she was rattled.

Unce Frank did the same once again and the scores stood level at deuce.

"Come on, Commo'dant!" Seamus shouted, clambering back up the bank, while Leonie called for quiet.

The next service also went to Aunt Maeve's backhand and, as Cormac trundled his uncle forward in the offchance that she

could answer it, she somehow managed to get her racquet to the ball. It was a wild shot and it soared through the air, high above Cormac's head, and, while he was still turning the wheelchair, he heard it bounce well beyond the Commandant's reach.

"Out," Leonie called.

"Are you sure, Leonie?"

"No doubt about it, Ma'm."

"Dammit!" Aunt Maeve exclaimed again. "Advantage Commandant Connolly."

Seamus rubbed his hands with glee. "That's right. Game an' set p'int to himself. Five shillin's in the bag!"

"Game, set and *match* point," Aunt Maeve corrected him. "But don't count your chickens."

"'Fair daffydils we weep to see ye . . .'"

"Shut up, Seamus," Leonie insisted.

Cormac wheeled his uncle to the baseline. "This is it, Uncle Frank. You're serving for the match."

His first ball was long and fast, and Aunt Maeve shouted "Out!" with an almost girlish relief; Leonie confirmed the verdict.

The second was in and close to the net. Aunt Maeve rushed forward and, to Cormac's amazement, just managed to get her racquet low to the ball. It was coming their way, but without much force, so Cormac put his head down and drove the wheelchair forward as hard as he could.

It was only after he had skidded to a halt that he realised Aunt Maeve's return had landed back on her own side. He jumped and spun in excitement: the game, set and match were his – and Uncle Frank's.

In the euphoria of victory he took a moment to realise that he had propelled his uncle out of the wheelchair: the Commandant was spreadeagled over the sagging net, hanging in an undignified sprawl as if he had fallen from a low-flying aircraft. Strangely, he was still clutching his racquet.

Leonie stood motionless on the bank, her hands over her mouth. Aunt Maeve and Seamus ran to lift the Commandant

from the net. Cormac held the chair still as they raised the slumped figure and hauled him back into it. Then Aunt Maeve bent down and, easing the racquet out of her husband's hand, kissed his forehead. Her face, clouded with anxiety, brightened greatly when her husband raised his head and winked at her.

She was laughing and breathless as she stood stroking his cheek and Cormac could see she was taking both her defeat and the near disaster with surprisingly good grace. There was no trace of resentment: if anything, her eyes were even brighter than at the start of the game.

No longer able to remain on his feet, Cormac slumped to the ground and lay on his back, exhausted and bewildered. He was just conscious enough to hear his aunt order Leonie to bring out some champagne – "And, let me see, three, four . . . five glasses. Come on, jump to it! Don't just stand there with your mouth open. And Seamus, you wheel the Commandant to the summerhouse. This other creature's done in, by the looks of it, but we'll soon put some colour back in his cheeks. Five shillings I owe you, you old rogue, but I bet you had some anxious moments there. You had a good run for your money, that's for sure."

"Oh God I did, Ma'm. A good run's right. You done mighty altogether an' for a while there I thought you had the pair of 'em bet. But it was a fair match and he never let up. Himself an' Master Cormac. Ye played a right good game, all three of ye. Vice versa is right."

That night, as Cormac set off for the long climb to his bedroom, Aunt Maeve called up to him from the hall. The light through the stained-glass panels of the halldoor was painting fairytale colours on the walls.

"Cormac, I want to thank you for this evening. You made a real game of it. Without your determination it wouldn't have meant anything."

He thought of the resentment he had felt during the match and the near calamity at the end. "Maybe I drove him a bit too hard."

"You did the right thing. It had to be like that. That's the kind of man he is. That's why I played as hard as I could too."

Then she seemed to have second thoughts: she leaned against the wall facing her reflection in the mirror. "No, Cormac. To be really honest, that's not altogether true . . . "

"What do you mean?"

"I wanted to win. I really wanted to beat him, for all the . . . pain he's caused. Is that very cruel of me? I'm sure it is. I suppose there's a part of me that resents what's happened, even though I know it wasn't his fault. Can you understand that?"

"I think so."

"As if I was demanding . . . I don't know . . . some kind of retribution. But I was really glad when he won. That was the best possible outcome. And you played a very large part in it."

For the first time in all the years he had lived in her house Cormac felt he had some understanding of his aunt – and she was not the complete stranger she so often seemed.

"You're a brilliant tennis player. I never knew you were so good," he told her.

"Oh, I'm not all that good, at tennis or much else. I like to win, that's all."

"Well, I think you're brilliant. It took two of us to beat you."

She smiled and he noticed in the eerie light that her eyes were glowing again. "You're kind to say so. If you like, I could teach you the little I know. Think about it and we'll talk again."

"Goodnight," he said and continued upstairs to his attic room.

Chapter Four

EDDIE WAS STANDING with Ann Marie Donovan on the steps of the county library. She put her books down and started pulling on her school coat. When he held it for her, she smiled.

Suddenly the air was full of a strange whirring sound, as if a squadron of model aeroplanes was coming at them from the sky.

"Jaysus, look who's borryin' books these days. If it isn't the bould Eddie Dwyer."

It was Mouse Morrissey and his cronies swarming down the street on their fleet of doctored Raleighs. Besides the usual stickers and emblems, the bikes had cigarette cartons attached to the spokes to generate a mechanical purr, an expression of their owners' craving for motorbike status.

"Isn't that young Dwyer from the Pearse Estate? I never knew he could read."

"He on'y borries books with big print."

"How's Anne of Green Gables?"

"Up the yard, Dwyer. Give it to her, ya boy ya."

"You'll be first in there, Dwyer. Virgin territory, if ever there was . . . "

Suddenly the street was empty again and Eddie's head reverberated with replies that might have been: he looked at Ann sheepishly.

"What was all that about?"

He picked up her books and shuffled them, glancing at the titles. "Who? Them? The four bikemen of the apocalypse."

"Do you know them?"

"Sort of, a few years back – before the invention of the wheel. They used hang around the handball alley a lot, lookin' for blood."

"Oh?" She linked his arm.

"Actually, they're a variety of grounded vulture peculiar to this region. I was hopin' they were extinct by now."

Ann laughed. "They sounded more like rattlesnakes than vultures. A stampede of rattlesnakes, if you can imagine such a thing."

He slipped his arm around her waist and they began to walk towards her home, swinging along in their usual fashion between two piles of library books.

Ann and Eddie had been going together like this since their first term in fourth year. He had noticed her years before, when he was returning handball books that he and Cormac had borrowed from the library. She was always so absorbed in her reading that he had plenty of opportunity to gaze at her and let his mind wander – but it was almost impossible to catch her attention. He tried everything, from fits of coughing to dropping books, but nothing seemed to distract her.

When he asked one of his classmates about her, he was told she lived in an enormous house, with its own tennis court and stables, on the Currragh side of town. Her father was a doctor and drove a Mercedes. Her mother was a famous artist.

"It's not her house or her father's car I'm askin' about."

"Don't start reachin' for the stars, Ed. She's in a different league from the likesa you. It'd never work out. Besides, she's prob'ly a fuckin' prude."

One day, instead of gazing at her furtively and dreaming about a chance encounter at the checkout, he went over to her reading desk and confronted her boldly. "I want to walk you home. I need to get to know you. My name is Eddie Dwyer."

Heads turned in his direction and he noticed a startled look in Ann's eyes. "OK," she whispered. "You don't have to shout."

She had long hair like Eleanor's, a rusty colour rather than

blonde, and a perfectly oval face. She was small in stature, like Eddie himself, and had a well developed figure – but to Eddie, even after almost a year going out with her, her physique remained, as one of Morrissey's gang had rightly surmised, unexplored terrain.

Within a short while Ann had weaned him off the cowboy books that had become his staple diet, and they devoured every modern novel and book of short stories they could lay their hands on – many of them smuggled out of her father's library. They talked about them then as they lay in the sun beside the millpool or sheltered from the rain in a waiting room of the railway station: places like Canary Row, the Cape of Good Hope and Kathmandhu seemed just down the line.

They were conscious that they had become something of a feature in the town. Older girls sighed when they saw them coming out of the library together or walking along the cinder track beside the railway line. Sometimes Eddie felt very adult in her company, as if he had become, to use Eleanor's phrase, a fully-fledged human being; at other times, when older girls passed by and said "Ah, aren't they sweet", he felt like Gulliver in Brobdignag. Ann said she had the same sensation and called it her Alice complex.

In June of their first summer together, her family took her away on holidays to some place in County Donegal and Eddie waved her off in her father's Merc. He was left moping about the town in a state of pitiful dejection; at least that was how he imagined he appeared, and glances at his reflection in shop windows confirmed it to be the case. Drumaan and its environs, normally a source of endless stimulation, seemed deserted the day she left.

To make matters worse, Cormac was driven past in his auntie's black car and he didn't even wave – although they were stopped in traffic a few feet away from where Eddie was standing. Eddie pretended he hadn't seen his old friend and tried to look cheerful.

Everywhere he wandered he imagined Ann rushing around a

corner to tell him the Mercedes had broken down and her father, in a fit of pique, had decided to come home. In the station he studied bus and train connections between Drumaan and Donegal: somehow Kathmandhu and the Cape seemed more accessible.

She had promised to write regularly, so Eddie leapt out of bed early the next morning and ran downstairs in anticipation of her first letter. To his dismay, the only contributions from the postman were an electricity bill – which his mother put on the mantelpiece on a pile of other bills – and a letter from Auntie Josie saying how well Jimmy and Michael were getting on in their new jobs or marriages. He trudged back up to the bedroom and crawled under the blankets.

"Give her a chance," his mother said after a similar performance the next day. "She'll hardly be there yet. Why don't you go over and stay for a while with your gran'father in Belmont? You could help him save the hay an' get to know your gran'mother as well. I'll send on any letters that come."

"Would I get paid?"

"Are you jokin'? Sure that pair haven't a bean between them. Besides, where would you spen' money out there in the middle of nowhere?"

"I'd save up and get a bus to Donegal."

Eleanor laughed. "Oh, my! He's got it real bad for a lad of fifteen."

"Sixteen actually, next month."

"Poor Eddie. You're lettin' yourself in for a rude awakenin', there's no denyin' it."

"Don't be goadin' him," Mam said. "Isn't she a gran' girl for him, even if they're both a bit young to be carryin' on? He could do a lot worse in this town. A lot worse." And she glared at Eleanor.

"If they wanted you with them in Donegal, they'd have invited you, wouldn't they? I wonder why they didn't. Perhaps they think Ann Marie needs a change of scenery. Some pals nearer her own class." And she pronounced the word to make it

rhyme with "boss". "Taking her away is a manoeuvre, if you ask me."

"What do you mean a manoeuvre? They go there every summer."

"She's a dooley, remember."

"A what?" Mam asked.

"A dude, a hick, a toffee arse."

Mam clicked her tongue in disapproval.

"Tell us, Ed. Did you notice if she packed her tennis racquet and whites? Which is it her Daddy drives, a Bentley or a Rolls? You should see it, Mam, a big, shiny black yoke . . ."

"Leave off, Eleanor, for once an' for all."

"It's a Mercedes, for your information. And I didn't watch her packin'."

"She's a huntin', shootin' an' fishin' type, Mam, if ever you seen one. They'll probably put her in boardin' school for the last few years before she does her Leavin'. And then she'll sail straight into Uni in Dublin to do law – or medicine maybe, so's she can take over Daddy's practice. Trinity, probably. No slavin' to qualify for grants for our Ann, oh no!"

"She's a Catholic, isn't she? She can't go to Trinity."

"She can go where she likes. There's no such word as 'can't' for the rich, whether they're Catholics or Protestants, Mam. Don't you know that?"

"Eleanor, what's ailin' you, in the name of God?"

"I'm tryin' to warn him, that's all, before he gets totally hooked. Remember what happened over his pal Cormac Mannion. He faded out of the picture mighty quick, didn't he? After he took one look at this kip."

"I don't need you interferin'. Maybe you should've gone to England – before you turned into a right oul' bitch."

"Eddie, Eleanor! No more of that talk, d'you hear?"

Eleanor paced around, snatching up kids' toys and comics and tossing them roughly into a corner of the room. "I'm just sayin' there's two sorts of people in this town and never the twain'll meet. There's the golf-rugby-tennis set, and there's us. When did

you last play a game of golf, Eddie? Face it: the fellas on this estate wouldn't know a number five iron from a hockey stick."

"So?"

"So how're you goin' to hang about with Ann and her friends? Where'll you bring her? To the GAA grounds for hurlin' matches, is it? Or better still, to watch gurriers beatin' the wits out of each other in the Mary Immaculate Boxin' Club?"

"Why not?"

"Yeah, she'd love that, wouldn't she? Face it: you can cross the gap for a while maybe, but that's all. The doctor's daughter and the son of a drunken corporal: it's hardly the perfect match, is it? What would you do if they ever invited you for dinner? And think if they invited your parents!"

"Eleanor, cut it out," Mam insisted. "Enough is enough!"

But Eleanor was beyond reach. "You should see the place, Mam. It's a bloody mansion, with stables and separate quarters for the maids. We're not in that league and we never will be. We belong in a lousy, rundown, flea-ridden estate in the back of nowhere." With that she brushed past the table and blazed out of the house, slamming the front door behind her.

Mam sighed. "Dear, oh dear! I don't know what's got into this family this last while. Will I never get a minute's peace again as long as I live? That girl has too much fire in her for her own good."

Eddie said nothing. He was thinking of Ann, not his mother or Eleanor. The small, sad face looking back at him from the rear window as the car sped along the street in the rain. He had been standing at the sweetshop corner, pretending he just happened to be passing; they had slowed down for the traffic and then accelerated with a soft swish. Yes, it had seemed as if they were carrying her away to safety all right, out of his clutches.

There were tears in Ann's eyes when they parted the night before. "I'll write every day. It's only a few weeks. We'll soon make up for lost time, I promise." And she pressed his hand tight before turning and running up her driveway.

Maybe Eleanor was right. Maybe she had heard something in the town about Ann's parents and how they felt about the

relationship. The whole thing might be a repeat of what had happened with Cormac after he was sent to boarding school.

"Don't look so sorry for yourself, Eddie. Eleanor talks a lot of rubbish at times. She's jealous of you and Ann, that's all there's to it. She's got no fella of her own, probably 'cause she's too sparky for the sheepish lads in this town. You'd be a lot better off spendin' a week or two on the farm with your Granma and Granda."

That day Eddie went off with some school pals to play football and in the middle of the game Cormac showed up for the first time in years. But Eddie felt too depressed to talk to him for long: he made up some excuse and left.

"Will you not do as I say, just this once?" his mother said later that evening. "I'll write your Granma a note and tell her you're comin' over to Belmont."

"What good will that do?"

"What good will sittin' here mopin' do?"

* * *

Granda was Mam's father and his name was Patrick Joseph McMahon. Eddie was to ask for his cottage when he got to Belmont. More than likely there would be no one at the bus stop, so he was given careful directions. He was also given a bag of homemade scones and soda bread to present to his grandmother when he arrived.

He was not to worry about Granma: she was a bit "gone in the head" and inclined to get things mixed up. But the longer you talked to her, the more sense she made. She had a heart of gold, Mam said, and she'd be delighted to have someone to chat to.

When he got off the bus at the Belmont cross, he looked around in dismay. There were few signs of human habitation. The bogland, with its white cotton flowers and scrawny furze, stretched away on one side of the road as far as he could see. It was an even flatter place than the Curragh, and the brown

surface, in between the yellow clusters, made it look like an enormous cemetery full of newly-dug graves.

The other side of the road was more inviting: it had a large plantation of fir trees and, beside it, a roadway winding uphill. In the distance he saw a wisp of smoke from a cottage and, further off, the grey outline of a country mansion. The cottage and the mansion fitted the description he had been given, so he set off along the road with his schoolbag of library books and clothes in one hand, and the bag of scones and soda bread in the other.

He was greeted at the cottage gate by two snarling dogs who took an instant dislike to him and competed for the privilege of amputating an arm. Eddie spun around and swung his schoolbag at them, but this only made them more hostile. Even waving the scones above their noses and saying "Good dogs, nice dogs!" failed to appease them.

His grandmother came from the cottage and set down a white bucket. "It's your townie smell, sonny," she said above the growling, and she grabbed one of the dogs by the tail and yanked him back from the gate. "They on'y ac' up like that whenever townies come aroun'." The other dog kept his eyes fixed on Eddie, his razor teeth bared.

Granma was wearing an old blue apron and black hobnail boots. She was smaller and greyer than she appeared in her photograph in the front room at home. He had no recollection of ever having seen her in person before.

"Get down, ye brutes!" she demanded, picking up a rusty frying pan from a windowsill and clobbering the bigger of the two dogs on the head. The clang had the desired effect and both animals slouched off towards an open haybarn.

"So, what can I do for you, young fella?"

"I'm Eddie. Eddie Dwyer. Your grandson." She looked at him blankly. "Didn't Mam write to say I was comin'?"

"She did."

"Well, can I come in then?"

"Who'd you say you were?"

"Eddie."

"I thought she said you was comin' Saturda'."

"This is Saturday."

"Are you sure?"

"Positive."

"Then you can come in."

The cottage was sparsely furnished but spotless. There were few ornaments and the only pictures were postcards of Blackpool and the Tower of London propped against a radio on the windowsill. On top of the kitchen dresser there was a black-and-silver accordion, and on the mantelpiece a loud metal clock, a rack of pipes and a small shoebox.

Eddie had noticed from the road that the cottage was connected to the electricity supply, but the only electrical appliance he could see, apart from the radio, was a bare bulb hanging above the table in the middle of the kitchen. Besides the earthy odour of turf there was a strange oily tang in the room and Granma explained that she used kerosene lamps as much as possible "to save th'electric for a rainy day".

The house was immaculately clean and orderly and he was surprised when two hens strutted in – Moll and Madge, she called them – jerking their heads about in search of crumbs. Granma fussed around too, a bit like a hen herself, making tea and cutting thick slices of bread and asking Eddie if he had come by boat or plane.

"By bus," he told her. "It's only twenty-seven miles from the Curragh."

She looked at him full of surprise. "You came in a curragh. That wasn't too smart, in squally weather the likesa this."

"No, from the Curragh. Drumaan. In County Kildare. That's where I live."

"This is Kildare. The County Kildare, though there's some thinks it's Off'ly," she said. "But you wouldn't min' them."

"I know," Eddie agreed with a laugh. "Some people don't know where they are halfa the time."

"Drumaan," she mused, as if it was some faint memory. "You must be in th'army so?"

"No, my Da's in the army. He's a corporal."

"An' was he wounded in th'ambush a while back, did I hear?"

"What ambush?"

"What ambush? You come from the Curragh and you don't know what ambush. Th'ambush in the Tango."

"Oh, you mean the ambush in the Congo. No. Da never went to the Congo."

"Then, why's he so sick?"

"I didn't know he was sick."

"He's your Da and you didn't know he was sick?"

He stuffed his mouth with bread to end the conversation but his grandmother continued to chat away. Soon he realised it didn't matter if you answered her or not; she just side-stepped your answers and prattled on, mostly to herself, as if you'd said nothing at all.

"You mus' be Josie's son so, Jimmy from Englan'."

"No. I'm Biddy's son, Eddie from Ireland."

"Josie tells me Jimmy's got a lovely girlfrien' an' they're goin' to get married. Have you got a girlfrien'?"

Eddie moaned. This was what he had come to Belmont to get away from. "Yes, I've a lovely girlfriend, nicer then Jimmy's I bet. But she's a dude or a dooley or whatever and her mother and father don't think I'm good enough for her."

Granma clicked her tongue in disapproval. "Shows how much they know."

"At least, that's what Eleanor says. So, what should I do about that?"

"First tell Eleanor to keep her nose outta your business," she replied; she was obviously more clear-headed on some subjects than others. "Then stop moonin' about with a long face on you an' take the bull be the horns."

In spite of her daftness, Eddie found there was something refreshing about talking to his grandmother: she was the first adult he had ever spoken to who treated him as an equal.

"Are you dead serious about this Dooley lassie?" she asked as she sat down to join him at the table and poured herself a mug of black tea.

He though of the sweet face in the rear window of the car. "I s'pose I am."

"Are you or are you not?" She seemed almost cross.

"I am. Yes, I am."

"Is it love, would you say?"

"It is."

Granma nodded approval. "That's all that matters then."

"And I don't care if she's a hick or a dooley – or a blue-tailed tit, for that matter."

"Then there's only the wan thing for it," his grandmother concluded, reaching across the table and patting his hand.

"What's that?"

"Marry this Dooley girl. Don't be forever puttin' it on the long finger. That's what I say."

"But I'm only . . . "

"No buts an' ifs. Shorta that, take her into the bed beside you an' make a solemn pledge. That's as good as marriage, you know, in the eyes of the Lord. I bet you never knew that."

Eddie looked at her in amazement. "Ye must have a different Lord out here than we have in Drumaan. Or in Newbridge or Kildare, for that matter."

"This is Kildare. The County Kildare."

"I mean different from the Lord in the towns."

"We have a differen' Lord all right. A more understandin' one, closer to nature an' the wild, d'ye see?" She leaned over close to him. "An' the dogs don't bark when he comes to the gate."

Whenever Eddie laughed, she laughed too and she never seemed offended. They chatted for a while longer and at one stage she stood up, chased Madge and Moll from the house and closed the half-door. "Himself'll be home soon and he doesn't like tham cluckin' hens in the house. Is today Saturda' or Sunda', d'you know? I've no head at all for the days of the week."

Eddie guessed that his grandfather stayed out of the house in the interests of sanity. Granma's blathering was infectious and by

the time Granda showed up for tea, Eddie felt his brain had been scoured out and left to dry in front of the fireplace, like one of the white buckets she used for feeding the hens.

He was a big man, and surprisingly formal. He greeted his grandson with a long handshake and Eddie noticed that while he was around Granma prattled a lot less. Whenever she made daft remarks, he replied thoughtfully so she wouldn't feel hurt or humiliated. There was a quiet respect between the old couple, and a lot of gentleness.

After the meal – which consisted of black and white puddings with more slices of bread and big mugs of tar-like tea – Granda suggested that Eddie accompany him on his rounds while Granma had her rest.

"Divil the resht," she remarked, rolling her eyes to heaven. Still she wouldn't hear of Eddie staying back to help her with the dishes. "Men an' young lads has to be walkin' the lan' talkin' – though what ye do talk about, God on'y knows."

His grandfather nodded to him, as if to say it was no use arguing with her, and they left the cottage together.

"Isn't it late enough to be savin' the hay?" Eddie asked as they strolled along a laneway in the evening breeze. He was thinking of how early in the summer the stacks appeared in the fields on the outskirts of Drumaan. It was only days since he and Ann had nestled together in a haystack, chatting about a novel they had both read – and he'd wondered how she would feel if he leaned over and kissed her on the mouth. It had taken a great effort not to put that impulse to the test. She had seen him gazing at her and smiled, as if she knew the struggle he was going through and was waiting for him to resolve it.

"It is late, son, you're right. But then things move at a slow pace in this part of the country."

They were standing on the crest of a barley field that swept down in waves to the granite walls of the Belmont estate. Over the walls Eddie could see the big house, with its tall chimneys and ornate windows, and he tried to remember an illustrated

book from the library that showed the difference between Tudor and Georgian architecture.

"That must have been a fine house in its day."

"It was. In th'old days all the land aroun' here belonged to the fam'ly that lived there."

His grandfather lit a white clay pipe and sucked at it with a matchbox held over the bowl; then he exhaled clouds of smoke that smelled like burning leaves.

"It was a powerful estate, providin' a livin' for upwards of twenty fam'lies. Now you wouldn't have ten, or eleven maybe, in the whole area."

Most of the families had shrunk to one or two old people, he explained, many of them living on the dole and whatever little they could scrape together besides: cash sent home by those that went abroad, pensions and fees for subletting the land. The forestry kept one or two busy as well.

"What's the reason for that? Is there no demand for what the farmers produce?" Eddie asked.

"Oh, there's a deman' alright, but the barley won't fetch a price these days. You'd need to have a thousan' acres to see a return. If y'ask me, the truth is, after all the centuries of strugglin' to own it, we put too much faith in the land an' not half enough in the people. That's what has the country in the state it's in."

He steered Eddie towards a grassy track that led along the edge of the fir plantation and stopped walking every now and then to attend to his pipe. The land, he said, had been "divvied" into too many small holdings. No one could make a go of the little they owned now, so they were selling it on or leasing it out to others and taking the emigrant boats to England or America.

He pointed out small fields and told Eddie which family each plot belonged to. "That was the Shaws' land up to the Troubles. Moira Shaw lost a husban' and two sons in the Civil War and after that she left home to live with her sister in Boston. Then it passed into the hands of the Donoghues and they had their trials too."

The problems continued long after independence, he told Eddie. De Valera's policy of trying to keep people on the land

was well-meaning but blind – "near as blin' as th'old man hisself".

"It wasn't only the war he kep' us out of, it was the real world. Irelan' has swam against the tide for long enough. It's time for the country to face fac's an' grow up. An' it's time for the church an' politicians to get off the people's backs."

They completed a circuit and were passing by the manor house again. They stopped while Granda relit his pipe.

"So, who lives there now?" Eddie asked.

"An old lady called Maureen Connolly an' her housemaid, that's all. It's in a woeful state of neglec' an' Mrs Connolly's nearin' the en' of her days, God bless her soul. There's two of them livin' there an' there must be room inside for twenty."

"I suppose they're Protestants?"

His grandfather laughed. "You'd think that all right, to look at all they own. But the fac' is they never turned."

They were an old Catholic family and over the years had played their part in the struggle for Irish freedom. They were not the kind of landlords you usually hear about, Granda said, and that was why the house was not burned down in the Troubles.

Eddie asked if there was no heir to take it over and turn it into a hotel or something commercial.

"She has an heir all right, but he won't be doin' much rebuildin'. He's an army officer, the same gentleman, and he was wounded in the Congo a few years back. He sits in a wheelchair all day, in a big place near ye in Drumaan. You may have heard tell of him: Commandan' Francis Connolly."

Eddie listened to the evening breeze whipping the trees awake. "I heard of him all right," he said, trying to remember where and when. "At least I think I did."

"I knew him from he was half your own age and a fine lad he was too. He always had a love for the milit'ry and he couldn't wait to get into th' army. He was a great patriot and he joined up more for th'adventure than for an'thin' else. He never wanted to be stuck behin' a desk and he'd no great shortage of money, as you can see."

By the time they turned homewards the light was fading.

"She'll have a bed fixed up for you by this hour. She'll have you above in the loft of the house, where your Mam grew up along with little Josie. Ah, they were the cheery pair, laughin' an' singin' from mornin' till night. You'll like it up there. If you stick your head outta the winda, you'll be able to see over the estate wall. An' you'll be well away from the cluckin' of them godforsaken hens."

They stopped at the gate of the cottage and looked up the roadway to the entrance of the big house.

"Commandant Francis Connolly," Eddie said, trying to remember why the name was so familiar. Wounded in the Congo. He could list the men who died for Ireland back in Easter 1916, but not the names of those who had died for peace only a few years before. History was queer like that: it taught you some things but ignored others.

"Aye, poor Frank Connolly. Not on'y is he a cripple, but he has neither son nor daughter to carry on the family line. So, there's no clear future for Belmon'."

That night Eddie dreamed he was raking hay in a field near the estate wall when an open car drove by. A girl was standing up waving to him. At first he thought it was Eleanor – but then he realised it was Ann and he waved back, dropping the hayfork to run after her. His grandfather reached out his hand and gripped him by the arm, saying, "Let her go. There's work to be done".

The car kept speeding towards the gate of the big house and, even before the driver turned and smiled at him, Eddie knew it was Cormac Mannion.

As he drove in through the gateway with Ann, Cormac tossed a handful of coins in Eddie's direction. To his dismay, his grandfather caught some in his cap and then got down on his hands and knees, rooting for others in the stubble . . .

Eddie woke in a sweat. It was shortly after dawn and he knew at last who Commandant Connolly was. He had to go out of the

cottage and put his face under the hand pump in the yard to get the dream out of his head.

Then he stood looking at the gateway of the big house till the two dogs crept out of the haybarn and crawled towards him on their bellies. They whimpered and cringed, transformed from the snarling brutes that had greeted him the previous day. They licked the water he offered them from his cupped hands but, when he made too sudden a move to pet them, they darted back towards the barn.

The next days were spent in the fields with his grandfather and some neighbours, all working together to save each other's hay. It was a great sunny time and they worked till the sweat made their shirts stick to their backs.

When they took a break the farmers cracked jokes and told stories about the old days; the wives and sisters carried out trays of tea and bread. Eddie counted the hours to these breaks, calculating the time by where the sun shone on the chimneys of the big house.

Some local lads joined in the work, boys of about his own age, but they were so shy that it was hard to get to know them. If he spoke to them at all they answered quietly, in as few words as possible, or they glanced at one another and smiled. At times, when the girls came by with tea or when they spied them walking along the road swinging their summer dresses from side to side, the lads turned their backs and swopped furtive glances, spitting on their hands and laughing about nothing at all.

The men were better talkers but they never tired of agreeing with one another and echoing each other's opinions. "You're right there, Mick. You're dead right about that." "There's no doubt about it, PJ, no doubt at all." But, for all their agreeing, the yarns they told were nearly always about conflicts of one kind or another – ancient disputes over land, incidents of unrequited love, family quarrels that ended up in acts of brutality. The stories explained why a place was called the Bloody Hollow or Murphy's Grave or the Black Priest's Wall; or

why you could hear the wailing of a child if you stood near a certain grove; or why a perfectly good house was only used for sheltering animals when it would have made a grand home for the family that owned it.

"You see that thicket above there?" Granda said one evening as they were walking home from a neighbour's farm.

Eddie looked over the hedge and saw what he thought was a fairy mound. It was a hillock covered in whitethorn trees and briars. It stood like an island in a lake of ripening barley.

"Fix that in your mind an' ask your Granma to tell you the hist'ry of that place. She can tell it better than anyone in the parish. An' it'll stop her pesterin' you about why you're not married. It's called the Mound of the White Bones. Get her to tell it to you some time before you leave for home."

Another time, very early one morning, he woke Eddie and said he was taking him to a place called the Clearing. They had to go quick if they wanted to get mushrooms before the birds ate them. They walked a long distance through acres of plantation and then crossed an open field towards a more ancient wood. After the carpet of dead pine needles in the forest, the grass of the wood was cool and refreshing.

Granda pointed out oaks, beeches, elms, ashes and silver birch and, with the dawn light filtering through the branches, he told Eddie how to recognise each different kind of tree. They stopped at clusters of honeysuckle and lavender and he rubbed the petals between his fingers to release their scent.

As they walked on, he chatted away about what an amazing thing a mushroom was; how it could grow up overnight and push its way through the ground, though it was so soft and fragile that it broke if you handled it roughly. And he particularly marvelled at how the spores lay in the ground and thrived best in dark, damp soil. "A bit like we grow ourselves in our lifetime, in the quiet an' the dark," he said with a smile.

He told Eddie that when he was young the grassy floor of the Clearing was often white with mushrooms. One morning, when he was reaching down to pick some, a great white bird had risen

up and flown past his face. It was a heron maybe, or a barnacle goose, he never knew which. He hadn't seen the bird at all until he was almost on top of it and then it had flown up past him, almost knocking him over with fright.

Later he had learned that the white bird of dawn brought peace and happiness to those who saw it and he wondered if that was why he had been blessed with such a good life. He sensed Eddie's surprise and said: "Of course, not everyone would take a thing like that as a sign an' maybe they'd be right. But then I wonder do they reco'nise good fortune either when they see it. Sometimes I think the world's half blind an' we have no eyes any more for the wealth an' riches that's within reach of us all."

In the evening time, after tea, neighbours often called to the cottage and sat talking till late at night. Usually the conversation revolved about farm prices and land deals and the failure of government policies to halt emigration. Over the years the country had been allowed to lose its lifeblood, some would say, and that could only spell disaster for the future.

There was talk of the struggle for independence and the Civil War that followed, as if these events had taken place only a week or two before. Opinions were offered on the "open door" government of Seán Lemass, with his policy of attracting foreign money to build up the country and encourage new industries.

"One way or th'other," one sad-looking man never tired of saying, "the drift away from the land'll go on – whether it's to Boston an' Manchester or on'y to Dublin an' the big towns."

Most of the neighbours felt the country had taken a wrong turn and would soon lose its character altogether. What was needed was clear land policies and strong government.

But Granda usually took a different line. One night he said: "Do any of us know where we're goin' halfa the time? We're on'y stumblin' aroun' in our own shadow if y'ask me." He puffed his pipe and everyone waited to hear what he had to say. "But maybe that's the way it's right to be. Many's the wild thing grows without our plantin' it, isn't that right, Eddie? Maybe the same holds true for countries."

"Are you sayin' that all we fought for was the right to sell the lan' to the highest bidder?" the sad neighbour asked. "What we lose now, we may never win back. We're betrayin' generations who died for Irelan'."

"Don't fret yerself, Mikey," Granma interjected. "PJ'd be the first in the fray if they tried to take his poor bit of scrub away from him. He's on'y sayin' these things to get a rise outta ye. If ye lived with the man as long as I done, ye'd know when to hould yer whisht and when to hit back."

Granda laughed. "I'd fight for the land all right. But I wouldn't condemn all to live on it. That was the big mistake. I'd lave things take their own course more. Lave people have a bit of . . . unsureness in their life. And then let's see what the future brings of its own accord."

"Sure wasn't it that exac'ly that had halfa the people fleein' the country in days gone by . . ?"

After these discussions, someone would take down the accordion from the dresser and urge PJ to play a few bars. "C'mon there, y'oul' cod ya. Give us a bar or two to banish the cowld." Then, after his usual routine protestations, he would take the accordion and wink at Eddie, and before long the house would resound with ballads and reels. Granma and the other old folk would tap their feet and laugh at each other across the room. And then, when Granda came to the end of a tune, the men would rap their stout bottles on the kitchen table and demand another.

Sometimes Eddie went up to his little room and read over Ann's letters while the music filled the house below. His mother had been forwarding them as she had promised. At other times, when he took the dogs for their nightly stroll, he could hear the accordion and the peals of laughter a long way from the cottage.

If there was light in the sky he would walk towards the big house and sneak into the enclosed grounds through a small picket gate. It was eerie in there but he felt safe with the dogs by his side. They stayed close to him, pressing their flanks against his legs and crouching on their bellies when he stopped to

examine a tree or gaze at the moon. If he stayed still for a long time the younger one whined and licked his fingers, checking to see if he was still alive.

Somewhere along the way, he thought, in his labours in the fields or sitting at the turf fire talking to Granma, he must have lost the smell of the town.

The day he was leaving, his grandmother made him two big ham sandwiches for the journey. She was still convinced he was facing a stormy voyage in a curragh and not a short bus ride to Drumaan. She stuffed the lunch pack into his schoolbag and handed him his books and the letters from Ann. He had tied these into a precious bundle and Granma insisted that he should keep them out to read "during the voyage".

"Now, remember all I tol' you, son. An' tell that Mam of yours to let you come an' visit us soon again, wind an' weather permittin'." Then she pressed her face against his. "I pray God you'll be happy an' not too hard on them that wen' before you."

As he walked with Eddie for the bus, Granda's eyes remained fixed on the road. "She rambles away to herself but a lot of the time she makes her own kinda sense. There's not an ounce of harm in her anyway, that's one sure thing, an' she's after takin' a mighty shine to yerself."

"I'll miss her a lot," Eddie told him. "And I'll miss you too."

His grandfather smiled and went very quiet. When they were near the end of the walk he said: "Bring your Mam out to visit us one of the days. I know she's a busy woman but she shouldn't be shy of her own flesh an' blood. She buries herself inside in that town, as if she has reason to be ashamed of somethin', but she's nothin' to regret, nothin' in the wide world. She's a good mother an' you're a walkin' credit to her. You can tell her that from me."

They sat on a low wall and Granda puffed at his clay pipe while Eddie stared out at the array of colours on the bog in front of him. The air was full of the drone of insects and the chirping of little birds that swooped and dived over the bright gorse and heather. He had learned their names since he had arrived:

martins, wagtails, curlews and bitterns. The cotton flowers bobbed in the breeze and there was a rich scent of brown turf blending with the leafy odour of his grandfather's tobacco. *I'll remember this scene*, he told himself. *I'll treasure it always.*

Granda suddenly pressed a brown envelope into his hand. "I want you to take this an' no nonsense. You more than earned it with your work an' good cheer. I wish it could be more, but that's the way it is. An' this is a letter for your mother. Next year come back to us, with that girlfrien' of yours if you want, an' we can teach the two of ye how to cut turf as well as to toss hay."

Eddie was surprised at the invitation and his grandfather laughed. "Don't worry. She can sleep above in the loft an' you can go out in the barn with the dogs. Many's the night I was put out there meself when I'd too much drink taken. But, to tell you the truth, I never had a night's sleep in any bed to equal the rest I got out there." He laughed mischievously and relit his pipe.

When the bus appeared at the end of the road they both got to their feet. "Did you ever ask Granma to tell you that story?"

"What story?"

"The Mound of the White Bones, she calls it?"

"Oh my God, I forgot." Eddie felt a sudden stab of regret. The strength of it startled him: was it a sign? Was he never to see his grandmother again? Or his grandfather, maybe.

"Don't fret, son. There'll be time for that yarn an' others like it, you can be sure of that. Plenty of time."

As the bus pulled up beside them and throbbed quietly, he took Eddie by the shoulders and pressed his grandson's face to his chest.

"God bless you, Ed. You're a good lad. Don't worry about a thing now, d'you hear? We'll still be here nex' year, an' the year after with the helpa God. You know what I think: you'll be sick of the sight of us be the time we're wheeled out. Give our love to your Mam an' all the fam'ly."

* * *

"Eddie's back, Eddie's back!" Philomena yelled. The twins jumped up and down in the hallway echoing the refrain. While they spun him around and tugged at his bag, his mother come down the stairs making an urgent appeal for calm.

"My, my, such a racket! My God, Eddie, we missed you. Let me see you. You look great, all tanned an' healthy lookin'. Come inside an' tell us all about it. Children, calm down an' let him talk. You'll wake up the baby with all this shoutin' an' roarin'."

They bundled into the kitchen and Eddie eventually calmed the kids with the sweets and comics he had bought on his way home. "Wow!" Philly exclaimed. "Is this for me? How'd you know that's my favourite comic, Eddie?" And she threw her arms about his neck and hung there while he swung her around.

"Now, take the sweets outside and be careful to share them," he ordered the little ones, pleased at the air of authority his first pay packet had given him. "Granda paid me five pounds," he told his mother. "And he gave me an envelope for you too."

She took the envelope and looked at it for a moment; then she put it down on the table and shook her head. "I can't be takin' from what little they have; it isn't right. An' you shouldn't either. I meant you to go over there an' help them out as a favour, that's all."

"You know there's no use arguin' with Granda. He wanted to pay me. Besides, I worked like a dog. I don't feel bad about takin' the money. But I swear I didn't expect it."

"An' tell me, did you get on well with them? What did ye talk about? I'm dyin' to hear everythin'. Start at the beginnin'."

"First make some tea and make it real strong and black. In a mug, if we have one."

As he recounted the events, his mother relished every detail, laughing and shaking her head. He told her about arriving on the bus and the sight of the dark bog; being greeted by the dogs; Granma's theory about townies and there being two Gods; the work in the fields; and the conversation and music at night around the turf fire.

"God, it brings it all back to hear you talkin' about it. Did they tell you about how the places got their names?"

"They did. I wrote them out in my diary so's I wouldn't forget. But there's others I have to learn about when I go back."

"An' when's that goin' to be, do you think?"

"The sooner the better. But this time I want you to come too. They're dyin' to see you, you know."

"How am I supposed to travel over there with all the kids? An' where, d'you mind tellin' me, would we sleep? In the barn? Or in the loft above the fireplace?"

"Wouldn't Eleanor mind the kids here? Just for a couple of days."

"Not the way she's behavin' lately. An' anyway I don't want to leave her here when himself's likely to roar in drunk any minute of the day or night. She's had more than her share, God knows."

"Then you and Eleanor go and I'll stay back and look after the kids."

Mam laughed and patted his cheek. "I can see you gettin' up in the middle of the night to lift the wee ones. An' you'd have to do the cookin' for Philly an' the twins. You'd probably burn the house down."

"Let's see if we can work it out somehow between myself and Elly."

His mother was up now, pottering about the kitchen.

"Do you know what I think?" Eddie said, not wanting the spell between them to break.

"What?"

"I think Granma puts on half that daft stuff. Forgettin' what day of the week it is and all that. But I think she really believes in two Gods."

"You know, Eddie, I think you're right." She sat down again at the table. "I'll tell you somethin' I never tol' a livin' soul. But first promise you won't breathe a word to anyone."

"I promise."

"My mother an' father never got married. That's why they don't go to Mass or confession. I think some of the time she mixes up the days of the week it's to hide the fac' that they never

take the sacraments. It started like that anyway an' then it became a habit, do you know what I mean?"

"I think I do."

Eddie had wondered why they had not gone to Mass in all the weeks he was living under their roof, but he had put it down to the need to save the hay while the fine weather lasted. When he looked back on it now, he and his grandfather were always the first in the fields on Sundays and when the others arrived, they were wearing dark suits, and hung their jackets on trees or hedges before settling into the field work.

"It's funny they never asked you if you wanted to go."

"I suppose they just don't think of those things any more."

"An' needless to say, you wouldn't have thought of askin' yourself. You'll have tell the priest you missed Mass three Sundays in a row, do you hear?"

"You were sayin' about them not marryin'."

His mother glanced around her. "Josie and me were born out of wedlock an' you know what that makes us. That was a great load for us to carry when we were growin' up an' it explains why Josie was always so set on gettin' those lads o' hers married an' settled down. It probably explains a lot about me too, though I'm not too sure what."

"And why did they never get married?"

"Because she already had a husban' when she met my father. By all accounts the family had forced her into marryin' so they could join up two farms. But she'll tell you about that herself now that ye're such good pals. She never makes any secret of it. She tried to get an annulment from the church. She wrote to the bishops an' even the Pope himself, but nothin' came of it." She stood up and went back to her work. "Oh, if they were well-to-do types, higher up the social ladder, she might have got a differen' response."

"So, they just went ahead and started livin' together?"

"That's right. They took the law into their own han's."

Eddie remembered Granma asking him not to be too hard on those that went before him. His grandfather was right: she made her own kind of sense. And Granda had meant something other

than Eddie thought when he'd said Mam had nothing to be ashamed of.

"Is that why you never kept in touch with them over the years?"

His mother stopped stacking dishes and leaned against the sink. "I s'pose it is. I s'pose deep down I'm ashamed of them. An' God knows I've no right . . . "

Eddie went over and stood beside her. "Come on, Mam. You've got to go and visit them. We'll manage it some way or other. It's one thing for them to be drove out of the church like that, but you shouldn't be turnin' your back on them too. They're your flesh an' blood. If you decide you want to go there, Elly an' me'll arrange it some way."

"Why're you cryin', Mam?" Philomena asked as she came in from the yard, her face smeared with chocolate. "Are you havin' another baby?"

Mam looked up and she and Eddie laughed. "No, Philly love. I'm not having any more babies. I'm cryin' with happiness that I've got such a good son an' you've such a good brother."

Eddie didn't see Eleanor till later that day. She breezed in the front door and ran straight upstairs to her room. He got up to follow her but his mother warned against it. "You're better to leave her be. She's in a queer mood again these days. I don't know what's got into her at all lately. Go on with the story."

He had been reading a comic to Philly and the twins, so he returned to the task, acting out the parts as best he could and competing with the baby waking upstairs. There were shrieks of delight from the kids, who were sitting attentively on the old settee beside the kitchen stove. Philly was leaning over his arm looking at the pictures. Mam was smiling too, as she stood at the stove, heating a bottle for the baby; occasionally she stirred the coals with the long poker which she always left in the fire.

Suddenly they heard the scraping of metal studs. A chill came over the room as they listened to the shuffling outside the front door. Mam scuttled the fire. "Go on with your readin', Eddie."

The halldoor was flung open and he heard his father trying to close it and fumbling with the lock. "Fuckin' bust," he complained. The house shook as the door was slammed back against the wall. "Typical! Broke, like ever'thin' in this kip."

Eddie glanced around the room: his mother was leaning over the stove, staring at the baby's bottle that was standing in a saucepan; the twins were gazing at their hands, playing some finger game, withdrawing into themselves; Philomena was clutching his arm and demanding that he go on with the story from the comic. Her tone had changed now and she was cranky, petulant.

When he looked at the page, he could hardly focus on the words. He was conscious of his father propping himself against the portal of the kitchen door. "Well, well! Is this all the greetin' I get in me own house? I swear to Jaysus."

"Go on readin', Eddie," Mam said.

"'Go on readin', Eddie,'" his father mimicked her; Eddie felt Philomena tighten her grip on his arm.

"You better go upstairs an' sleep it off. I thought you were on manoeuvres all this week."

"You thought, you thought. So, Eddie's back from his wee jaunt in the bogs. The Prodigal Son. Well, are you not goin' to say hello to yer oul' Da?"

"Hello."

"So, now we can kill the fattened calf I s'pose. But you better have a bath an' get the smell of pigshite off you firs'."

He staggered back into the hall and they listened in silence as he trudged upstairs, his boots hammering the bare boards.

"Jesus! I forgot the baby's in our room. I moved him in, in case you wanted to lie down," Mam said under her breath.

At that moment Eddie heard his father opening the door of the big bedroom. He swore about the house crawling with babies and little screaming brats. Then he slammed the door, crossed the landing and pushed open Eleanor's door.

"What do you want, bargin' in here? Get out of my room," she yelled.

"What are you tarted up for, you little hoor? Where do you think you're goin' dressed like that?"

Eddie threw down the comic and stood up. Mam moved to intercept him. "Take it easy, son."

The voices could still be heard upstairs. "Take that disgustin' rag off or I'll take it off for yeh."

"Get your hands off me!"

There was the sound of glass breaking. "Fuckin' bitch!"

On his way out the kitchen door Eddie brushed past his mother. She called after him as he ran upstairs. He fell against the top of the bannister and a pain shot through his arm. The second he reached Eleanor's room his hands were tight around his father's neck.

They both lost their balance and fell sideways on Eleanor's bed. Eddie felt his grip weakening: his father had raised his knees and was pressing them against Eddie's chest. He was pushing his son's face away with the heel of his palm. The pressure became harder, more painful . . .

The same moment Eddie lost hold of his father's neck, he realised Mam was in the room. She yelled at him and pulled him back with one hand; she was holding the kitchen poker in the other.

His father struggled to stand up but she pushed the smoking metal in front of his face, threatening to scorch him between the eyes. There were terrified wails from various parts of the house. Eleanor was sobbing in a corner of the room, clutching her blouse. A glass tray she used for her brooches was lying broken on the floor, its contents scattered.

Eddie tried to calm his mother by placing a hand on her shoulder, but all her attention was fixed on her husband. "Get out of here for once an' for all. I never want to see you in this house again. Or anywhere else for that matter. You've no rights here, good, bad or indifferen'. You forfeited them a long time ago."

His father sat up on the side of the bed, careful not to move in the direction of the poker. "All right, Biddy. I'll go. Put down the poker. Put it down, for Jaysus' sake."

She lowered the poker and ordered everyone out of the room. "Eddie, look after Philly an' the twins. Eleanor, you see to the baby." As Eleanor came to the door of the bedroom, Eddie reached out to touch her but she turned away and edged past him. He heard her going into the bathroom and running water; it sounded as if she was getting sick.

As he was steering Philly and the twins downstairs, he heard his mother cross to her own room and pull out a trunk she kept under the bed. "You've got ten minutes to pack your clothes an' get outta this house. If you're not gone by then, I'm callin' the guards."

"All right, I'm leavin', Biddy." There was less slur in his voice now. "But I'm goin' of my own accord. It's my house you're livin' in, remember, the whole fuckin' lotta ye. We'll talk about this again when ye've all cooled down. An' you've no groun's to be callin' the guards, none whatever."

"I wouldn't be so sure of that," Eleanor said calmly. Eddie had never heard her voice so hard and cold. "There's things could be sworn in court that would put you in deep trouble an' you know what I'm talkin' about."

There was a long silence upstairs and then he heard his mother sobbing: it was that deep, bitter sound he dreaded more than any in the world. He tried to imagine what Eleanor meant.

"Jesus Christ!" his mother yelled, all vestige of control now gone. "Get him out! Get him out of our lives! He's blighted us all. I swear I'll never look at the man again, as long as I live. Never again! I swear it!"

* * *

Mam spent much of the next three days in her room. Even the kids seemed to know not to ask too many questions or make too many demands. There was a hush in the house that no one dared disturb and at night, after Eddie had done his chores for the day and gone to bed to read, he heard his mother and Eleanor talking in low voices in the room next to his.

On the fourth day, Mam was back to her old routines and Eleanor seemed greatly perked up.

"Eddie, wait till you hear. I saw your Ann in town with her Mum this mornin'. I hardly reco'nised her out of her uniform. She's a lovely wee thing I've got to admit."

"Then they must've got back last night," Mam said. "She couldn't have had much of a holiday writin' you all them letters."

"How many did we forward to Granma's, Mam? Fifteen, wasn't it? Not to mention the pos'cards. Tell us, what does she have to say that takes fifteen letters, Eddie? We only got to read the pos'cards."

"Buzz off!"

"'Buzz off,'" Eleanor mimicked him. "I see you're gettin' into practice. Buzz off! Golly gee! Bad luck, old chap!"

Eddie laughed: there was much less malice in Eleanor's banter these days. Besides, he was too excited to care.

"You should hear her, Mam. 'This is my Mum. This is Eleanor, Eddie's sister.' She's that polite! 'Please tell Eddie I'll meet him under the town hall clock at half past two. That's if he has no other plans.' 'You can bet your pants he has no other plans,' I said and she went scarlet. Then Mum chimes in with her funny Dutch accent: 'Why don't you and Eddick come over and play tennis some afternoon? We could easilick make up a foursome. Have you a partner you'd like to bring along, Eleanor?' 'What about Tom Egan,' I felt like sayin'. 'That's if he's not too busy ridin' Brenda Devereux under the railway bridge.'"

Mam clicked her tongue in disapproval.

"It never crosses their minds that we don't know how to play tennis, that we don't have any tennis racquets, let alone partners, an' that we wouldn't be seen dead in short frilly whites, even if we could afford them."

"That's only snobbery. Inverted snobbery, Ann calls it."

Eleanor laughed. "I've been called a lot of things in my time, most of them unrepeatable, but I've never been called a snob.

Things are lookin' up, there's no doubt about it. That's good, inverted snobbery!"

"You better get cleaned up, Eddie, if you're meetin' Ann at half two. And Eleanor, I wish you'd stop wearin' that blue stuff on your eyelids. How many times do I have to tell you, it makes you look . . . common?"

"Jeez, maybe Eddie's right. We're all turnin' into snobs in this house. The last thing on earth I want to look is common. After all, this is the Pearse Estate." And she started rubbing off the blue make-up with some cotton wool, chanting in a posh elocution voice: "How now, brown cow! Take that blue stuff off right now."

The shyness Eddie felt as he walked up the town to meet Ann was a new experience. It reminded him of the way the Belmont lads whispered when the girls came out to the fields with tea and bread. He had thought about her all the time he was away, writing to her nearly every night in the little loft bedroom. He had described for her all the things he had seen and heard in Belmont, even the quieter sensations of listening to the firs and cypresses at night and watching the moon through the oak trees of the big house, with the dogs panting at his side.

Granma had posted the letters every time she walked to the crossroads to do the shopping, and that was mysterious in itself: his mother's mother acting as a go-between. To put himself to sleep over the drone of voices at the fire below he used to imagine the journey each letter made from the time it left his hands to the moment it arrived in Ann's – and then picture her bright eyes scanning his words, bringing them to new life.

If he found himself in a haystack with her now, he was sure he wouldn't be able to resist kissing her, however she might respond.

When she saw him waiting for her under the town hall clock she hesitated for a second and then broke into a run. They buried themselves in each other's arms, soothing away all possible doubts. There were one or two wolf whistles from

somewhere but they seemed unimportant. His whole world was the warmth of her neck and her silky hair brushing his face.

"Let's go for a long walk," she whispered. "Far away from the town. Out to the millstream maybe. Let's be alone."

"There could be a lot of kids at the mill, but we'll give it a try."

"You look great. All tanned and strong. I think you've grown a bit."

"In a month? I doubt it. Would you like me to be taller?"

"Eventually. But I like you a lot the way you are. An awful lot."

"You look great too. But you didn't get as much sun as I thought."

"We spent most of the time in the car, driving here, there and everywhere . . . "

"That's the worst of having a Mercedes."

" . . . and it rained all the time. In Donegal they say if you can see Mount Errigal, it's going to rain . . . "

"I know. And if you can't, it's rainin' already. You told me in three of your letters."

"I suppose I was running out of things to tell you – in words, at any rate." She smiled at him and turned away.

He was right about the millstream: it was teeming with half-clad kids hurling themselves and each other into the turbulent water, so he and Ann left and walked back to the great expanse of the Curragh. She wanted to link arms even more than usual and, in the strange privacy that the open landscape offered them, he felt more at ease holding her close to him than ever before.

Ann marvelled at the stories he told her about the friends and neighbours of his grandparents and asked for more details than he had been able to put into his letters. "So, what do you think was so special about the Mound of the White Bones?" she wanted to know.

"I never found out. I felt very bad that I forgot to ask. Maybe I was gettin' superstitious from all the stuff they told me."

"You're so lucky, you know, to have grandparents like them. Mine are dead on both sides of the family."

"In some ways I'm lucky, I suppose. But . . . "

"But what?"

He told her most of what had happened since he came home, but he left out what Eleanor had said to his father. Ann just held his hand very tight and said nothing.

Then, at some distance from Kildare town, in a hollow far from the drone of the Dublin road, they lay on the grass and he kissed her on the mouth for the first time. Her lips were even softer and more thrilling than he had imagined.

She seemed as excited as he was and they stayed in each other's arms for a long while. To regain their breath from time to time they lay on their backs and stared at the clouds drifting overhead. At one stage Ann trailed her palm slowly over his face, exploring it as a blind person might.

"Look," she whispered, pointing in the direction of their town.

He followed her gaze and noticed the church spire and rooftops outlined against the horizon. It had all the serenity of an old Victorian print. It was hard to believe this was the façade of the squalid steets and alleyways he knew so well, the town's public face. He thought of the walls of graffiti, the children playing in littered streets, the old men and women standing in doorways, their eyes drained of hope.

Then he remembered his mother brandishing the poker in front of his father's face; Eleanor's cold voice when she said there were things that could be sworn against him; and the sound of his father stumbling down the bare wooden stairs and into the street, spitting back curses at the family he had spawned.

Great masses of cloud rolled on indifferently overhead. There is only one world, he wanted to say to Ann; and he wanted to tell Eleanor too and his mother: one grey, tatty, brutal, beautiful world. The fences and barriers between people are imaginary, even the boundaries of time and space, old and young, rich and poor.

But he didn't know how to tell her this or if he really needed

to; perhaps their kissing said it all. She smiled at him and he held her close to him again, pressing his lips against hers and kissing her over and over.

It was almost dark when they started to walk back towards the town. He remembered nights waking from dreams in the loft above the fire, his head teaming with images of Ann lying naked beside him in some barn or outhouse. They stopped walking and he folded her tight against him again while they covered each other's necks and lips with kisses.

Suddenly their desire seemed unstoppable. He lowered his palm and pressed his fingers against her crotch.

"We're not far from the mill," she whispered. "The others will be gone by now. C'mon, let's run."

"The mill? Do you think so?"

"Isn't that what you want? It feels like you do." She was pressing him too, the way he had touched her.

"I do. I do . . . but . . . "

"C'mon. We've got to start some time."

"Are you sure . . . ?"

"Yes, I'm sure. C'mon!"

Later they walked back to town very slowly, stopping many times to kiss and whisper. They laughed a good deal and checked each other under street lamps, brushing away blades of grass that clung to their clothes. The town hall clock was chiming eleven when they reached the gateway of Ann's house.

"Will you get into trouble for being so late? You've been out for nearly ten hours, you know."

"Maybe," Ann said. She didn't seem at all worried; she was smiling at him, her eyes full of contentment.

"What do they think of you going with me?"

"They pretend not to notice."

"How do you think they feel?"

"I try not to think about that. What does it matter? We've got to rise above that kind of thing and do what we think is right. It's our world too, you know."

"They must have noticed all the letters. Everyone knows everything about everyone in this town."

"I wonder do they. For example, who knows about you and me tonight in the mill?"

"Nobody yet."

"Nobody ever. Except us."

"It only takes one pair of eyes. Some little creep like Mouse Morrissey. And then it's everywhere."

"What are you worried about, Eddie?"

"I suppose I'm afraid your parents'll hear something, or put two and two together, and then try to drive a wedge between us. We were probably safer before this, swoppin' books and stuff and walkin' about in the daylight. They could hardly object to that."

In the light from a street lamp he saw a shadow pass over her face. "You never talked like this before, Eddie. I thought you trusted me. If you really love me, you've got to trust me. It's what I think that counts, isn't it? Not what my father and mother think."

"I know, but . . . "

"Eddie, I don't feel any different because of what you told me about your father. If anything, it makes me love you more. And besides, I don't know about you but I'm not going to stand quietly in a corner and let my parents make all the running. I intend to teach them a thing or two as well. Now, go on home and stop worrying about nothing at all. I'll meet you tomorrow at the clock. Same time. But probably not for quite so long."

"OK."

"Well, go on."

"I was just wondering."

"What?"

"Us. We're so young. And yet it doesn't seem wrong."

"Why should it? Romeo and Juliet were only fourteen."

"Were they? Phew! That's a relief."

She laughed. "And if it's any comfort to you, I've read all my Dad's books about safe periods and unsafe periods, so you needn't worry about that. At least, not this time."

"You mean, we might do it again?"

"Go on, you chancer. You're just kicking for touch."

"How did you guess?"

Then, after one of their new unrestrained kisses, she tore herself away and ran up the driveway towards her house.

As he walked towards the centre of town, Eddie carried Ann's image with him and the warmth of her touch all over his body. The craving that had overwhelmed him earlier had been calmed: in its place there was a new feeling, a sensation of extraordinary lightness and strength. He felt ready to face any challenge.

Ann was right: it was their world and they could shape it whatever way they wanted. They could break it down and rebuild it to suit their needs. They were not compelled to live chained to the prejudices of parents or teachers or the generations who had gone before them.

Of all the people he knew perhaps his grandparents would understand best what he meant. He would have to teach Eleanor not to give in, not to become a slave to dark fears. And his mother as well: she would have to go to Belmont and be reconciled. Only then would she realise her own worth.

On the way through the centre of town he saw Tom Egan and his friends chatting up some girls outside a pub. Egan was leaning on the handles of his bike and acting it up, especially for the benefit of one girl. She had long blonde hair wound into a crown on her head; her eyes were heavily made up with mascara.

Eddie noticed that her blouse was open lower than those of the other girls and she was drinking from a beer can. She laughed a lot and at one stage playfully spluttered some beer in Egan's face. When he reached out and pulled her towards him, she folded herself seductively into his arms, fingering a pendant that hung from his neck and slipping her other hand inside his shirt. Then Eddie saw her lick the beer from his cheeks and eyelids – just as his grandparents' dogs had licked the tears from his face the day he left Belmont.

He turned down a side road and took the long way home to avoid witnessing any more of Eleanor's surrender.

1966

Chapter Five

CORMAC WATCHED A fly circling the light bulb of his bedroom. After a while it transferred its attentions to the skylight and he stood on his bed to let it out. While he was there he checked the neighbours' garden.

Despite his earlier reservations about the Lindeman tennis games, his attention was being drawn more and more in that direction. Imelda Lindeman was turning into one of the most beautiful girls he had ever seen and the transition was taking place under his gaze.

Her tennis was blossoming too. She competed these days with more adult opponents and Cormac never tired of watching her rise high to deliver a rasping serve or dart from the service line to the net in anticipation of a good return.

He frequently imagined himself jumping over her garden wall to press into her hands a copy of *The Spiral Staircase* – a school publication in which he played an editorial role by dint of his friendship with McEldowney. In these reveries she always received him graciously, dropping her racquet and throwing her arms around his neck. *I've read your poems already*, she would say, referring to his sonnets in the magazine, and lead him off to some shady nook. *I can't tell you how thrilled I was when I realised they were about me.*

Then he would recite some of his favourite lines:

> "The nectarine and curious peach
> Into my hands themselves do reach;
> Stumbling on melons as I pass,
> Ensnared with flowers, I fall on grass . . ."

This fantasy had been prompted by an actual event the previous summer. From his perch in the tree above the roof of the lawnmower shed he had seen Imelda beating about in a laurel bush as she searched for a lost ball. Then, when she thought no one was watching, she removed her white tennis top, dried perspiration from her shoulders and breasts, and replaced the flimsy garment inside out. Only by clinging to the branch of the sycamore had Cormac stopped himself falling headlong on to the shed roof. "Coming!" she had called out when Maurice ordered his mother to see what was keeping her.

"Just a minute!" Cormac called downstairs when he heard Aunt Maeve asking Leonie to knock on his door.

He was still thinking of Imelda as he splashed his face in cold water at the bedroom sink. What would she think if she knew he was pining for her day and night? And how would she react to the kind of approach he had in mind? Apart from McEl D's Marxist-Leninist rantings in *The Spiral Staircase*, she might take exception to the over-explicit language of some of Cormac's sonnets – laced as they were with erotic tennis metaphors, such as "desire's half-volleyed body shot" and "the top-spin of ecstasy".

It was just as well, he thought, looking for reassurance in the mirror, that he had addressed them to an anonymous beauty, "The Pale-limbed Leda of the Laurels" – though he might have chosen a less transparent pseudonym than Cornelius Mann.

McEldowney and Cormac had become close friends the year a polio case had been discovered in the boarding school. One of the juniors went down with the disease during the second term and the school was suddenly awash with medical inspectors in white coats and a strong smell of disinfectant. A quarantine was imposed and while it lasted there were no parcels or visits, even though the boarders were kept in the school right through the Easter holidays.

McEl D's verdict was that the whole thing was a Jesuit plot. Who was to say that the men in white coats weren't Curia spies? Or agents of the Spanish Inquisition, Cormac suggested with an irony that went unnoticed.

The polio quarantine was a strange, unreal time, boarding school without the usual class and study routines and with a smell of DDT in all the corridors. Whenever the boys entered or left the buildings, they had to disinfect the soles of their shoes and wash their hands with a foul-smelling soap. Even games were suspended, since physical exertion, it was claimed, might leave them vulnerable to infection.

Everything took on a new significance. Prayers were imbued with the notion of disease as a warning from God. Or as a symbol of the moral debilitation resulting from the sins of the mind and the body that boys were prone to. And when the school Rector prayed – *beseeching Awr Lawrd who died on the cross to rise up again and come with his army of saints and redeem us from awr sins* – Cormac had visions of Jesus in a white coat, working healing miracles from the back of the Corporal's jeep.

He spent much of this interlude compiling *A Personal Diary and Record of the Plague* in the style of Samuel Pepys and trying to compose Miltonic sonnets, most of which were about disease, unrequited love and the transience of friendship. ("The bonds of love are frail as silk," he wrote in one of his poems, "and frailer than a spider's thread . . . ")

To distract himself from all this gloom Cormac helped McEldowney produce his newsheet and was rewarded with the title of co-editor. They printed it surreptitiously on the teachers' Gestetner and distributed it free each month as an alternative to the official school bulletin. Their main obstacle was the sneering derision of their schoolmates, dedicated as they were to the allied pursuits of rugby and locker-room jokes.

In time Cormac imagined himself becoming a major poet and a celebrated champion of the poor. After years in the wilderness he would win recognition as a great visionary: his role would be

one of bridge-building – between rich and poor, art and science, socialism and spirituality. His destiny was as a kind of civil engineer of the spirit, his reward Imelda turning her head on a pillow and saying, *I'm so proud, Cormac. I know you did all this for me.*

In preparation for this calling no challenge was too much. On the Twelfth of July the previous year he and McEldowney had taken a bus to a working-class area on the outskirts of Belfast and stood at the gateway of a rain-drenched field handing out copies of *The Spiral Staircase.* As marching Orangemen approached to the accompaniment of pipes and Lambeg drums, Cormac's knees began to shake: he even tried to hide his copies of the magazine and look as if he just happened to be passing.

But his companion seemed fired by the challenge. A small band of purple-faced youths gradually gathered around them, prompting McEl D to launch into a blistering tirade against the sectarian polarisation of the Irish working class. Cormac eventually mustered enough courage to give a short speech, echoing his comrade's sentiments – but his southern midlands accent, rather than anything he had to say on the subject of capitalism north and south, generated such animosity in the crowd that he and McEldowney had to rely on two officers of the Royal Ulster Constabulary to spirit them away to safety.

That evening, after an RUC patrol car had dropped them in the sanctuary of the Malone Road, McEl D unashamedly relished the scent of jasmine and lavender in his father's garden. "It just goes to confirm, Comrade, that you can't force the pace of history," he declared. "Progress responds only to the drumbeat of fear."

Cormac found Aunt Maeve in the dining-room poring over a folder of property papers and other legal documents – the kind of material that would have provoked stammering apoplexy in McEldowney.

"Good morning, Lazarus," she said, glancing at the gold watch she wore suspended from her neck. "You didn't really imagine you'd find breakfast being served at this hour?"

"No. I just came in to say hello."

"I suppose you'll be off for a canter first thing."

Cormac sat at the table opposite her and looked around the room. "I don't think so. I want to get my bearings first."

"I hope you're not cooling off the riding. It costs us a pretty penny to keep the mare, you know."

"I'm glad you've kept her, very glad. I just don't feel like a canter right now. I can't get over the improvement in Uncle Frank. How is he this morning?"

"Fine. I heard you two chatting till all hours last night. Did you ever think he would regain so much of his speech?"

"It's great. I hope I didn't tire him out."

"There's nothing he loves more than to hear all your news. What were you talking about?"

"Oh, not much really. I told him about school. He talked about his childhood in Belmont. He seems a bit upset about the situation there."

"Yes, since his mother died it's all come flooding back. All the old memories." Her tone was impatient, as if she had little time for nostalgia. "I thought of taking you out to attend the funeral, but you were just back in school and I didn't want to disturb you."

"I'd like to have attended the funeral . . . for Uncle Frank's sake."

"There was no point. You hardly knew poor Maureen. And besides, Frank was just starting the new medication at the time. I had too much on my hands." She was leafing through papers and tapping them into piles like decks of enormous cards.

"Are you working on a new property deal?"

"Not exactly a new one. I have to tidy up things at Belmont if we're to put the place up for sale. Most of the deeds and leases are in a dreadful state. Maureen was not an astute business lady, I'm afraid."

"She seems to have been very popular."

"Yes. I'm sure she meant well, letting the tenants accumulate backlogs of rent, but she may have done them and the estate

more harm than good in the long-run. Anyway David Lindeman is coming here this morning to help me with the papers."

"Imelda's father?"

Aunt Maeve glanced at him and smiled. "Yes, and Maurice's too, by all accounts."

Cormac felt his face glow. "Of course. Maurice and Imelda's father. That's what I meant."

"You might think of getting to know them better this summer. You've been a bit stand-offish in the past."

"Funny, I was thinking the same thing."

For a moment his head was awash with laurel bush images and he was only dimly aware that Aunt Maeve was listing off other "nice families" he could get to know.

" . . . and then there's the Donovan family. They have a lovely daughter, Ann Marie. But you know her, of course. David tells me Imelda has become very friendly with Ann recently. Why don't you and Maurice make up a tennis foursome with the two girls? Do you want me to arrange it?"

Cormac thought of the peevish Maurice and shuddered. "Well, if you don't mind, first I want to . . . maybe look up one or two friends . . . boys of my own age that I've lost contact with since I left the local school."

"I see." His aunt looked at him for a moment and then returned her attention sharply to her papers. "Eddie Dwyer, no doubt."

He stood up to leave. "If you like I'll ask Leonie to bring you a cup of tea."

"No, thank you."

He paused at the doorway. "Aunt Maeve?"

"Yes?"

"Could the backlog of rents in Belmont not simply be written off?"

"Written off?"

"Yes, as a bad debt, you know . . . so the tenants could start again on a clean sheet."

She held a fountain pen between her two palms and stared at it as she spoke. "Would that things were as simple as that. The

fact is, Cormac, that money is needed for the upkeep of the estate. If that money isn't there, then everyone's welfare is at risk, our own included."

"But, couldn't you . . ? I don't know. Is there not some way . . ?"

"I'm trying to sort it out so that those who are most fit and active can stay and work the land, while the people in need of health care and other facilities can be moved into town where these things are available. That would make the whole place more viable, don't you think?"

"That seems . . . reasonable, I suppose."

"Well, so it is. Don't sound so surprised."

The Commandant was sitting in the conservatory surrounded by potted geraniums, a copy of the *Irish Independent* on his knees. His eyes were fixed on an angry-looking bee banging against one of the windowpanes. Cormac opened the window and the bee soared out; it was his day for releasing insects, he thought.

"Good morning, Uncle Frank." He extended his hand for the customary handshake but his uncle held it a little longer than usual. "Is there anything wrong, anything you need?"

The Commandant glanced in the direction of the dining-room and pointed to the door leading to the garden.

The wheelchair made a crunching noise on the gravel as Cormac steered him around to the sunny side of the house. "I'm sure you need some air. It can get stuffy in there with all those geraniums."

"Funny smell," his uncle said, twitching his nose. "Cow's piss."

Cormac sat on the grass between the wheelchair and a large hydrangea. They were on a raised part of the terraced garden, looking down on the tennis court where the Commandant and Aunt Maeve had engaged each other in battle a year before. After its hibernation in the lawnmower shed, the net was back in place and Seamus had obviously been at work with the old line-marker; even the metal posts were freshly painted.

"I think he wants a replay."

"'Vice versa!'" the Commandant chuckled.

"I don't suppose you've played since."

"Not much." He swung his arm. "Knock-up, that's all. No game without you."

"I was only the legs."

His uncle shook his head. "No game without you."

"Perhaps we should organise another one – to entertain Seamus and Leonie, if nothing else."

"Maeve too busy. Belmont business."

"Yes."

"Sad. Sad." He shook his head again.

Cormac didn't understand: he hadn't noticed anything sad about the plans Aunt Maeve had outlined to him. "She tells me she's trying to sort it all out so the estate doesn't fall into rack and ruin."

"Good place. Good people. Very sad."

Leonie had been sent over to nurse the old lady for a while before she died and she had told Cormac a little about Belmont. But she hadn't said anything about people being upset.

"What people are sad?"

"Old people. Farmers. Lease land all round. Now farmers out. Maeve wants people out."

"But I've just been talking to Aunt Maeve. She says she only wants to save the place by rehousing the older tenants who can no longer work the land. It's for their own good."

The Commandant shook his head and grew so agitated that his speech was further impaired. "Vict. Vict."

"You mean, she plans to evict them?"

"Vict them. Yes. All out."

Cormac said nothing and thought about what he was hearing. Was Aunt Maeve acting on her husband's behalf or taking advantage of his condition to do things her own way? Perhaps she had painted a benign picture of what she was up to just to keep Cormac at bay.

For all his military formality, there was something humane about the Commandant and Cormac recalled how he had been

devastated by the tribal and land conflicts in the Congo. His letters home had been full of the poverty and injustice of it all. It was hardly likely that he would approve of evictions from his own ancestral lands.

But it was always possible that his uncle was raving. Sometimes it was hard to know what his state of mind was and whether he was capable of rational thought at all. It often seemed that his isolation was driving him to extremes of anxiety and that he was directing more of his bitterness against his wife than she deserved.

"Are you worried about what Aunt Maeve will do to the Belmont tenants? Is that it?"

The Commandant nodded. "Worried. Yes."

"But surely in this day and age their rights are well protected. By the law, I mean."

"Law's an ass. Law's an ass." Then he uttered another word which Cormac didn't catch at first; it sounded like "edition."

"Tradition," he guessed at last. "You mean they have traditional rights. Surely their leases will . . . "

His uncle shook his head. "No leases. No paper. Go there. Go there. Talk to Maeve."

"But they must have squatters' rights at the very least."

"Talk to her. Go over. Find out."

"She's getting advice from Mr Lindeman. Won't that clear the matter up?"

"Lindeman horseshit," he replied, slapping the arm of his wheelchair. "Horseshit Lindeman. No balls. Under her thumb."

"So, what do you think I can do?"

"Talk. Go there. Argue."

* * *

"What do you want goin' to Belmont for?" Leonie demanded the next morning.

"I just thought I'd have a look at it, that's all."

"I s'pose the Comma'dan' put you up to it. He's got a bee in his bonnet about that place so he has."

"What makes you think that?"

"He sent me over there to nurse his mother, God rest her soul, for the last few weeks of her life – but she already had a nurse. I think he was up to somethin' but I'm not too sure what."

"What could he have been up to? It's his property after all."

"I know it's his property, but your auntie's talkin' more an' more like she owns it. It was his idea I went over there an' he had me visitin' people all over the place an' seein' how they were gettin' on. I didn't like snoopin' about an' it didn't make me too welcome in some quarters either. Still, he paid well for th'information I brought back, harmless an' all as it was."

After breakfast Cormac borrowed Leonie's bike and set off for Belmont. When he left Drumaan, he took a series of by-roads past stud farms and country estates and cycled through miles of the greenest pastureland he'd ever seen. There was a light breeze and the birds seemed to cheer him on.

Aunt Maeve had driven him over to see the Commandant's mother once, but that was a long time ago. He remembered the old woman huddled in the drawing-room of an enormous house, shaking her head about her son's condition and saying she knew he should never have joined the army. Cormac spent the day snooping about the house and garden. When he was leaving with his aunt, the old lady beckoned him over to her and pressed a five pound note into his hand.

She used to come to Drumaan at Christmas time, driven over by a sour-faced steward who managed her estate. He was a dark, sullen man who sat in the kitchen of Aunt Maeve's house staring at Leonie. Once, when he reached out to grab her, she gave him a sharp blow on the head with a saucepan. After that, whenever he drove the Commandant's mother to Drumaan, he turned down Aunt Maeve's offer of tea and sandwiches in the kitchen and sat waiting in the car.

Gradually, as Cormac cycled on, the landscape began to darken. Soon a vast expanse of bogland stretched to the horizon on either side of him and for long stretches there was no birdsong, just the incessant buzz and hum of insects. He cycled

past empty farmhouses and byres – monuments to the bankrupt policies of successive governments, he thought, planning how he might describe the scene in an editorial for *The Spiral Staircase*. But at heart he felt an elegiac poem along the lines of *The Deserted Village* might be more appropriate. It might begin with an Eliot-like cry of despair: *What are the roots that clutch, what branches grow . . ?*

It was noon before he found Belmont, an island of rich grazing land and barley fields with clusters of trees all around and a large fir plantation on one side. Here and there on the roadside were small artisan cottages built of the same cut stone as the great manor that presided over the area. From the highest point he could get to, he looked back the road he had come and the bog stretched out on either side like a dark ocean.

The windows of the manor house were shuttered and there were chains and padlocks on all the entrances to the grounds. An auctioneer's "For Sale" sign, with the name and telephone number of David Lindeman's firm, had been bolted to the main gate.

Some men and boys were working in a field near the estate, walking behind a horse-drawn cutter and raking the hay with large wooden rakes. They watched Cormac cycling up to the gates but, as soon as he turned towards them, they went back to their labours. Shortly afterwards three men passed him on their way to the plantation, but they didn't glance in his direction.

When he cycled to the gate of a cottage to ask for a drink of water, two scrawny mongrels bared their teeth and growled at him. He was about to leave when an old woman came out and asked him what day of the week it was. She scolded her dogs and locked them into a haybarn. Then she went inside and returned with a mug of strong tea and some thick slices of buttered bread.

Cormac sat on a wall and asked about Belmont. He was writing for the school magazine, he explained, and he'd heard it was an unusual place.

"It's unusual all right," she said. "The people that lives here

hasn't los' sight of theirselves yet. They still know who they are anyway."

She told him the history of the area, describing how the family who owned it had developed the land over many generations and stood by their working folk, not like many of their kind; but now, she said, by a sad twist of fate, that was all coming to an end.

"Why is that?"

"For one thing, the lan' has not the same need for people any more; it's all machinery these days. But besides that, the last of the Connollys was never blessed with a son an' heir. No chil' of any description."

It was a strange shock for Cormac to have this said to his face: had he been a son of the Commandant's, or even a distant blood relative, he might have been expected to take on the role she was talking about. But he was outside the fold, not worthy of the task.

"Maybe some good buyer will be found," he said. "Someone who'll keep it as it is."

The old woman then told him about a Swiss businessman setting up pig farms throughout the country – "unnatural farms, more like factories than an'thin' else if y'ask me". He had been prowling around the place a lot recently and word had it he was to be the next owner. Needless to say, the local people would be the last to be told.

She rambled on for a while, telling him anecdotes and legends about the place, and confessing she was worried for the future; everything and everyone was being swept away. Her own two daughters had left many years before and put down roots in different places; they had families of their own to think about and had lost all connection with Belmont.

When Cormac asked if her husband was out working in the fields, she told him he had died some months before. But she was used to fending for herself and if God was kind he would take her soon too. As she started indoors he offered to pay her for the tea and bread, but she shook her head and smiled. "This is Kildare,

the County Kildare. God bless you, son. Come an' see us again sometime. An' in the meantime don't print an'thin' too hard about us in that paper you're writin' for."

The men and boys he had seen working in the field were sitting down now, drinking tea and smoking, and there was a peace about the place that reminded him of his old home in Westmeath. He thought of going over to talk to them, but how would he introduce himself without revealing who he was?

As he cycled home, he wondered what possible benefit had been gained from the trip. If the Commandant wanted to argue the Belmont people's case with Aunt Maeve, why didn't he do it himself? He raised his eyes and looked at the bog road ahead: soon he would be back in safer terrain and could turn his mind to greener thoughts again.

When he told Aunt Maeve where he had spent the day, she glanced at the Commandant before answering his questions.

"Over the years the rents, even when they were collected, barely covered the cost of keeping up the estate. We've simply got to rationalise the situation, that's all there's to it."

Leonie was standing beside her, holding a silver dish of braised ham. Aunt Maeve placed a few slices on the Commandant's plate and some on her own. Then Leonie came and stood beside Cormac.

Aunt Maeve continued. "Yes, there is a buyer. Or, rather, a potential buyer, but understandably he's insisting there are no complications on the leases before the sale goes through."

"Complications?"

"Yes. If that means freeing the estate of some of its remaining encumbrances, then so be it."

Cormac thought of McEl D's face – a mixture of horror and triumph. "It all sounds a bit like eviction," he said, glancing at his uncle for support. "Is that possible in this day and age?"

Leonie set the meat dish down on the sideboard before starting the same round again with a selection of vegetables.

Aunt Maeve spooned some French beans onto the

Commandant's plate. "That depends on the terms of the contracts. That's where David Lindeman's advice is so vital. It may be simply a question of stepping up the rents to a rate that compels people to move. At the moment they bear no relation to the market value of the land."

"Would many people be forced to move?"

"Not many. Just the tenants who are old and unproductive. They had a special relationship with the Connolly family, mainly because Frank's people were prominent nationalists, you know. Two of his uncles were imprisoned in the Curragh during the War of Independence." The Commandant nodded slowly to confirm this information.

Thank God for the National Struggle, McEl D had declared ironically in his Belfast oration. *It keeps the working-class off our backs.*

Aunt Maeve continued. "One of the tenants, to give you an example, is a widow in her eighties. By all accounts she's senile and quite incapable of looking after herself. The plan is to rehouse her and others like her at a low rent in a council housing estate in town."

"But why?"

"Our buyer is a man who intends to revitalise Belmont by bringing in continental farming techniques. It's in the long-term interests of the country that we forge ahead with this kind of sale. We've got to import the latest production skills or we won't survive in the modern world."

Cormac was conscious of Leonie setting the vegetable dishes down on the sideboard and leaving the room. He looked at his uncle whose whole attention seemed fixed on the trembling hand raising food to his mouth: he clearly had no intention of joining the fray.

"Do you think it's right to move an old woman like that? She's probably spent her life in the country. Putting her into a council estate would be . . . like caging a song bird."

"We can't afford to be sentimental, Cormac. We've got to think of progress. Time moves on. We're part of the real world now. Look at your uncle: he was injured serving with the United

Nations in Africa, not fighting in some . . . parochial skirmish. God knows this country was stifled long enough by backward-looking policies and sentimental attitudes."

"I know all that, but this is a special situation. When you go out there and see these people, they're not just statistics on a piece of paper. They're not sheep or cattle to be herded about the country. I've spoken to them, for God's sake. They're human flesh and blood."

Aunt Maeve set down her knife and fork and said nothing for some moments. When eventually she spoke, her tone was cold and formal. "You're very young, Cormac, young and impressionable. You live in splendid isolation from the realities of life . . . no, let me finish. I'm responsible for the economics of this household and they include your education, your food and clothes, the mare, and even your trips to see your father and sister in Westmeath."

"Aunt Maeve, that's not fair. I didn't ask . . . "

"Cormac, don't interrupt me. All I'm saying is that the things I do and the things I propose to do, whether you like them or not, are for your good and for your uncle's. I'm not doing this on my own account, do you understand?"

"Yes, I do understand. But I think . . . "

"Before we hear yet again what you think, let me tell you what I know. I know that it's more charitable to rehouse those old people than to leave them out there, cut off in the wilderness. They need nursing and modern health-care, the kind of attention they can only get in town. Many of them are living in dreadful squalor at present. They know nothing about hygiene. Do you think that's as it should be?"

"Have you asked them what they want?"

Aunt Maeve sighed. "Really, Cormac, don't be so naive. We didn't give you a choice when we decided to take you away from the Brothers and send you to a more suitable school."

"I was a child . . . "

"You're still not much more than a child and I wish you'd remember it. Do you think we should give Leonie a choice as to

what room she should sleep in or when she can come and go? We have responsibilities and we must honour them. If we rehouse the older tenants for their own good, then we can divide their holdings and share them out among the remaining younger people: that will help them meet the rent increases. Can't you see, it makes sense from everyone's point of view? Now really, I don't want to hear another word about this, ever again."

Cormac looked helplessly at the Commandant but his uncle just sat there, fidgeting with a napkin ring and saying nothing.

After a while Aunt Maeve lifted the bell and rang irritably for Leonie. "What's keeping that wretched girl? Sometimes I wonder if she spends half her life in a trance. I'll obviously have to talk some sense into her too."

He went to the stables and spent some time smoothing the mare's coat with a stiff brush. The brush strokes worked off some of his frustration. Why had his uncle not said a word? Why had he not come to his rescue?

How could he ask Aunt Maeve to keep paying a groom and having the mare exercised at the expense of the people he had seen at Belmont? If he told her to sell the horse, it would make the point that he really cared; and then he would have to refuse to go back to the boarding school and insist on taking work in some local stable or factory. All that would surely make her sit up – and it would be a fitting gesture for the co-editor of *The Spiral Staircase*.

But, in the end, would it make any difference? Aunt Maeve had used the mare and his other expenses only as an argument. She would sell the estate no matter what Cormac said or did. McEl D and his mentors were right: individual freedom is an illusion; we are all part of the caste system and march to its silent drumbeat.

He stroked the mare's face and nose, and fed her some extra oats. She was a little overweight, he thought, but that would go after a few weeks' exercise. He remembered the exhilaration of riding her out in the early mornings when the jockeys and

grooms were taking their leaner mounts to the Curragh; he remembered watching the steam rising from the horses' flanks as they all cantered across the plain in the sharp morning air.

It was better to turn his mind to such things; and to plan how he was going to approach Imelda. If only he could let her know how he felt about her and some of the plans he had for them to run off together . . . maybe even set off some morning on horseback . . .

But maybe not: maybe that would stun her into silence, just as his uncle seemed to have been struck dumb by his outburst with Aunt Maeve.

He left the stable yard and went down the laneway into the field behind Lindemans' house. The first crows were returning from their day's foraging and circling the elm trees. It was a warm evening and he lay on the ground to watch them.

He dozed for a short while, his legs stiff from the long bike trip that morning. He only gradually became aware of voices drawing near him on the other side of the garden wall.

"Imelda," a girl was saying. "I really don't understand it. Read it again."

"All right." There was a rustling of pages.

> "'The second song began in May;
> Your laughing eyes . . .
> Your nakedness without shame . . . '"

"I like that," Imelda's friend said and laughed. Cormac knew that laugh but couldn't quite identify it. "'Nakedness without shame'."

"Am I to go on or not?"

"Go on. I'm just repeating the bits I understand."

He recognised the voice: it was Ann Marie. The wind strengthened and he found it difficult to hear everything they said.

> "'Our lips met and set the woods aflame
> As if the day was witness . . . game;

And all winter long . . . said
The dark child in you had turned away and fled.'"

"It's beautiful, Mel, even if I don't know exactly what it means. Did you say Martin sent it . . . ?"

"Yes," Imelda replied.

"Martin Keane?"

"O Ann, . . . the most wonderful man . . . We really had such a fabulous time . . ."

"Did he write it for you?"

"He sent me a book . . . You've got to meet him. He's done great work . . . poor people all over the world . . ."

"It's the most romantic poem . . . I wish Eddie could . . . "

The voices faded away and all Cormac could hear were the crows screeching as they hovered over their nests in the elms. He stayed where he was until it was almost dark and his clothes were moist with dew.

* * *

"You look very gloomy today," Leonie said, watching him as he dragged a spoon in his cereal bowl.

"Do I?"

"I hope you're not comin' down with some bug."

"I've just got a bit of a cold, that's all."

"You don't want ridin' out and gettin' into a lather of sweat, so. That'll only make it worse."

He stood up from the table and realised he was dizzy. Still, he wanted to be out of the house, so he walked to the stable and saddled the mare. Once or twice he had to lean against her warm body to steady himself.

"You're not dressed properly to go out riding," a soprano voice piped in his ear and he turned to see Maurice Lindeman clinging by his elbows to the half-door.

"I'm only going to take her for a walk today, Maurice. I don't feel too well."

"Can I come some of the way?"

"If you like. But you'd better get your mother's permission first."

"Gosh! Thanks, Cormac." He slid from view – but almost immediately there was a scrambling noise and the white face was back in the doorway. "Will I be able to ride a bit?"

"Sure."

"Wow!"

He disappeared again and Cormac heard him running excitedly out of the yard. By the time Cormac was trotting the mare towards the field, Maurice had reappeared wearing a riding hat which kept sliding over his eyes. He dragged the field gate open and Cormac cantered the mare a little to work off her friskiness. The air revived him and he felt less dizzy. Then, when the horse had settled down, he dismounted and called Maurice over.

"You'll have to show me what to do. I've never ridden this big a horse before."

"First, let's see if we can get that hat to sit still on your head."

"It's Mel's actually."

"Is it? I didn't know she could ride."

"She's having lessons in her new school. She's lucky, isn't she?"

"She's very lucky. And so is her tutor."

Cormac spent the next hour teaching Imelda's brother the basics of riding – how to mount and sit, how best to hold the reins and how to use his thighs and heels to exert control. To his surprise Maurice turned out to be a good pupil, willing to overcome his nerves without being reckless, and soon he had the mare trotting up and down the field with Cormac jogging ahead holding the reins.

"Gosh, Cormac! This is great. Do you think we could do it every day?"

Cormac looked up at him and gasped for breath. "I doubt if . . . I'd survive. Down you get now . . . the way I showed you, mind."

"Maybe this will help," a gentle voice suggested.

Cormac spun around and saw Mrs Lindeman approaching with a tray of orange drinks. He glanced at the open picket gate behind her but there was no sign of Imelda.

Mrs Lindeman was a tall woman with fine features, not unlike her daughter's. She smiled a lot and brushed her hair back in a girlish manner. Cormac examined her face for glimpses of Imelda in years to come.

She laughed nervously. "I feel a bit like I'm in an ad."

Cormac realised he had been staring at her. He took a glass and thanked her.

Maurice continued stroking the mare's forehead as he gulped down his drink. "Maybe she'd like some too."

"Who?"

"The mare. Her name's Sarah, Mummy. Isn't that a nice name for a horse?"

"Mind she doesn't chew the glass, dear. Hold it away from her nose. Cormac, you're very kind to devote so much time to Maurice this morning. I hope he thanked you."

"He did, Mrs Lindeman. Many times. He's a quick . . . learner. Soon he'll . . . be able . . . "

For some reason Cormac was finding it difficult to speak. Was he really standing there, talking to Imelda's mother? The ground seemed to be shifting – just as it had one day long ago when his uncle's riding boots shuffled towards him out of a wardrobe. He looked to the elms for stability.

"Sorry, Mrs Lindeman. What was I saying?"

"You said 'Soon he'll be able . . . '"

"Yes. He'll be able to ride . . . by himself."

"Wow, Mum! How soon, Cormac?"

His mother intervened. "Not until you're really quite used to controlling her, pet. Isn't that right, Cormac?"

Cormac nodded but he was unable to say anything: the field and its occupants were now swaying in a sickening motion. Even the trees were lurching.

"Cormac, are you feeling all right? You look very pale."

"I'm fine. But I think maybe . . . maybe I'd better . . . go and get changed."

"Yes, it's quite chilly. You'd never think it was the month of June. Are you sure you're feeling all right?"

"I'm fine, thanks, Imelda . . . I mean Mrs Lin . . . Fine."

He led the mare home with Maurice in the saddle and, after he had removed the tackle and Maurice had clambered up through the trapdoor to fill the manger with hay, he walked to the house and dragged himself up to his room.

He slept fitfully for some hours and only got out of bed when Leonie peered in to see if he was coming down for dinner. She told him Aunt Maeve had spent most of the day with David Lindeman, reading documents and talking about how to get the people off the land at Belmont.

She was polishing the hall mirror by the time he came downstairs. At first she was unaware of his presence behind her on the staircase; she stopped polishing every now and then and looked in the direction of the dining-room door. Cormac became aware of voices and realised she was eavesdropping.

"Well? What have you found out?" he asked.

She spun around and then gestured for him to lower his voice. "I'm on'y doin' what the Comma'dant asked. He's afraid they're plottin' somethin' behin' his back."

"And he asked *you* to spy on them? I find that hard to . . . "

"Ask him yourself if you don't b'lieve me."

"So, do you do everything he tells you to do, or just the things you fancy doing anyway?"

Leonie spun around again and slapped him hard in the face. As he reeled back against the wall, she turned and ran down the short flight of stairs to the kitchen.

"What's wrong?" Aunt Maeve demanded, opening the dining room door. "I thought I heard a crash."

"No, Aunt Maeve. I . . . just slipped on a mat, that's all. Sorry if I disturbed you."

"Well, thank heavens nothing's broken. Try to be more careful, Cormac, for heaven's sake. David, this is my nephew; this is Mr Lindeman. I don't believe you've ever been introduced

before. I was just saying to Cormac how nice it would be if we all had a little get-together, a garden party maybe . . . "

Cormac said little during the evening meal and afterwards walked slowly down to the stable to feed the mare. Stroking her neck, he whispered that he realised he had lost Imelda for good; someone had moved in to fill the gap left by his indecision. The horse blinked her enormous brown eyes. "It's no good," he told her. "She's obviously in love with this Martin bloke. He travels the world feeding the starving millions and writes much better poetry than I do."

The mare dragged wisps of hay through the bars of the manger, pulling her head from side to side as if to say *I can't give you much in the way of advice on these matters. But I'm all ears, if that's any good.*

"And to make matters worse," Cormac went on, "I've gone and offended Leonie into the bargain. I don't know what got into me. Anyway she flew at me and slapped my face."

The mare seemed unimpressed with this catalogue of woes and Cormac left the stable yard still deflated. The crows were reconvening on the elm trees and he followed them down to the field and leaned against the metal gate. At about the same time as the night before he heard voices from the Lindeman garden. He turned to leave but something Ann Marie said stopped him. She was talking about Eddie. Something was wrong.

"Where is he working?" Imelda asked.

"The County Bacon Curing Plant. You know, out past the railway bridge, near the handball alley."

"You don't mean the abattoir. Oh no, Ann, he's not working there?"

"He has to. His family's so poor. Do you think he's too ashamed . . . Sometimes I think he can't handle . . . he's always asking what my parents think . . . "

Again the voices faded below the level of the crows and Cormac stayed still a while, thinking about what he had heard.

<center>* * *</center>

"I think it's time I made another attempt to track down Eddie Dwyer," he told Leonie the following morning. He was still shaking, but not as dizzy as the day before.

There had been no reference to the slap but she was stamping around in a more sullen state than usual, even for a washday. She was carrying a laundry basket out to the garden but stopped suddenly and came back into the kitchen.

"Tell us, for once an' for all: why did you never stay friends with Eddie Dwyer?"

"Why do you think?"

She set down the basket. "Then you know who he is. I guessed you had to know."

"Even before you read it in McEldowney's letter." She looked at him blankly. "I've known ever since the day you sent me to his house. Maybe you remember that."

"I tried to make it obvious a few times, but it was like talkin' to a wall. You didn't wan' to know, I s'pose. An' I didn't wan' to spell it out."

"I was slow enough, I admit."

"Well, if it makes any difference, it's all over between me an' Bill, this long while back."

There was nothing to say to that, so Cormac stood up to leave.

"You'll find Eddie at the han'ball alley. He goes there most days on his break. He's workin' in th'abattoir, keepin' his fam'ly alive, by the soun's of it. He had to drop out of school, seein' his father was kicked outa th'army."

A wave of dizziness passed over Cormac and he sat down again. Leonie poured him a glass of water and set it down in front of him. "Stay where y'are for a minute or two and listen. It won't hurt you to hear the truth, y'know."

"You don't have to tell me anything you don't want to."

She sat down opposite him. "One of his kids reported Bill to

<center>*169*</center>

his senior officer. He was put on a kin' of trial – probation they called it – more for his drinkin' than for his . . . carry-on here. But I was as glad. I wanted to get out of it anyway. An' I knew he hadn't the guts . . . " She started fidgeting with a clothes-peg.

"The guts for what?"

"Oh, he was always goin' on about quittin' th'army an' leavin' his wife. She was a nobody, he used say; she didn't count. We were goin' abroad to start up a new life. At one stage it was New York; another time New Zealan'." She shook her head. "Always some place with a 'new' in it. An' I was that desperate I never thought about his fam'ly. Not until you turned up."

"Me? What had I to do with it?"

"You changed everythin'."

"How's that?"

"Up until that time I'd b'lieved everything Bill tol' me about his wife havin' money an' parents that would look after her. The break-up had nothin' to do with me, he said; he was leavin' her anyway. An' then you started talkin' about your new pal, Eddie Dwyer. I guessed who he was right away. You tol' me Eddie had no money an' never had food to bring to school. I asked aroun' an' foun' out the whole thing was lies: Bill never had any intention of leavin' his wife an' she'd no money of her own, not a penny to her name. So, finally I put an en' to it all." She stood up and brushed down the creases in her uniform. "I made up my min' for once in my life. It wasn't easy, I can tell you, but it was right."

She was standing at the doorway, not ready yet to return to her routine. "I let it drag on for far too long so I did. She was a nobody, she didn't count. That's what he tol' me, an' I b'lieved him 'cause I wanted to." She shook her head, still scolding herself and tossed the clothes peg into the laundry basket. "So now you know the whole story. You could start blackmailin' me now, if on'y I had anythin' to make it worth your while."

"I'm sorry you went through all that. I've some idea how a . . . a loss like that feels."

"What do you mean?"

"I lost . . . I think I lost . . . Oh, never mind."

She seemed surprised. "What you wen' through was much worse, the worst thing that can happen a livin' soul at any age."

"What are you talking about?"

She set down the basket again and came over to him.

"An' I wasn't much help to you either, I was that wrapped up in himself at the time. To tell you the God's truth, I was scared outa me wits that I'd get caught. That's why I added to your misery an' hounded you all the time for spyin'."

It took Cormac a moment to realise that she was talking about his mother's death, not his failure with Imelda. In all the years no one had ever spoken of her death as a loss or a suffering he had any right to acknowledge. It was just another taboo, something almost shameful to admit.

Leonie was still standing over him. "I tried to make it up to you in other ways over the years, Cormac. I don't know if you noticed. I'm . . . real fon' of you, do you know that?"

"Is that why you belt me every chance you get?"

She laughed. "I s'pose it is. But you push me to it sometimes. You asked for it yesterda' so you did, insinuatin' God on'y knows what between me an' your uncle."

"I wasn't really . . . I was only . . . "

"Shh. It's no matter now."

She was smoothing his hair back from his brow and her palm felt soft and cool. "I'm very fond of you too," he said.

She smiled and looked into his eyes. "Well, if you feel like that why don't you ever stan' up an' give us an oul' hug now an' then? The same as you would to Angie if she was aroun'."

Cormac did as she asked, pressing their cheeks together.

"My, you're like an oven," she said, returning the hug.

Then the sweet scent of her body flooded over him. He wondered would it be different to hold Imelda like this. He drew Leonie closer to him. Suddenly he took her face in his hands and pressed his lips against hers.

Startled, she writhed a little at first but then grew still. When he released her, she turned quickly to the mirror over the Rayburn and began to rearrange her hair.

"Hmm! That was more than I bargained for. I was thinkin' of somethin' more brotherly, to tell you the truth. Somethin' I wouldn't have to tell the pries' about in confession."

"I'm sorry . . . I hope . . . I don't know what came. . . ."

"It's OK. I'm not sayin' . . . "

"What?"

"Never min'." She went to pick up the basket again but Cormac held on to her hand. "You can't turn me into Imelda Lindeman, you know. She's the love of your life, admit it. She's in for a treat all right, a real treat, that's for sure, if you ever get round to scalin' that wall."

"I think maybe I left it too late with Imelda," he muttered, but Leonie didn't seem to hear. She looked unsettled, as if for her too the kiss had been a disturbing subsititue of sorts, a reminder she could have done without. She stood in front of him, leaning against the table.

"Ever since we broke up, Bill's a changed man. He jus' fell apart. First he was thrown out of his own house for arrivin' home drunk an' abusin' the kids. Then he was sacked from th'army. He's fas' becomin' the kin' of down-and-out you'd toss a few coppers to. He drinks now from mornin' till night. How his fam'ly survive, I don't know. Seemin'ly the oldest girl, Eleanor, went off jus' lately to work in Englan'. Maybe she's sendin' some money home. An' Eddie works in th'abattoir, but that can't add up to much."

Gently she extricated her fingers from Cormac's. She picked up her basket again and made for the door. There she stopped and looked back at him. "If you knew the plans we had, Bill Dwyer an' meself. Such plans an' dreams. We were goin' to conquer the world, so we were. To conquer the world."

Before he could say anything she was gone.

Cormac found an old handball in his room and walked across town towards the alley. On the way he passed lads he had known years before: they were hanging around a street corner, chatting up girls. They nodded silently at him as he passed.

There were others on the railway bridge, younger kids,

waiting for trucks they could clamber on to, to get a free spin to the alley – or even, if they were lucky, as far as the next town. Eddie and Cormac had done that once and, when they failed to get a lift back, trudged all the way home across the Curragh, cursing their luck.

He left the bridge and, as he walked past the abattoir, he could hear animals screeching above the drone of machinery. There was the heavy, intestinal smell that hung in the air on slaughtering days. Chainsaw blades screamed through animals' bones. It was hard to imagine Eddie armed with knives and cleavers, tossing pigs' entrails into bins.

At the alley he disturbed a courting couple who could not have been more than twelve or thirteen. The girl made a big production of buttoning her blouse and tucking it in while her boyfriend spat on the ground and looked half-amused, half-embarrassed.

"He usually gets here about half-twelve," the girl told Cormac. "He's a cool han'ball player, the same Eddie Dwyer."

"One of the best in the county," Cormac agreed. "But would he beat Tom Egan? That's what I'd like to know."

The girl took her hair out of a band and immediately put it back in again. "Who?"

"Don't tell me you never heard of Tom Egan."

"C'mon," the boy said sullenly and the pair sauntered off to pick up their bikes.

When they were out of sight, Cormac practised for a while – but it was hot work and he was tiring fast, so he sat in a corner and waited.

When Eddie arrived Cormac watched him throw his bike to one side and walk head down towards the alley. He was wearing jeans and a t-shirt and looked tired and unkempt. He went to a wall of the alley, removed a loose block and took a handball out of the cavity. He was just about to bounce it when he noticed he had company.

Cormac stood up with difficulty. "Hello, Eddie."

"Ah, Cormac. What are you doin' here?"

"Nothing much. Waiting for you."

Eddie bounced the ball and slapped it against the base wall of the alley. When it returned he hit it back again. "You look a bit pale."

"I'm OK. I hear you've been doing regular practice."

"Yeah, pretty reg'lar. Who told you that?"

"Leon . . . I mean someone I met up the town."

"Yeah?" Eddie kept playing the ball to his own right hand.

"So, what are you practising for this time? Another match, is it?"

"No. Just to keep fit, I s'pose."

"You look in pretty good shape to me."

"Do I? Good."

"So, how've things been?"

"OK."

"I hear you dropped out of school."

"You hear a lot."

"And you're working now."

"Yeah. Over there in th'abattoir. The County Bacon Curing Plant actually." Eddie stopped slapping the ball and held it in his hand. "Did you ever see the inside of an abattoir?"

"I can't say I did."

"No. I didn't think so. But you probably eat meat all the same." He bounced the ball again. "Roast pork. Bacon an' cabbage. Bangers an' mash."

"So, what's the big deal? You work in an abattoir. Someone's got to work there."

Eddie was hitting the ball harder now. "Yeah. Someone's got to shovel the world's shit, that's true. But why me?"

Cormac couldn't answer that. "Are you annoyed with me about something?" Eddie stopped playing and stood, looking at the ground. "Why don't you say it if you are? Spit it out for Christ's sake."

Eddie bounced the ball up and down once or twice. "Why did you never tell me my Da worked over at your uncle's house?"

"You mean back in first year?"

"Yeah."

"Well, believe it or not, I didn't know he was your Da. I only found out later, during the Christmas holidays, when Leonie sent me over to your place. You were in bed with the flu, but I spoke to . . . "

It was too late: he had said her name and Eddie flinched – just as his father had done that day on the doorstep. He glared at Cormac for a second and turned his gaze towards a corner of the alley. "Who did you say?"

"Who what?"

"Who sent you to my place?"

Cormac tried to sound casual. "Maybe it wasn't her. Someone told me you were in bed with the flu that Christmas . . . I don't remember . . . "

"You said a name."

"Did I? Oh yeah. Leonie. It must've been Leonie."

"Who's Leonie?"

"She's my aunt's maid, that's all. She's from Offaly or some place, I don't remember exactly."

"And what business had she sendin' you to our house?"

"She heard me talking about you, that's all. She knew we were pals at the time."

Eddie's attention was still fixed on a corner of the alley, as if a ghost had just passed there. Suddenly he shook himself out of his trance and started slamming the ball against the wall again. Cormac had never seen a handball struck with such force.

"Do you want . . . to play a game, for old times' sakes?" he asked.

Eddie caught the ball in his hand and glared at him again. "I don't play games any more." He sent another shot against the wall.

"That sounds a bit . . . final. What's all the practice for so?"

"It's something to do, that's all."

"You could plant artichokes. Or pull nails out of planks of wood." Eddie kept smashing the ball back and forth. "What I mean is, why all the practice if you won't play a game?"

After a few more volleys Eddie stopped and turned towards Cormac again. "You've heard of deterrents, haven't you? Like in nuclear deterrents."

"Sure."

"Well, that's what han'ball is to me."

"Sorry. I don't get it."

A note of exasperation came into Eddie's voice. "A nuclear deterrent is not for firin'. It's for deterrin'. I play han'ball to deter. Do you understand?"

"So, who're you trying to deter?"

"Whoever comes along, I s'pose."

Cormac watched Eddie volleying to himself again. He was now extraordinarily like the Corporal: even more like him than he had seemed the previous summer playing football on the outskirts of town.

Still dizzy, Cormac bent down and picked up his jumper. What was he doing here, grovelling to Eddie as if he owed him something? He looked at him stroking the ball so smugly that it landed in exactly the same place each time. He was trying to create a world that shut everyone out: not just Cormac and Ann Marie and his father – the whole human race.

He turned to leave. "Well, I'll be going so. See you around, Eddie."

"See you."

As he walked off pulling on his jumper he could hear the steady beat of the handball. He listened for some variation but, as far as he could tell, Eddie hadn't even glanced after him as he left the alley.

At the entrance to the abattoir two trucks loaded with pigs drew near, forcing him up on the grass. Cormac waited for them to swing in through the factory gate. Then he stood at the entrance and watched the animals being driven down the steep ramps and herded towards the building.

Some of the pigs, sensing their fate, tried to run free. The drivers strode after them and lashed them back into line with

sticks. Then they herded them on, squealing and whimpering, towards the galvanised door at the side of the abattoir.

A worker came from the building and slid open the metal door, screeching it along rust-packed rollers. His apron was smattered with blood and grime. From inside the building the warm, sour stench made Cormac's stomach heave.

Some of the pigs from the truck became agitated again. They broke from the herd – only to suffer more spine-cracking blows. Then, one by one they were all rounded up and driven into the slaughter chamber. The men followed them in, dragging the door tight behind them.

Another truck arrived from the direction of the town and stood in the yard waiting to be unloaded. A driver jumped down from the cabin and strolled towards the office with papers to be signed. He had red, curly hair and a blubbery face full of freckles. Through the bars of his truck Cormac could see the seething pink animal flesh.

His head ached. Voices and faces were taunting him: his uncle sitting in silence, leaving him to challenge Aunt Maeve alone; Imelda telling her friend of her new love; Leonie at the kitchen door, saying how she and Eddie's father had planned to conquer the world; Eddie glaring at him and hammering the handball over and over against the alley wall.

Suddenly, before he knew how, he was in the yard. He clambered up on the frame of the truck. As he knocked out the metal pins that held the tailgate in place, he heard a strange voice, not unlike his own, muttering: "McEl D will approve of this. Definitely he'll approve."

He jumped aside and the tailgate fell behind him as he ran for the road. When he looked back he saw it was lying flat on the ground: it had failed to form a ramp to let the animals run free.

"Jesus Christ, Hugh. Quick! Come out, quick."

Two men rushed from the building as the first of the pigs hurtled off the back of the lorry and landed on the ground. One man waved his hands to frighten back the rest. It was too late:

others followed the first, pressed on by the terror-stricken herd behind. One by one they hit the ground with a sickening thud.

Cormac stood paralysed outside the abattoir gate and watched them hopelessly trying to resist the fall. Flailing their short legs, they landed on the concrete yard or on the bars of the fallen tailgate. Some fell on their faces and sides; some on the flat of their backs.

What had he done? What in God's name had come over him?

A number of pigs lay motionless, probably dead; others were squealing and screeching, unable to rise; a few survivors clambered over each other in blind animal terror. One was bent down with its face to the ground, blood pouring from its nostrils, its forelegs clearly shattered.

The men seemed bewildered as they dragged carcasses aside; they were standing on writhing flesh in their attempts to get to the back of the truck. Cormac clutched his forehead with both hands.

"Jesus Christ!" the foreman roared. "Quick, Hughie. Over here. Call the lads out. Quick!"

"How in Christ's name did that happen?"

Other workers and drivers rushed out to help. At the sight of the men, the pigs still on board cowered back from the truck's edge.

"Some fucker must've loosened the tailgate," the freckle-faced driver yelled looking around. "Some cunt . . . " His eyes fell on Cormac standing outside the gate. "Hey, you! What d'you think you're doin' there?"

Before Cormac could stop himself the words were out. "Murderers! You're killing them. You're slaughtering the pigs!" His voice was grating, even to his own ears.

The driver had been walking towards him but the crazed outburst halted him. "Are you some fuckin' headcase or what?"

"You're tyrants, so you are. You think you're mighty now, but 'Sceptre and crown, must tumble down . . . '" He was beginning to falter. "'Rise like lions . . . '"

The red-haired man stared at him open-mouthed.

Suddenly the dizziness lifted. "I was just passin', that's all. I heard a noise and . . . "

The tailgate was back on the lorry and the foreman came from the yard and intervened. "Did you see an'thin', sonny? Did you see how it happened?"

"He could've had a hand in this," the driver said. "If y'ask me he's pissed out of his fuckin' mind."

Cormac shook his head. "No. It just fell off. I saw it falling, just as I was walking past."

"I wouldn't say it was him, Hughie," the foreman said. "He's not the sort'd be up to that kinda caper. C'mon back."

The driver ignored him and kept glaring at Cormac. "Don't think for wan fuckin' minute, young fella, that I don't know who y'are an' what you're up to – though for what reason you'd do a thing the likesa that . . . You'll hear more about this before too long. An' the Comma'dant will hear about it too, take my wor' for it." He turned and followed the foreman back to the yard.

"I know what it was," another driver shouted as the men dragged animals aside. "Them fuckin' gurriers above at the bridge. When I slowed down to take the ben', a ganga them brats clambered on board. They must've done the same on you, Hughie, an' undid them fuckin' pins before they leapt off."

"Did you see who they were?"

"Them Masters brats, that's who they were. Little fuckin' gurriers. I'll have somethin' to say to them, be Jaysus, when I nex' get me han's on them."

"It could've been them knackers above at the Sidin' . . . "

Cormac sat on the grass verge and waited till the empty lorries had driven away. The metal door was closed now and the only sounds, since the squealing and screeching had ended, were the faint drone of machinery and the steady rhythm of Eddie's handball ricocheting around the alley.

He stood up to leave but everything went dark.

"I thought I heard a woeful row. What happened? Cormac, are you all right?"

There were voices but no faces.

"He'll be OK on that sackin'."

"Yeah, I know the road."

"The sight of them pigs must've sickened him."

"Hospital, maybe."

"Dreadful stench."

"Lord, save us all."

"Call Dr Donovan."

"Who's Hughie Driver?"

"Fumigate the room."

"I've no idea, Ma'm."

Then the litany ended and he was able to make things out. Footsteps and doors closing. It was all perfectly clear.

"It's all right, Cormac. Stop frettin'. You're moanin' about nothin' at all."

It was Leonie's voice. Water cooling his parched throat. He could feel her palm on his forehead. She bathed his neck and chest with a damp cloth. He tried to open his eyes but they were sealed.

"Whisht," she said quietly. "No more of your rantin'."

Later, when it was dark, the seals broke. Leonie was still leaning over him. "It's all right," she whispered. "You're OK. For a while I thought you were never goin' t'open them big spy's eyes again."

He looked around. "'And in the dust be equal made . . .'"

"Oh, no. You're not still ravin'? You near put the heart across me, you were blabbin' that much in front of herself."

"My God, am I glad to see you."

"Shh! Stay quiet. You're not over it yet. Dr Donovan says it could take a few . . . Cormac. Cormac, can you hear me . . ?"

The next days were a blur, but he gradually put together the missing pieces. When he had failed to respond to the gong and Leonie's calls, he had been discovered trembling and sweating in bed. He was falling in and out of a bewildering fever every few minutes and rambling on without discretion. Aunt Maeve had

come up to see how he was and told Leonie to sit by the bedside and wipe his face with a damp cloth while she went to ring for the doctor.

"How did I get up here from the alley?"

"Eddie got someone to drive you home in a truck."

"In a pig truck!"

She laughed, "That's just what your auntie said. An' the way she said it too. You know you're more like her than you think."

"I thought there was a queer smell."

"It's nothin' like it was, believe you me." She took out a ten-pack and lit herself a cigarette. Then she held it for him to inhale.

He shook his head. "'Sceptre and crown must tumble down . . .'"

"Oh, no. Don't tell me you're away again."

"No, I'm just thinking."

"I was out on my half-day. Seamus says he oxtered you up here, but he never let on 'cause he thought you were outa your head drunk."

"Shows the way his mind works. What day is it? How long have I been out?"

"Since the day before yesterda'. The day the rumpus broke out in th'abattoir."

Cormac groaned. "Oh no. What did I do?"

"Shh, you done nothin'. Seemin'ly some pigs broke loose an' attacked the drivers. It ended up in a fierce battle. One of the drivers rounded on some tinker kids an' beat them up, don't ask me why. I suppose he figured the knackers put the pigs up to it."

Cormac groaned again. "Oh, don't talk about it. I was there. In fact, I'd better get up and report . . . "

"Stop jumpin' about an' lie still."

"You don't understand. I caused the row. I tried . . . I tried to . . . liberate the pigs but it all backfired, do you understand?"

Leonie stubbed out her cigarette. "Are you still ravin' or what? Will you lie down an' stop blabberin' – especially in front of your auntie – or we'll *all* en' up in the shit heap. God, are you never goin' to come out of this coma or whatever it is?"

The next morning, Dr Donovan arrived in the attic bedroom reduced to almost the same condition as his patient. He sat on Cormac's bed and wheezed: "Ah! The dead arose . . . You'd better have . . . a few good jokes, Cormac Mannion . . . to make up for that awesome climb."

Aunt Maeve stood behind him with her arms folded and announced: "He's been charging around the county like a lunatic on Leonie's bike and not wearing the proper clothes. I'm not in the least surprised it's come to this. He's the most headstrong individual I ever encountered. And to crown it all he ends up being delivered home in the back of a pig lorry."

Her railing was a relief: there was no sign that she had heard anything about the abattoir fiasco; and there was even the faintest trace of concern in her voice.

"Well, you'll be glad to know the blood test was negative," Dr Donovan said to Aunt Maeve.

She blessed herself. "Thank God for that."

"You had us worried you know, young man. Especially after what you might have been exposed to in that boarding school a while back. But now you've got the all-clear."

"He's been putting the heart across us, ranting on about someone called Hughie Driver and reciting mad poetry with his eyes closed."

Dr Donovan clicked his tongue. "It's not the done thing, Cormac. If you're going to recite mad poetry the least you could do is open your eyes."

When Aunt Maeve and Leonie had left the room, he said: "I think she's preparing you for a career as a steeplejack, keeping you cooped up here ten thousand feet above sea level. Another foot or two and you'd need an oxygen tank."

He started into his routine with stethoscope and thermometer and, as he checked Cormac's pulse, he looked disapprovingly around the room. "The crow's nest, you should call this place."

"I like this room," Cormac protested with the thermometer in his mouth. "It's got a good view."

The doctor glanced at the skylight. "A good view? If you like pigeons' bums, I suppose."

"Who're you calling a pigeon's bum?"

Dr Donovan laughed. "Shh. Lie still." He took the thermometer out of Cormac's mouth.

"I never meant to hurt those pigs. I just wanted to set them free."

"My God, you're worse than I thought." He looked at the thermometer gravely. "But your temperature's coming down."

"What about Imelda Lindeman?"

"What about her?"

"I have a good view of Imelda Lindeman from up here. At least I did before she fell for that Martin guy. Oh, my head!"

"I think you should lie still and not talk so much."

"He sends her poems and travels around the world feeding the poor."

"Who?"

"Martin Keane."

"Well, if that's what has you in this state, you can relax. Martin Keane is her cousin and he's twice her age."

"How do you know that? Are you a spy?"

Dr Donovan chuckled. "No, I'm not a spy. My daughter, Ann Marie, is a good friend of Imelda's and she told me all about him. He's a lay missionary in Latin America and he's not in love with Imelda. He's in love with a Colombian woman. At least he gave up the priesthood to marry her."

"But . . . but . . . "

"But nothing. He was in Ireland for a rest recently and stayed for a few days with the Lindemans. He's Martha Lindeman's first cousin and they're all crazy about him. But only in a brotherly way, so you can put your mind at rest on that score."

"Really?"

"Really and truly. And you may be interested to know that Imelda Lindeman, far from being in love, is open to advances from eligible young men. From what I hear, one from you might even receive consideration."

"My God, you're a brilliant spy."

"Now, what's all this about freeing pigs?"

Cormac groaned. "Oh, don't remind me. The important thing is that Aunt Maeve never hears . . . "

"Why don't you tell me about it? Get it off your chest."

"First promise you won't . . . have me put down . . . "

Before he left, Dr Donovan chuckled some more, wiped his glasses and declared: "I don't know what it is, Cormac Mannion, but you always manage to cheer me up, no matter how many flights of stairs I have to climb to get to you."

Cormac was sorry to see him pack up his medicine bag. At the doorway the doctor stopped and looked back at his anxious patient. "Now, stop worrying. And stop taking the whole world's cares on your shoulders. I've told you I'll talk to this Hughie chap and you won't hear another squeak out of him. I've blinded more learned men than him with science in my time, believe you me."

The days that followed were punctuated with other visits. One was from his sister, Angie, who told him plans were afoot for her and their father to take him on a holiday in Kerry as soon as he was over his fever. Aunt Maeve had been in touch and told them about his condition.

His father was off alcohol for over a year now and he was a changed man, Angie said. Maybe Cormac should think of coming home to live in Westmeath.

"I don't think so, somehow. I don't think I could hack that."

"It sounds to me like you've a lot going for you in this place," Angie said, looking around his room and sipping the mug of coffee that Leonie had brought her. "I think Aunt Maeve is crazy about you in her own odd way. She talks about you non-stop. And Leonie tells me there are some other attractions next door, but you haven't quite got around to them yet."

"When were you talking to Leonie?"

"Oh, I'd a long chat with her while you were dozing."

Cormac could not conceal his admiration for his sister. She

was pacing about his room, dressed in a smart blue-and-green suit and scarf, and looking for all the world as elegant and assured as their mother. She even sounded like her when she spoke.

From what she told him, there really seemed to be a major improvement in their father's condition. "Maybe it's time for both of us to rally around him more. We can't really blame him for Mum's death, you know."

"I wasn't conscious of blaming him," Cormac said, but after his recent excursion into the twilight zone he knew anything was possible.

"I wasn't either. In fact, I blamed myself more than him. But I started seeing a . . . doctor recently and I discovered all sorts of things I hadn't admitted before."

"You're seeing a psycho?"

"Yeah, what's the big deal? I was having problems sleeping. For some reason I couldn't get Mum out of my head."

"Why did you want to?"

"Exactly. That's what Dr McCall said. It's not the memory that's the problem: it's just . . . "

"What?"

"It's just the . . . pain of losing her that we want to be rid of. We've done our share of grieving, all three of us, in our different ways. More than our share maybe. Now we've got to get on with our lives. And Mum can inspire us to do that, better than anyone – if we learn how to remember her right."

When Leonie came up with his medicine, Cormac asked her to bring the album from the Commandant's quarters and he and Angie spent some time looking at the pictures of their mother applauding Aunt Maeve's tennis win. Aunt Flo was there too, like a ghost in the background, and they talked for a long while about the three sisters whose lives had taken such different courses.

Before she left Angie returned the album to the Commandant's study and came back to the attic. "It would be lovely if you would write more often. I think Dad needs that much at least. Just tell him your news and gossip and any

adventures you've had in the last while. I've got to go now. Aunt Maeve is dropping me to the station, but I'll be in touch, I promise." She hugged him and left the room without looking back.

When she had gone, Cormac got out of bed and sat at his desk. With considerable difficulty he wrote a long letter to his father; and later, after he had given it to Leonie to post, he fell back into bed exhausted.

As he emerged more fully from his fever over the next few days, his main visitor, much to Leonie's amusement, was his equestrian pupil, Maurice. He had to put up with a lot of excruciating chatter from Maurice about films he hadn't seen and books he hadn't read, but he endured it all, in return for morsels of information about Imelda and Martin Keane.

Soon it became clear that his good deed of teaching Maurice to ride was paying a handsome return: from what the boy told him it was clear Dr Donovan's version of events was correct. If he ever recovered from this tenacious virus, Cormac resolved he was going to give up eavesdropping and spying forever.

He had a short letter from Dr Donovan some days later, enclosing two tickets for a tennis club dance.

> I would have delivered them personally, only I ran out of helium for my aerial balloon! I hope you can think of someone you'd like to invite to the dance, preferably someone with an interest in tennis.
> Incidentally, all's quiet on the pork front. It seems somebody got to your Hughie friend even before I spoke to him. Now, who do you think that could be?
> Charles Donovan

"It has to be Eddie," Leonie said. "Who else?"
"I thought I heard his voice all right, just after I conked out."
"I tol' you he arranged gettin' you home."
"Yeah. In a pig truck."
"Well, what did you expec': a friggin' Rolls Royce?"

"It's funny he never came by to ask how I was getting on."

"Maybe he's shy of this place. You'll prob'ly have to make the firs' move."

"I'm sick of making the first move."

Leonie sat in silence beside the bed.

"Anyway, it's all over and done with," he said quietly. "He doesn't want to know me and that's that."

"You could write an' thank him for gettin' you home. You could tell him . . . You could . . . "

"I could what?"

"Maybe you're right. Maybe that wall's too high to scale."

There was a knock on the bedroom door and for one moment Cormac imagined Eddie had come to visit him. Leonie opened the door and Maurice stepped into the room.

Later that evening, before Maurice left for home, Cormac gave him a letter to place in his sister's hands. In return for this simple task, he undertook to give him any amount of riding lessons he might want and the boy's eyes lit up.

Cormac had spent a long time composing his thoughts and made his messenger promise to hand them over with the utmost discretion. He also sent Imelda a ticket to the tennis club dance, but after much deliberation decided against enclosing a complimentary copy of *The Spiral Staircase*.

1967

Chapter Six

ONE MORNING EDDIE'S mother came to his bedroom earlier than usual. "Ed," she whispered, opening the curtains. "Are you awake?"

He woke up to see Mam looking sadly at her daughter's posters of Bob Dylan and the Rolling Stones. Since Eleanor had gone to live in England Eddie had taken over her room but he had never had the heart to change it. Mam sat on the end of the bed.

"What time is it?"

"It's early. I'm wakin' you 'cause there's a letter I want you to look at before you go to work."

She handed him an officious-looking typed page, the kind of document he had become used to handling in recent months. He had left the abattoir and was now employed as a gofer in a solicitor's office in town. It was only slightly better paid than the old job, but it was quieter and less bloody.

His first thought was that the letter was a police summons for his father – or possibly notice that he had sold the house and they were all out on the street. It was from solicitors called Lindeman and Partners and printed across the top were the words "Without Prejudice".

> Dear Mrs Dwyer,
> I am writing on behalf of Mrs Maeve Connolly, executor of Connolly Estate Holdings at Belmont, County Kildare.

As you may know, the estate and its adjoining lands are now being prepared for sale in accordance with the owner's wishes.

My client is aware that your mother, Mrs Nora McMahon, is of the belief that she holds from her late Common Law husband a contractual lease giving her claim to the benefits from some acres of tillage and pasturelands at Belmont. However, this is not the case.

With respect to Mrs McMahon's years and unofficial status, however, the executor has asked me to convey to you her willingness to make a proposal concerning the holdings in question. Because of your mother's fragile state of mind, she thought it best to put this proposal to you in the first instance.

In return for a complete surrender of all claims concerning the house and lands in question, Mrs Connolly is willing to overlook accumulated back rents. It is her plan to devote a percentage from the sale of the estate to setting up a fund for the elderly residents of Belmont. This would operate for the lifetime of those, who, like your mother, have spent their lives as tenants of the Connolly family, and are now unable to fend for themselves.

In short, the fund would go some way to enabling Mrs McMahon to find accommodation and health care in a more appropriate location for the remainder of her years. May I suggest that you or your sister in England might urge your mother to accept this offer and perhaps consider taking her in to live with one or other of you, thereby maximising the benefits of Mrs Connolly's generous offer.

If you would like to discuss this proposal further, I would be happy to put myself at your disposal.

Yours sincerely,
David Lindeman

"Well, what do you think?" Mam asked. "It looks like we might have Granma livin' here with us. How would you feel about that?"

"How would *I* feel about it? You mean, how would *she* feel about it?"

"You'll have to go over an' see. Anyway, you needn't worry

about bein' moved to the other room. I'd let her have the big room an' I'd move in with the kids."

Her eyes stayed fixed on the dressing table and the few pieces of costume jewellery that Eleanor had not taken with her to England.

"Would you like to have her living here?"

His mother smiled sadly. "It'd be nice in a way."

"But how do you think she'd take it? She loves her farmhouse and the dogs. She belongs over there beside the trees and the wild, as she calls it. This place would be hell to her: she'd go *totally* off her head."

"Well, she'd be better off here than in some ol' folks home. Or in Birmin'ham. Just think if she woun' up over there with Josie."

"She'd be better off left where she is."

His mother stood up and went to the window again. "There's no point in you gettin' agitated about this. If they're sellin' out, she's got to move an' that's all that's to it." She began straightening some of the books he kept on the window ledge.

"Hold on a minute. First we should look into this. We should get it examined by another solicitor."

"You know we can't afford that."

"I'll get someone at work to look at it. You can bet any money you like there's more to this than meets the eye."

"You're gettin' awful high an' mighty these days, ever since you got in with that Grealey crowd. But you'll learn, an' it won't be from them books that you'll learn it: few things in this life are the way you want them to be. You just take things as they come."

"Let me hang on to this letter for a day or two."

She stood at the foot of the bed with her arms folded. After a moment she sighed. "Oh, all right, but don't go showin' it to every Tom, Dick an' Harry in town. There's private family things in there."

"I know. That's what puzzles me."

When she had left the room, he lay back on the pillow and read the letter again. Why were the Connollys going to such

lengths to soften the blow of buying his grandmother out? He couldn't help feeling that Lindeman and Mrs Connolly wanted the whole business conducted on a personal level so that it wouldn't be looked at too closely from a legal point of view. There were references to Granma's "Common Law husband" and her "unofficial status": how did they know about these things? In fact, how did they know to write to his mother in the first place? Or that Josie was living in England?

As he got dressed he thought more about the letter: there was almost an element of blackmail in the references to Granma's unmarried status. Play along with us, they seemed to be saying, and we'll treat the old lady like one of the respectable people of Belmont. If you don't, we'll evict her – if not on the grounds of a faulty lease, then on the grounds that she has no legal right to inherit leasehold from the man she lived with.

He went to the bathroom and splashed his face and neck. He was back in his room and almost fully dressed when Nuala stuck her head in the bedroom door. "Mam says you're to hurry up or you'll be late for work."

"OK!"

She seized the opportunity to squint at Eddie's sanctuary. "God, but this room's a mess. You better clean it before Elly comes home. She'll be comin' home soon, won't she? When we get our summer holidays."

"I hope so."

"Will you be movin' back into our room when she comes?"

"No, I'll be moving into the west wing."

"The wha'?"

"The cat shed, dumbo. Hurry up, you, or you'll be late for school."

"If you're writin' to Elly, tell her to bring home plenty of them English sweets. You know, them sucky ones with the fruity taste." The little face was all bright-eyed and appealing.

"Write to her yourself, you lazy sod. You and your sucky sweets!"

When Nuala and the twins were packed out of the house with their schoolbags strapped on, and Philly had sauntered off at a more leisurely pace, his mother came back into the kitchen.

"Listen here, Eddie, you needn't get carried away over that letter. I'm sorry I showed it to you in the first place."

"Just take it easy, Mam. There's no harm in getting a second opinion. That's not going to hurt anyone."

She set a teapot on the table and carried plates and cereal bowls to the sink. "That kind of thing costs money. And anyway the law's not on our side."

"Now you're beginning to sound like Eleanor."

"Things I tol' no one but you are printed there in black and white. What am I to make of that?"

"Make of it what you like. Do you want a cup?"

She continued to clatter away at the sink. "You've got to admit it's mighty queer."

"Are you saying I told them?"

"I'm not sayin' anythin'. I'm just thinkin'. How much did you tell your pal Cormac?"

"You know I haven't hung around with him for years. Besides, he wouldn't pass on that kind of information. Whatever they know, they found out somewhere else, probably in Belmont itself."

"Are you sure you can trust him?"

"I'm telling you I never mentioned Belmont to him, ever. Anyway, you told me yourself Granma didn't make any secret of not being married."

She came back to the table and started to wipe it with a damp cloth, catching the crumbs in her palm. "She didn't, but we did, Josie and me. At least we kept it from bein' known by every lout and layabout in town." She continued wiping the table long after it was clean. "Listen, Eddie. When it all boils down, Cormac Mannion's one of *them*. He's their flesh an' blood. He probably stan's to inherit whatever they make from the sale of the place an' a lot more besides."

"Jesus, Mam! He's no longer a friend of mine. I never see him. Are you telling me I'm lying or what?"

"Don't swear at me, son. I'm just sayin' you can't be so sure of his sort. They've different ways of lookin' at things, his people. That's a fact of life."

Eddie stood up and pushed the chair against the table. "A fact of yours, maybe, but not mine. I'm not going to crawl or grovel before anyone in my life, now or ever."

"Take it easy, Eddie."

"No, I won't take it easy. I'm going to work. There's no air in this house."

"There's no need to raise your voice at me. Blood's thicker than water. That's all I'm sayin'."

"You talk about blood but, I swear, sometimes I wonder: do you have the same blood as your father and mother at all? One thing is certain, you bring it no honour. When I think of the stand they took in their life for what they believed in and how you and Auntie Josie treated them in return . . . "

His mother pulled a chair over to the stove and sat down. "What are you sayin', Eddie? Do you know what you're sayin'?"

"I'm talking about making a stand, not letting things drag on and on, forever getting worse."

"Didn't I drive your father out of this house? Didn't you see me makin' a stan' then?"

"Yeah, but only after I had him by the throat. Only after . . . God knows what Eleanor had to go through."

"Eddie, take it easy before you say somethin' you don't mean."

"That's right. Don't mention it and it never happened. That was the day I came back from Belmont. I went for him the minute I heard Eleanor screaming, but it was Granda gave me the heart to do it. I loved that man and I can never forget that you and that snobby bitch, Josie, let him go to his grave believing you disapproved of him."

She was glaring at him now and he turned away to avoid the hurt in her eyes. He grabbed his coat from the back of the chair and left without looking back, slamming the kitchen door behind him.

He snatched Eleanor's bike from the shed, wheeled it around the side of the house and pedalled hard across town. At the railway bridge he stopped to let his anger pass. He leaned on the parapet and stared down at the tracks.

He had stood in that place many years before while his father talked of each man fighting his own fight. His words had been ones of proud defiance, but they had proved empty in the end – as empty as the promise he had made to meet Eddie later that day in the handball alley.

He squinted down the silver tracks towards the old railway Siding. It was there that his father was sharing a cold, squalid life with others like him, the town's human rejects. In the distance he could see the cluster of old sheds that housed them – whenever they finished staggering about bonfires or fighting among themselves in the doorways of pubs.

Maybe, in some ways, it was better to live at that level, without pretence or hypocrisy. His father's life and his own surely ran on fixed parallel lines and would converge sooner or later, merging into one track.

A church bell rang out the hour and Eddie shook himself out of his trance. He glanced around at the smug world of Drumaan with its maze of houses and shops. The bell seemed to be admonishing him: the narrow streets of the hucksters beckoned.

Eddie's boss, Harry Grealey, was one of the town's most successful hucksters. In addition to his legal practice he owned various shops and premises, and one of Eddie's weekly chores was to cycle around each Friday and collect rent from Harry's tenants.

The Grealey empire was administered from a dingy office above Petals, a record-cum-flower shop run by an old school friend of Eleanor's, Carol Phelan. In the dark cramped offices upstairs the amplified heartbeat of Carol's music could be heard pulsing away below.

Harry, the senior partner in the firm, would sigh and adjust his earplugs: he detested pop music but could not bring himself to question the dictates of commerce. When he handed Eddie his

weekly brown envelope he sometimes said: "Perhaps you'd run down like a good lad and persuade your pal Carol to turn the volume down a notch or two, just so we can hear ourselves think."

The other family partner was Damien Grealey, a nephew of Harry's and the only reason Eddie found the place bearable. Eddie sometimes ran messages for Damien – and for his wife who was forever losing the keys of her car and forgetting to collect the children from school.

It was under Damien's guidance that Eddie began to take a correspondence course in law. Damien had devised a programme of reading for him and he treated Eddie with a respect he certainly hadn't known in his previous employment.

Everyone said Damien had an incisive mind. He was the obvious person to advise Eddie on the Lindeman letter.

His first reaction, like Eddie's own, was one of suspicion. "They wouldn't be going to such lengths unless they knew they hadn't a leg to stand on," he said.

The monotonous shunting of the Beatles' *Taxman* wafted up through the floorboards.

"I wonder what Lindeman is really up to."

"They obviously put in an awful lot of homework," Eddie suggested.

"That's Lindeman's hallmark. He's as dull as dishwater but he works hard. From what he says here it seems your grandparents were pretty much ahead of their time."

"They were unusual, I suppose."

"That's putting it mildly. So, what do you want me to do about all this?"

"I was hoping you'd advise me. Maybe even . . . more than that. But we couldn't afford to pay you much."

"There wouldn't be any question of payment, forget about that. But I'm not sure I'd want to take on this case, even if I thought there was one in it."

"What do you mean?"

"I mean, it would entail a lot of work and, in the end, there'd be no guarantee . . . "

"I could do all the groundwork. It'd be valuable experience. You said yourself I need as much practical work as I can get."

Damien stood up and paced about the room. "You're too close to this case to be able to see it objectively, Eddie. This isn't the kind of experience you need."

"But that's the point. That's why I'd be prepared to slog it out – in my own time, I mean. Strictly in my own time."

"Eddie, can't you see they've covered their tracks? How do you think it's going to look to a district justice? Mrs Connolly will come across all sweetness and light. I know the woman, Eddie: she's an old hand at this game. She and her family have been dealing in property for generations."

"If you're afraid to take it on, I'll find someone who will. The trouble is I've only a few quid saved. But maybe I can borrow some."

Damien went to the door and glanced in the direction of his uncle's office. Then he came back and sat on his desk to be nearer to Eddie.

"Listen, Ed, I'd better warn you. David Lindeman and the old man are like that." He crossed two fingers. "Lindeman bailed my uncle out of a mess he landed in just a few months before you came to work here. It could have cost the firm a lot of money. Harry owes him one, do you understand?"

"What's that got to do with anything? We're talking about a professional relationship. Isn't that the whole point of the adversarial system? You don't just pick and choose the cases you like."

"Take it easy, Eddie. You're up to your gills in theory right now and that's as it should be. But we live and practise in the real world, not inside the covers of text books."

"Why did you say *I* was too close to the case, when what you really meant was *you* were too close to it? Is it because you live a few doors away from Mrs Connolly? Is that why you won't take it on?"

Damien said nothing. Eddie began to think his mother was right: the law was on *their* side. And, if that was the case, what

was the point of his going on with his studies? He might as well quit now and not fool himself any more.

"If you ever met her," he said as calmly as he could, "if you knew my grandmother, you wouldn't put her second to Mrs Connolly. Or to Lindeman, for that matter. She's entitled to be heard, that's all. She's entitled to have a say in how and where she spends the rest of her life. And she's not being offered that say. Not by Mrs Connolly or by Lindeman or by you." He started to move towards the door.

"I can see this all means an awful lot to you, Eddie. But you don't understand: it's impossible for me to handle."

"Then how do you think it'll look when I go to another firm? You've taken on known criminals, for Christ's sake. You told me so yourself."

"Don't do anything while you're in this state. Surely one of the things you've learned is not to go off half-cock where the law is concerned. I've one or two contacts who may be able to get some information. I'll talk to them first and then we'll see. But I'm not promising anything, you understand. I'll just check it out. Is that clear?"

"You don't look yourself today," Carol said as she turned down the music and started to water the roses she kept in plastic containers by the doorway. "Are your studies not goin' too well?"

"Don't you start."

"Oh, it's like that, is it?"

"I'm sorry, Carol. I had a row with my mother this morning."

"Oh, dear. Why don't you sen' her some flowers? I'll get them delivered for you. Or I'll drop aroun' myself."

"She needs every penny I can bring home. Things are too tight for flowers."

"She needs more than money, Ed. We all do. Go on, pick out some she'd like and you can pay me later." Eddie shook his head. "Then I'll just have to sen' them myself an' preten' they came from you."

"Please don't. I'm not ready for that."

"So, what were you arguin' with your Mam for? You know how I feel about her. I think she's one of the best people aroun'. I mean, think of what she's been through."

Eddie said nothing. He busied himself flicking through some new releases.

"You remember that time Eleanor was afraid to stay in the house with your father. She used to come aroun' to our place at night . . . "

"Carol, I'm not sure I want to hear this."

"I'm only sayin' . . . "

"Please drop it!"

She put down the watering can and came over to him. "I'm not tryin' to rub salt in the wound, Eddie. I'm just sayin' your mother went through a lot. You all went through a lot. Eleanor tol' me about it at the time. But you're not goin' to get over it by pretendin' it never happened."

He flicked the records to the back of the rack. "So, what do you want? That we spend the rest of our lives sittin' around broodin' over the past?"

"If it still hurts, maybe you should . . . "

"Some things are better off forgotten about, Carol. They should be buried in a deep hole at the bottom of the garden. That's assuming you've got a garden, of course."

"That's the point I'm makin', Eddie. You've buried them but you haven't forgotten them. You've never forgiven your Da for the way he let you all down. And you'll never be free of him until you do."

Eddie turned away and started to leave the shop. Carol caught him by the arm. Her tone was angry. "Don't walk out on me, Eddie Dwyer. I'm talkin' to you, do you hear?"

"Who are you to fucking lecture me?"

"What's that supposed to mean?"

He pulled his arm free of her grip. "Carol, why don't you just go back into your fantasy world? Keep playin' your records and sniffin' your flowers and, who knows, any day now . . . Neil Sedaka or Paul McCartney will waltz in and whisk you off to

Never-Never Land. In the meantime, lay off me and my family, will you?"

After a moment of uncertainty Carol's face dissolved into laughter. "Boy oh boy! You're in some whopper today, there's no doubt about it."

Eddie stopped in the doorway.

"OK, Eddie Dwyer, I promise I won't lecture you any more." She laughed again. "That's good, Neil Sedaka waltzin' around Drumaan. Come back here till I make you a hot cup of coffee. Come on, you cranky bollix!" He hesitated. "C'mon."

"OK."

"God knows, you're right. I'm in no position to lecture anyone. If you only knew the half of it. Neil Sedaka, where are you?"

They sat at the back of the shop and drank coffee from large mugs.

"I'm sorry, Carol. I don't know what got into me. You just scraped a raw nerve, that's all."

"I hope you're not killin' yourself studyin'. From what I hear you're goin' to fly through your qualifyin'. At leas' that's what Damien thinks. He says you've got real flair for things legal."

"I'm beginnin' to wonder about Damien. I always thought he was one guy you could trust, but now I don't know."

Carol stared at the mug in her hands. "Oh? Why do you say that?"

"Just something that came up. I'll tell you about it another time. I better get back upstairs."

"Oh, by the way, I'd a letter from Eleanor yesterday. She said she could be home for a visit by the end of next week."

"That soon? Great!"

"Shit! Maybe I wasn't meant to tell you."

"I'll keep it a secret. She got her exams, you know."

"I know. She's a qualified hairdresser now. And a beautician as well. Imagine! I was wonderin' if I could put in a word for her with my cousin in Newbridge. Wouldn't it be great if she could get a job that near?"

"It'd be fabulous. But would she be interested?"

"I don't know. She says she's had it up to her gills with Aston Villa fans an' the like. But she doesn't soun' like she's ready to come home for good. Not yet, anyway."

Eddie felt restless again and started to move. Carol handed him a pile of letters. "If you're goin' up, will you take these with you? Oh, I nearly forgot: there's one for you among them. A very familiar hand and a County Wicklow postmark. Does that ring a bell?"

"Ann!"

Carol gave one of her romantic sighs. "Oh what I'd give to be able to sen' the blood racin' to some fella's cheeks like that!" Then she turned aside and started tidying away records. "Yes, Neil Sedaka or Paul McCartney would fit the bill nicely, thank you very much." And she smiled at him as he left her shop.

An hour or so later, when the *Theme from Elvira Madigan* had run its course, Eddie heard Neil Sedaka's chirpy voice from below.

> "Oh, Carol! I am but a fo-ol,
> And I love you dearly,
> Though you treat me cruel . . . "

He spent most of his lunch break wandering around the old railway buildings in the Siding. Some disused carriages had been shunted there and abandoned many years before. He heard a scratching noise from behind one of them and followed the sound.

A tinker woman in rags and a shawl was raking the ashes of a bonfire with a blackened stick. She spun around when she heard his footsteps on the cinder behind her. Her face was bloated and scarred and her hair matted thick with grease. She held the charred stick defensively in front of her as he approached.

"It's OK," Eddie said, trying to calm her, and he asked if she knew where Corporal Dwyer could be found.

"Bill Dwyer, is it? Who's lookin' for him?"

"I am. I'm his son, Eddie."

She glared at him. "If you've got money for him, I'll gev it to him meself." Her mouth curled into a smile revealing two or three blackened teeth.

"I've no money. I jus' want to talk to him, that's all."

The smile vanished and she continued to stare at him. "Eddie Dwyer, did ya say? Ya work beyon' in the abathwire, I hear tell."

"I used to, but that was a good while ago."

"Then I wouldn' be hangin' roun' here if I was you, son. There's blood on the han's of them works in that place – an' I don't jus' mean pigs' blood. They drew trouble down on innocen' heads so they did."

"I don't know anything about that. I just want to talk to my father."

"Some brats broke the back off a truck and sen' scoresa pigs to their deaths, we was tol', and as usual our lads was hel' to blame. You must've heard tell of it. It was on'y a year back."

"I heard about that all right, but . . . "

"We had the guards down on top of us, makin' all kin'sa charges, puttin' the blame on innocen' travellers. Some people's still wil' sore about tha', y'know."

"I'm telling you, I know nothing about that. I just want to talk to my father, that's all."

"In that case, cross over the thracks to the Greyhoun' Bar. But don' tell him it was me sent ya. An' don' expec' much in the way of chat nayther."

His father looked up from his corner of the pub, his bloodshot eyes barely able to focus. His voice was hoarse and faint. "Ah! Edward the Firs', I swear to God."

The man beside him lifted his head and stared past Eddie's shoulder. "Pleased to meet ya, son. Packie Connor's the name." Eddie shook the man's clammy hand. "Yer oul' man thinks awful high of ya, Eddie son. Awful high, so he does."

"Have a droppa somethin' while you're at it, Ed. A glasheen of somethin', son." He was slumped on a settee, wearing an old brown suit that Eddie remembered first seeing the day the twins

were christened. That day he had looked spruce and fit; now the suit was crumpled, the seams ripped at the shoulders.

"I just want to talk."

"A bird never flew on the wan leg," Packie declared, chuckling at his own joke.

"I've just got a couple of minutes, Da. Can we talk outside?"

"Packie, did I ever tell ya . . . Eddie's not far off runnin' the County Bacon Plant all on his own? He's no daw, is our Eddie. Be Jaysus, he's got brains to burn, I swear to God." He was getting worked up now and his voice was stronger.

"I'm not workin' there, Da. Not any more."

"Brains to burn, I tell ya . . . "

"An' why wouldn' he, Bill? Doesn' he come from the besht stock?"

Eddie tried again. "Da, will you come outside?"

"Faith an' he does. An' he's a walkin' credit to his oul' man, not like the resht of them ingrateful little brats. Spoiled gurriers is all they are. They all take after herself. An' what's she, I ask ya? A nothin', a nobody. Even ashamed to talk of her father an' mother. Afraid with good reason, min' . . . "

Eddie started to make for the door.

"Do ya know what my trouble was, Packie? I gev in too aisy. I hadn't the heart . . . "

"I know, Bill. You're too sof'. I always said that. Bill Dwyer's too sof' for his own good."

As Eddie reached the door, he could still hear his father's voice. "I should've ruled with an iron fisht, but what's the use talkin'? You've on'y the wan chance in this life, I swear to God. That's what I believe, Packie, an' you can take it or lave it. On'y the wan chance . . . "

When Eddie got back to the office, Damien was on the phone and he gestured for him to pull over a chair. He wrote the name Dreissman on a piece of paper and slipped it across the desk. Then he tilted the phone in Eddie's direction.

"Yes, it's Dreissman all right. He's been after this Belmont place for years, but his lawyers found flaws in some of the leases."

"Then there's no problem for the tenants," Damien said, winking at Eddie.

"It's not as simple as that. Some of the leases are up for renewal next year and the landlord has the option of jacking up the rents. The whole business has been dragging on, but Dreissman is still keen. He's given the Connollys a few more months to sort it out."

"So our Mrs Connolly is trying to evict them under another name."

"Oh, she knows very well how to make her actions look benign. Listen, Damien, I'll look into the Belmont business further and be back to you in a day or two. It might be worth a shot, that's all I can say for now. All the best."

"Thanks, Neville. I owe you one. Good luck."

When Damien put down the phone he jotted a few notes on a pad.

Eddie was almost afraid to speak. "That was fast work," he said.

"I like to put my free time to good use."

"So I see. Well, what do you think?"

"I think it's an interesting situation. But if you want the firm to go on with it, you'll have to be prepared. We could have a long, tough fight on our hands."

Eddie almost leapt out of his seat. "I want you to go on with it, sure. But what about Mr Grealey and his debt to Lindeman?"

Damien smiled. "It must be that Mozart that Carol's been playing all morning. When I spoke to him at lunchtime he was in a real mellow mood. He said we would be a lousy firm if we weren't prepared to act in a case like this. And he agreed that we should waive the costs for one of our own. I couldn't believe my ears."

"One of our own?"

"Yes. That's what he said."

"That's fantastic."

"I'll need a written authorisation to act for your grandmother.

That'll have to come either from the old lady herself or, if she's not deemed *compos mentis*, from your mother as the next of kin."

"I think it should come from my gran'mother: it's her they're planning to move. And besides, I'm not sure about my mother any more. She's got no fight left in her: it's like she's given up on life."

"I'm sorry to hear that. Well, then you'll have to get on your bike and go to Belmont. And what about your father? Did you have any luck tracking him down?"

"I spent the lunch break lookin' for him. I went to the Sidings first . . . "

Later Damien said: "Eddie, this Belmont business is a big undertaking. It could turn into a long fight and could cost you an important friendship, have you thought about that?"

"You mean Cormac Mannion?" Eddie sat down and tried to look composed. "I suppose that's just a risk I'll have to take."

* * *

As he drew near Belmont Eddie got off the bike and sat on a grass bank to catch his breath. He took Ann's letter out of his back pocket and read it for the second time.

> Dearest Eddie,
>
> Remember the wonderful day last summer when we cycled miles out to the woods. Well, I foolishly described it (or part of it anyway!) to Imelda and now she never stops talking about it; in fact, to be quite honest, she's leaning over my shoulder this very minute
>
> *Hi, Ed. This is Mel XX*
>
> (sorry about that) to make sure you don't forget your promise.
>
> You promised (in case you've forgotten) to make it up with Cormac (finally) and to bring us all (me and Imelda and Cormac) to an even more exotic place, beside some lake in Westmeath or Tipperary, a place where we could

swim and lie in the sun and have picnics – and maybe, if we brought two tents (two, mind you, that's what you said), stay for a couple of nights.

Well, the fact is, Mel is really crazy about Cormac, so much so that

Lies, lies – Mel XX

(please ignore these asides, especially the xx's) that she came up with this brilliant (!) idea: but first let me outline the problems.

1, We're both trapped in this creepy boarding school till Friday, June 16th, when we have the last of our Leaving papers. (Oh lucky you, that you dropped out in time to miss all that!)

2, Cormac, according to Mel, is trapped in his school till Sunday 18th, because of a boring centenary weekend, with prize givings, parents' days, sports displays etc, etc (yawn, yawn!)

3, Almost as soon as we get home we're all going to be hauled off out of harm's way by our respective families – me to Donegal on June 20th for six weeks of rain instead of the usual four, Mel to France (with brother Maurice) for a two-month cultural jaunt – O quelle joie! – and Cormac presumably on his usual routine, which Mel will now describe in remarkable detail:

Hello Ed. This is me again (Mel XX). Cormac's summer schedule: Belfast-Drumaan exchange with friend McEldowney – 2 weeks; Lough Corrib to stay at aunt's country lodge – 2 weeks; Westmeath to visit father and sister – 2 weeks; leaving a mere fortnight in Drumaan, when I'll probably be in Bordeaux or Avignon, before we're all dispatched to our various third level institutions for further brain washing and torture. (Oh, for the long summers when he used to creep about peering over the garden wall and I pretended I didn't notice!!)

– Mel XX

So, now for her brilliant solution: Mel and I are to tell our parents that school ends on Sunday 18th, not Friday 16th; you assemble bikes, tents, sleeping bags, food, cooking utensils, anti mosquito cream, swimming togs (or

do we need them?) etc etc and wait for us at Martin's Cross at noon on Friday 16th.

Maybe one of your driver friends from the abattoir would drop you over there with the bikes; the tents are in the corner of Imelda's father's garage – you'll have to spirit them out well in advance; and, by the way, the garage is never locked.

Then we'll all cycle over to Cormac's school, mingle casually with the families and guests at the centenary celebrations and Mel will use her ample charms (she's objecting to the word ample!) to lure Cormac away with us (on his own bike, of course, which he keeps in the school).

If you think this is a reasonable plan, then you're as far gone as we are. If you think, on the other hand, that it's a really a mad, demented, hare-brained scheme, you're probably right, but such are the flights of fantasy induced in otherwise intelligent beings by long periods of unnatural captivity and separation.

I know, I know: what about the luggage, the parents calling to collect us, the prospect of expulsion, the risk of pregnancy, the danger of drowning, the disgrace to the family name, the midges in the woods, the big bad wolf, the parish priest etc etc? However, I promised Imelda I'd tell you about it, so there you are, that's the 'plan'. See you at Martin's Cross on Friday 16th!!

Or, more probably, under the town hall clock between two and three. No bikes, no tents – just you.

All my love
Ann

* * *

"I came to see how you are," he told Granma when he arrived at her gate. The dogs were bounding about, whining with excitement and licking his hands. She looked at him blankly for a moment from the doorway; then a smile of recognition came over her face.

"It's me, Eddie."

She laughed. "D'you think I'd ever forget a face that ugly?

209

Come here an' give us a hug, Ed. See, the dogs remember you too. Get down, ye brutes."

He followed her inside and she went through the same motions as when he had first arrived in her house two years before. But her movements were slower now, heavier and sadder, and her hands trembled as she set out the mugs and plates on the table. She no longer resisted when he offered to help.

"I was hoping you'd let me stay for a short while."

"Of course I will. But you'll have to make up the room yourself. I'm beyon' scalin' them heights any more. So, tell me all. How's everyone at home? All fit an' well, I hope."

"Fine. Not a bother on any of them."

"I hope so. There's enough real sorra in this worl', you know. We've no call to be manufacturin' more."

"It must be lonely for you now since Granda died."

He remembered the grey November day they had all traipsed out in their dark clothes from Drumaan to Belmont and walked behind Granda's coffin – all except his father of course. And there had been talk of visiting Granma more often after that, now that she was on her own, but nothing had ever come of it.

"Aye, you'd miss him, quiet an' all as he was. But he's not far away, you know. That's what I do tell meself. He hasn't gone far. An' we'll be together again soon, I've no doubt in the worl', arguin' the toss like we used in th'ol' days. An' gettin' in each other's way, jus' the same."

She pottered around, chatting and buttering bread, before sitting down opposite him and filling two mugs with hot black tea. "Now, tell us: did you ever get aroun' to marryin' that Dooley wan yet?"

"Not really. I took some of your advice though."

"You want to min' she doesn't slip through your fingers."

"We made a solemn pledge, like you said."

"You know your Granda and me was never married and divil the bad luck or illness we had all our life."

"I think you made your own good luck, both of ye."

"We put down our own path anyway. But aren't you gettin' awful wise in your ol' age?"

"I don't know about that."

When he brought up the property question, she said she'd been visited only the previous week by Commandant Connolly's wife.

"She was here herself?"

"Sittin' where you're sittin' now. But don't ask me what day of the week it was. Tuesda' or Frida' maybe."

"And how did you get on with her?"

"Mighty. Well, mighty up to a point."

"Oh? What does that mean?"

Mrs Connolly was a fine lady, his grandmother said, and very polite; but when it came to talk about moving and going to live in town, Granma had told her she had no intention of leaving the house until she was carried out feet first. The land was consecrated ground, she had explained to her visitor, consecrated by two lifetimes' work and nothing would alter that fact. "That soon put an en' to her gallop, I can tell you."

"So, what did she say then?"

"Oh, she tried to tell me this an' that about doctors' care and nursin', but I tol' her I was here till I died and there'd be no more talk of leavin', not now or never. I tol' her that ol' yarn from aroun' here, d'you 'member? The one called the Moun' of the White Bones. An' I said: 'Jus' like the lovers in that story, we're all part of the earth itself an' can never be moved by any livin' soul.' That gave her somethin' to think about, I'm tellin' you. I could see it sendin' a shiver through her col' bones."

"So, what had she to say to that?"

"Oh, she went awful quiet then, so I left her be and said nothin' for a long time. An' then she spoke in a real sof' voice altogether. 'Mrs McMahon,' she says. 'I'm honoured to have met you. You're a fine, brave woman. I'll be in touch with you again.' An' then she stood up and lef' the house without another soun'."

"Amazing! You put a spell on her."

"I did me best to anyway. 'I'm honoured to have met you,' she

says. 'And I'll be in touch with you again.' An' her voice was that sof' I could hardly make out what she was sayin' over the cluckin' of them two oul' hens."

"Do you think she's going to drop the case and leave it at that?"

"I do not. I'm a bit long in the tooth to fall for sweet talk the likesa that. For all her palaver, I seen a col' look in her eye. She's still plannin' to get me off the lan', I'd swear – an' that's what she was thinkin' even as she sat there plamásin' me to sweeten the blow. She'll try to fin' some other way, though what that might be I don't yet know."

That night Eddie took the two dogs over the lanes and by-roads that he had last walked with his grandfather. He stopped at the cemetery beside the estate wall to listen to the night breeze in the trees. Granda's grave was the most recent plot and the best tended. The air was sweet with the perfume of pine needles and honeysuckle. The dogs crouched down beside him and rested their chins on their paws.

As he left the cemetery, he thought of Ann and how soon they'd be together again. He pictured their reunion under the town hall clock and he smiled at the prospect of holding her close to him. There would be wolf-whistling and cat-calls as usual, but why should he care about that?

"This summer I'll bring her here, come hell or high water," he said and the dogs tilted their heads and looked up at him curiously. "And I'll bring Cormac and Imelda here too," he told them. "What do you think of that?"

Walking back to the house, he wondered about Mrs Connolly and her visit to his grandmother. She had said she would be in touch again. Had Lindeman's letter to his mother been written before or after the visit? It must have been after; it must have been the "other way" that Granma's intuition had warned her to expect.

From the post office at the crossroads he rang Damien the next

morning and got permission to spend a few days visiting people in Belmont. He told him he wanted to find out what kind of pressure they were under from the Connolly-Lindeman scheme. Then he bought a pad and a folder and set off on his rounds.

Most of the locals remembered him from his summer working there and welcomed him into their homes. Women told him that prayers and novenas were being offered to prevent eviction, but he heard less pious responses from the men in the fields and the farmyards.

A number of different proposals had been made by Mrs Connolly and Lindeman; anywhere there was a loophole in a lease it was being seized on and made the pretext for questioning the occupants' rights. Some old people had been approached in person with financial offers. It was clear to Eddie the intention was to unsettle the community and make people uneasy.

One sad-faced old man, whom Eddie remembered from the discussions in his grandfather's time, was trembling with rage. As he lit his pipe and filled the room with blue smoke, he talked of burning down the big house rather than letting the area fall into foreign hands – but his wife whispered to Eddie on his way out of the house that her husband's bark was a lot worse than his bite.

Even among the younger tenants there was confusion. In the atmosphere of uncertainty some were talking of leaving Belmont for good; others were going to stick it out. There were bitter debates within families, some arguing in favour of progress and new employment, others defending ancient rights.

Eddie spent two days interviewing people and assembling documentation to pass on to Damien – but he knew he could never convey to him how deeply the community was already split.

"Divide an' rule," his grandmother commented when he reported back to her. "I never thought I'd live to see anyone be the name of Connolly usin' them tactics. But then she's on'y a Connolly be marriage, that's all." And Eddie smiled at the disdainful way she pronounced the word "marriage".

"We'll call their bluff, Granma. Damien is the best lawyer in the county."

"I hope you know what you're doin', Eddie. You don't wan' to start gettin' people stirred up unless you inten' to stick to the task."

"I'll stick to it, don't worry. I won't give up without a fight." Then he added under his breath: "I'm not like Mam, you know."

Granma stopped fussing about the kitchen and sat down at the table. "So, Biddy finally stood up to your Da and drove him outta the house," she said. "An' about time too."

Eddie looked at her in amazement. "How did you know about that?"

"Sure, doesn't your Mam tell me all."

"Did she tell you the day of the funeral, is that it?"

"Hadn't we enough on our min's that day? No, she tol' me in one of her letters. 'If it wasn't for young Eddie workin', I don't know what would've happened to us all,' she said. She has you up on a high pedestal, so she has. You wouldn't wan' to be lettin' her down."

"I didn't know she was writin' to you. When did she start doin' that?"

"Biddy writes to me all the time now, since before your Granda died. An' great letters they are too. I get one from her every week, sometimes two. Don't ask me what day, though. I've a fierce head for the days of the week."

"Since before he died? That's strange."

"Oh aye. She had it all squared up with him before he departed, whatever misunderstandin' there ever was between them. He felt sorry all his life he hadn't more t'offer her. He knew she had a bad time with your father an' she had all them kids to look after – includin' yourself, the most troublesome of all!"

Eddie remembered his mother pulling away to the stove when he challenged her.

Granma got up and walked slowly to the mantelpiece. She carried back a shoebox of letters and set it down on the table. "Your Mam is a great writer, you know. Halfa what's here is hers. An' there's a few from yourself, not that many, min'. An' Josie in Englan', of course; she writes when the spirit moves her, but

that's not too often be the looks of it. Eleanor wrote once or twice too. The rest is bills an' that kinda stuff. The eyes are not as good as they used be, you know. But I jus' about manage to make out . . . "

"That's strange," Eddie said. "Very strange."

On his way back home, he decided to take a shortcut through the Drumaan Clearing. This was a tract of scrubland that had been zoned for development, but only a few houses had been built before the town funds ran dry. As he drew near the area he noticed caravans and trailers stationed around the open space: a circus company was setting up residence. It was a French Canadian troupe and they had sent out clowns to entertain the local children while the tent was being erected.

People of all ages had come to watch and they were standing around in groups or squatting on the grass. In the centre of the area an enormous mass of white canvas lay splayed out on the ground. Workmen were unravelling ropes and wires and two crane-like scaffolds stood ready to take the weight of the marquee when it was hoisted.

Kids ran around the perimeters of the Clearing, their voices competing with the hum of generators. They pointed excitedly as zebras and ponies were led from the trailers. Loud-speakers had been suspended from telegraph poles and soon the whole neighbourhood vibrated to the beat of vintage pop songs. An old Beatles song was played and a great cheer went up.

> "I'll get you anything, my friend,
> If it makes you feel alright.
> For I don't care too much for money . . . "

A convoy of army trucks and personnel carriers suddenly appeared and pulled over to the grass. A sergeant jumped out of a jeep and spoke to the foreman in charge of erecting the tent. He then barked an order and a dozen or so recruits leapt from the trucks and ran to join the circus workmen.

The soldiers were quickly assigned positions and told which

wires and ropes to pull. The command was given and the mass of canvas rose up – great wings struggling to open, as the men hauled ropes, clamped them to metal pegs and tightened them with winches. There was a cheer as the flapping canvas reached the hilts of the scaffolded poles, as if some extraordinary goal had been achieved. At first it fluttered furiously, but then, as the wires and ropes were tightened, it stiffened into a great white dome. People applauded again and turned to each other smiling.

Eddie smiled and applauded too. And he remembered: a white bird had risen up and brushed his grandfather's face one morning in Belmont. Now one had risen for him too. If only Ann was here: Ann and Eleanor and his mother and all the kids. They were not blind to such things; their hearts would have lifted up, just as his own had. And Cormac would have laughed too, the excited way he used to laugh when he saw a perch lurking in the reeds or when Eddie played a good handball stroke.

A small, round-faced woman standing next to Eddie brushed against his arm. "They'll be hard-pressed to folly that, I swear. That's the besht I ever seen in all me born days." Then she blew her nose tearfully in her apron and went back, sniffing, in the direction of her house.

When the operation was complete, the circus people shook hands with the soldiers, offering them cigarettes and other tokens of gratitude.

Eddie was about to leave when his heart stopped cold: a soldier was walking across the green towards him. He was smiling and calling Eddie's name. The man was wearing a smart corporal's uniform and as he drew nearer, the smile gradually turned to a look of concern. It was only when the figure was within feet of him that Eddie realised he was staring at Tom Egan, not his father' ghost.

In his smart military uniform Egan was transformed: he had lost weight and his face was now clean-shaven and tanned. "Eddie! Don't tell me you don't reco'nise me. 'Who's that thrip-

thrappin' over my bridge?' Oh my God, but we had some quare times in those days."

Eddie looked at him in amazement.

"Hey, they tell me I've changed, but I'm not the Abominable Snowman." He put his arms around Eddie's shoulders and gave him an affectionate bear hug, nearly lifting him off the ground. "Be the hokey, I'd think twice about challengin' you to a han'ball game now so I would. I should maybe've thought twice about it at the time. But that's all water under the bridge, as they say . . . "

"Tom. I didn't expect . . . "

"Well, don't look so surprised. Didn't you hear I joined up? We're just back from a stint in the Middle East. Boy, am I glad to be home. Come on, walk back to the jeep with me an' I'll tell you all about it. There's free fags goin' over there and comps into the circus if you play yer cards right. So, tell us your news. What've you been up to since?"

Later Eddie watched the soldiers boarding the trucks and the military cordon driving away towards the Curragh. As he picked up Eleanor's bike and set off for home, Fats Domino was crooning in the background:

> "I bin aroun' the worl', it's true,
> Lookin' for someone exactly like you,
> An' what did I fin'? I foun' that it's true
> Oh-oh-oh-oh, oh-oh-oh-oh, oh-oh-oh-oh . . . "

He could still hear the circus music in the air as he turned the corner and free-wheeled down into the Pearse Estate. He swerved once or twice to avoid broken glass. Without the usual armies of kids running and shouting, the streets seemed desolate.

As he jumped off the bike, he noticed a small figure squatting on the front step of his house. It was Mouse Morrissey. This was his night for ghosts, Eddie said to himself.

Morrissey jumped to his feet and met him at the gate. His face was pale and he was in a state of agitation. "I've a message for

217

you," he said, sticking a scrap of paper into Eddie's hand. "It's got nothin' to do with me, Dwyer. I'm just doin' you a favour, that's all."

Eddie had some old grievance with Morrissey, but he couldn't remember clearly what it was: something to do with Eleanor, he seemed to recall. Maybe the note was about that. Before he could stop him, Morrissey had slipped away and disappeared up the darkening street.

In the yellow light from a street lamp Eddie read the note.

> Eddie Dwire – come out to the railway Sidin. Your
> father needs you bad. Hes sick – Bridie Joyce.

Eddie got on the bike and rode back towards the centre of Drumaan. He could still hear the blare of the rock music from the circus field. He slowed down. Maybe it was all a trick: there was an air of lunacy in the town. What was he letting himself in for if he went to the Sidings at this hour? He thought of the tinker woman with her black smile.

On his way past Grealeys' he noticed a light on in one of the rooms. It was Damien's office bell. After a minute or two he heard footsteps on the stairs and Carol opened the door. She looked relieved when she saw who it was.

"Carol? What are you doing here?"

She smoothed the make-up on her cheeks. "I was just talkin' to Damien, that's all. A personal . . . business matter. What brings you here?"

"I'm sorry to barge in." She turned and led him upstairs.

"Something important's come up."

Damien was making a poor display of tidying away files when they reached the room. He looked uncomfortable but he spoke in his breeziest voice. "Well, old scout. I thought it might be you. We were afraid you'd emigrated altogether. What, tell me, did you unearth in the wilds of Belmont?"

"A lot of stuff, but that's not why I'm here. I just got home and a kid handed me this note."

"I've some news that will interest you, m'lad," Damien said, taking a file from the cabinet and placing it on the desk.

"I think you should look at this note first."

Damien read it and turned the scrap of paper over. "Who's Bridie Joyce?"

"I'm not sure. I think she must be the tinker woman I met at the Siding the other day. Remember, I told you about her."

Damien adopted one of his grave professional frowns. "She was asking for money that time, wasn't she? And vaguely threatening you into the bargain, I seem to recall."

"Yeah."

"Then be wary. If your father's sick, why would they send for you? Why wouldn't they get someone to call an ambulance, someone from one of the houses out by the railway?" He handed Carol the note. "What do you think, Carol?"

She frowned as she read it. "Looks a bit hairy to me, Eddie."

"Who gave it to you?"

"A little creep called Morrissey. I wouldn't trust him as far as I'd throw him."

"Well, I'll drive you over there if you want, but my advice is call the hospital and get an ambulance sent out. I really don't fancy taking my car over there. And you'll stay clear of that place too if you've got any sense, Eddie. Don't get involved."

"But he's my father."

"Is he? Remember what you said the other day. And remember the threats about people from the abattoir."

Carol was getting restless. "We'd better be goin', Damien. That's if you're still plannin' on droppin' me home." She was examining her face in a hand mirror and saw Eddie looking at her. "I'm sure it's a hoax, Eddie. Some kids' prank, that's all. Let the ambulance or the guards deal with it, as Damien says."

"Here," Damien said, handing Eddie a key from his ring. "Phone from here if you want and lock up when you're leaving. You'll be in tomorrow, won't you? Bright and early, I hope."

"Sure."

"And take a look at that file on the desk. Then put it away.

It's strictly confidential, but I know you can keep a secret. You're one of our own now, remember." And he winked pointedly at Eddie as he and Carol left the office.

Eddie put the note on Damien's desk and started to dial for an ambulance. As the phone was ringing he looked at the file: it was marked *Commandant Francis D. Connolly.*

He opened it and saw a last will and testament drawn up in Damien's handwriting. At the top of the page it was marked *Revised* and beside this was written: *As of the Thirteenth day of June in the year Nineteen Hundred and Sixty-seven.* The document was witnessed by Harry and Damien Grealey and signed by Commandant Connolly.

Attached to the will was a copy of a letter removing the executorship of Belmont from Mrs Maeve Connolly and David Lindeman, and conferring it instead on the firm of Grealey and Grealey. All future decisions concerning the Belmont leases would have to be approved by the Commandant – or, if he was too ill to be consulted, by the main beneficiary of the will in relation to the said properties.

"*Hello, hello . . .* " a shrill voice bellowed in Eddie's ear.

"Just a moment," he said, putting the receiver down on the desk. "Hold on a second."

On his way to the railway bridge he had to cross the site where the circus people were still making preparations. A gentler music was now wafting from the loudspeakers and the onlookers had started drifting away in groups.

> "I found my thri-ill,
> On Blueberry Hi-ill,
> On Blueberry Hi-ill,
> O-on Blueberry Hill,
> Whe-en I-I met you."

He rode past clusters of kids and cycled towards the bridge as hard as he could.

The will had mentioned two people he didn't know: Seamus Hogan and Leonie MacBride. The day of the pigs fiasco in the

abattoir, while they were talking in the alley, Cormac had said something about a maid of his aunt's called Leonie. That day too Eddie had been upset by the name but he had never worked out why.

When he reached the bridge, he turned down along the cinder path that ran beside the railway. Someone shouted: "There goes Eddie Dwyer, Drumaan's new legal eagle."

"Off ta visit the oul' Da, be the looks of it."

"Up the yard, ya bollix ya!"

"Get them off ya, Dwyer!"

Eddie slowed down. A young woman was walking towards him on the narrow pathway. She was dressed in dark clothes and carried an old-fashioned wicker basket. As she walked she let the basket hang loose in front of her, bouncing it gently against her knees. She was smiling to herself and gazing up at the evening sky.

He stopped and got off his bike. As she drew nearer, she seemed to hesitate. He stood to one side of the path to let her pass. She came closer, looking hard into his face.

"Are you . . . ?" she said and stopped.

"Am I what?"

"I just thought you were . . . someone, that's all."

"I am someone. I'm Eddie Dwyer."

She stared at him for a few seconds more and then turned away. "I'm sorry. I didn't mean . . . "

He felt a wave of anger. It was obvious there was some kind of conspiracy abroad: even the the mention of his name was taboo.

"Are you part of this game too?" he asked.

"What game's that?"

"This trick to get me out here."

She raised the empty basket and set it down gently on the handlebars of his bike. "I'm Leonie. Leonie MacBride. I work above in Comma'dant Connolly's. I know of you from talkin' to Cormac. He used tell me about you all the time. I don't know an'thin' about any games or tricks."

"Cormac?"

"Yeah. I know ye used be great pals, you an' him."

"How did you know me to see?"

"I knew you from your father. You're th'image of him – in certain ways. In other ways you're differen'."

"Well, Cormac never told me much about you."

She smiled. "Did he not? Maybe that's just as well. Maybe ye had more important things to talk about." She leaned across the handlbars and patted Eddie's arm. "I'm glad I met you, Eddie. I was just down visitin' your Da. I brought him some food. I try to bring him stuff whenever I get the chance. He's in a bad way, y'know, but there's no talkin' to him. There never was, not as long as I knew him anyway."

"Is it serious? I got a note . . . "

"Himself an' his mate got into a woeful fight over money, that's all. But they're sleepin' it off this minute. They'll be OK."

"Is there a woman there called Bridie Joyce?"

She nodded and glanced past him. He heard the hooting of a night train in the distance. It was clear she wanted to leave.

"I used know him real well, your Da, when he worked for the Comma'dant. We were . . . good pals for a while, him and me, but that was a long time ago."

"I only found out lately that he used to work there. Cormac never said anything, not till I asked him."

She looped the basket over her arm and glanced again towards the bridge. The train whistled again, closer this time. "I better be goin'. It's gettin' late an' I've no leave to be out."

He stood back to let her by, and then, as she edged past him, he knew where he'd seen her before. The trees were rustling all around the alley that night, warning him away. But now there were no trees, only the sound of the train racing nearer by the second.

"Are you the woman . . ? Were you with my father once . . ?"

She smiled at him and put her hands over her ears. "Where?"

"At the handball alley," he shouted. "I was there that night . . . "

There was a roar as the train rushed under the bridge and thundered past them. For some moments it was the only thing in the universe as it powered beside them on its fixed course,

obliterating all cares. Then, almost as suddenly it was gone – but the commotion still hung in the air.

When he looked around, Leonie still had her hands over her ears. "Yes," she was saying as she backed away along the cinder path. "Yes it was me. I was with him that night. An' other nights too." But he could only lipread her words – and guess something of their meaning from the pained look in her eyes.

He stood watching her till she crossed the bridge; and at one stage she glanced back at him and he thought she smiled – but it was not easy to tell in the uncertain light. Then she was gone.

When he reached the Siding, he found the tinker woman squatting beside the embers of a bonfire. She was eating from a brown paper bag, shaking the food into her hand. Occasionally she examined pieces of bread and meat and tore at them with her fingers. When she heard him approaching, she pulled a long burning stick from the fire and tucked the bag under her shawl.

"Where is he?"

She nodded in the direction of a warehouse.

Eddie found his father lying on some sacking in the corner of a shed. He appeared to be in a drugged sleep. There was a candle burning on the concrete floor near his bedding and some food beside him on an army tin plate.

He went nearer and saw that his face was covered in sweat. There were cuts around one of his eyes and signs that some attempt had been made to clear the grime around them. He became aware of a rancid, sickening smell and felt his stomach begin to heave. As he went to the door for air, he realised the woman was standing watching him.

"He's in a woeful state. He'd be dead to the worl' if it wasn't for that young wan."

"Why isn't he in the hospital? Why did you send for me and not an ambulance?"

"Sure what good's the 'ospital? He was there often enough, God knows, an' divil the bitta good it done him. It's not doctorin' he needs. He's far beyon' that."

"What do you mean?"

"I mean he's killin' hisself slowly – an' draggin' all an' sundry wit' him, meself and Packie there included."

"What are you talkin' about?"

She gestured in the direction of another corner. Eddie went back into the shed and took the candle over to what he had thought was a bundle of clothes. It was a human body, lying face down. From the greasy red hair he recognised the man his father had been drinking with in the Greyhound Bar. He bent down to feel a pulse.

"He's not dead," the woman said. "Not yet anyways." She grimaced and he thought she was smiling. "They were at each other's throats like mongrels, so they were. Savage fuckin' mongrels, the pair o' them. I don't know how ayther o' them's breathin' yet. Them kids were eggin' them on an' cheerin', so I collared one of the brats an' gev him the note. Morrissey, they call him. I tol' him I'd tell the guards how they was stealin' money an' puttin' theirselves mad on drink."

"You said in your note my father was sick."

"Aye. Sick in the head. I'm tired of the pair o' them. Drinkin' an' fightin' an' half killin' theirselves, night after night."

"I better go for an ambulance."

"Go for a priest, son. Never min' th'amb'lance. I often seen them get up after worser 'n that. Right as rain, the pair o' them. Then back to the pub an' all pals again, laudin' each other an' laughin' at their oul' second-han' jokes. It's enough to make a dog puke."

The figure in the corner stirred and made a moaning sound. "See. What'd I tell ya. It's wearin' offa them yet. In an hour or two they'll throw up an' piss it all outta them, like mongrels ya'd see at the bins in the street."

"Are they warm enough there?" He saw an army greatcoat in his father's corner and spread it over him. The other man was already covered.

The woman laughed. "Wait'll I turn up the centhral heatin'!" And she was still chuckling at her own joke as she walked back

towards the smouldering fire. "Wait'll I turn up the heatin', jus' so's no-one gets a cowld or an'thin'."

Eddie stayed inside. "Da, it's me," he whispered. "It's me, Eddie. Edward the First." He shook his father's shoulder gently and the slumped figure stirred; he mumbled something and then fell back into a deep sleep.

Eddie took two ten shilling notes out of his wage packet and stuffed them into a pocket of his father's coat. He went to check the other man and found him breathing fitfully. There was no sign of an open wound on his head, but one of his cheeks was swollen and scratched. He reached down and used his handkerchief to wipe away some of the hardening blood from the man's face.

"How long has she been comin' with food?" he asked the woman when he joined her at the fire.

"Leonie? Oh, ever since your ol' man firs' come here. She turns up three times a week, reg'lar as tha' night thrain. If it wasn't for her we'd all be dead a long time ago." Then she looked at Eddie and laughed again. "Maybe you're thinkin' it'd be betther for all if we was dead. Well, maybe it would. An' betther for us too. Hell'd be warmer than this kip, that's for sure."

Eddie stared at the embers. "You won't be going there, I can tell you that. You've had more than your share already."

"Aye," she whispered quietly, "you're right. Whatever bad we done, we paid for it be this time, that's for def'nite. An' God hisself knows that 'cause he seen it all. An' nothin's beyon' his power to forgive, nothin' in this wide worl'. So they say, anyway."

Eddie watched her as she poked the black remains of the fire. He knew he could tell her things he would never speak of to another living soul. Not to any priest or doctor. Not even to Ann or his mother or Cormac. He wanted to thank her for caring about his father but instead he sat and listened to some of the events of her life, things she recalled with humour as well as regret.

Before he left he rummaged in his pay packet and gave her his few remaining coins. "I'll be back," he promised, holding on to

her hand. "I'll get ye all out of here and into some place decent, if it's the only thing I ever do in my life. I swear to God I will."

When he reached home, he walked around the house to the back yard and left Eleanor's bike in the shed. His mother heard him and came to the kitchen door. "Is that you, Eddie?" she whispered, peering into the darkness.

He went to the door and put his arms around her. "Yes, it's me, Mam." He held her tight. "I'm sorry for what I said the other day. I don't know what got into me."

"Shh, that's all right, son. We all get hot an' bothered betimes. You look very pale an' you're drenched in sweat. Is there somethin' the matter?" She drew him in towards the light and peered into his eyes.

"Not a thing." He had just ridden back from Belmont, he told her. He was a bit tired, that was all.

"I guessed that's where you must've got to."

A great spray of crimson roses stood in a vase on the table. The room was warm. Eddie sat down, remembering something Carol had said about sending flowers if he wouldn't. He was just as glad she had done it.

"I see Carol was here," he said, touching a petal.

"Carol? Oh yeah. That's right. She brought me them flowers."

"Why didn't you tell me you wrote letters to Granda before he died? And that you were writing to Granma too all this time? Why did you never let on?"

"Why should I let on? I have my . . . private life too, you know. My own little secrets." She was filling a saucepan of porridge to steep for the night. "I'm sure you done things you never tol' me about. But that's all right. It doesn't mean we're hidin' or an'thin'."

"I don't know. It feels like we're ashamed somehow. I can't help thinking that's why Eleanor's over in England and hasn't the heart to come back."

"Eleanor's all right. Now, stop frettin' and tell me: how did you fin' your Granma this time?"

"She's great. Amazing. I really love that woman."

"I know you do, Eddie. You've a lot of love in you, an awful lot."

He looked at the flowers and pressed one of the petals, the way his grandfather had shown him to, to release its scent. "If I have, I got that from you."

She smiled. "Do you think so?"

"Yeah. But from others too. Eleanor and Ann. The kids. Your father and mother. Maybe even . . . who knows . . ?" He found it painful to admit.

"Say it, son."

"Maybe even from my father."

Mam came and sat beside him. "It's no harm to forgive, Ed. At least, that's what we're tol'." She put a hand on his.

"I know. But it's not that easy."

"To tell you the truth, you're further along that road than me. Much further along it. I've a lot to learn from my own son."

She was about to stand up but he held on to her hand. "I still can't figure out why you didn't tell me you were writing to your parents."

"Well, maybe you will some day." She pushed back her chair and returned to the sink, making final preparations for the night. "Do you know there's a circus in town?" she asked.

"Yeah, I know. I'm bringing you all to it – and Ann as well – on Friday. She gets home from school that day. Her parents too, if they'll come. You know, I've a funny feeling they will. It's a French circus: that'll probably give it a touch of class in their eyes. God, if only Eleanor was here! Remember her fretting about how we'd entertain Ann's family."

"And how can you afford to buy all them tickets?"

"I got a whole bunch free on my way home tonight. Hey Mam, do you know who I discovered was out in the Middle East?"

"Tell me later. You better run up and say goodnight to the kids. They've been missin' you like mad. 'When's Eddie comin' home? When's Eddie comin' home?' That's all I got from mornin' to night."

He heard a muffled sound from the hall. "I think I hear one of them shuffling around outside."

"Oh, by the way," his mother declared. "There's a surprise for you in the hall." And he noticed she said it in a very loud voice.

Before he reached the door, it flew open and Eleanor rushed in. She threw her arms around him and he felt the silkiness of her hair on his face. He held her with all his strength and she did the same with him – until eventually she drew back for air.

"Jesus, Mam!" she laughed as he pinched her. "I thought you'd forgot your cue, you took that long gettin' to it. You're the greatest pair of blabbermouths I ever heard in all my born days. 'I got it from you; no you got it from me.' Ouch! An' he *actually* believed you about Carol bringin' the flowers. Such an eejit . . . Ouch!"

She wriggled free of his grip and held him away from her at arm's length.

"Let's see you, Eddie: stan' back a bit, will you? And stop pinchin'. My God, I don't believe it. Look at the size of him. Will someone please tell me: whatever happened to my kid brother? Whatever happened to wee Eddie Dwyer, in the name of all that's holy . . ?"

1968

Chapter Seven

CORMAC WAS WITH McEl D and a gang of students, running before a police attack. He was elbowed to one side as rioters dragged a mounted police officer to the ground. The man was beaten and kicked till his face was smeared with blood. Then the other officers turned and charged again, lashing out with truncheons and yelling abuse. The students fled.

He ran along a narrow side street and up a steep flight of steps. Looking around, he saw the blood-smeared gendarme following him on his horse: he was alone. The steps stretched ahead of him as far as he could see; behind him the sound of hoofbeats, louder and louder . . .

Suddenly there was silence. Then the soft trickle of water. He was sitting at a fountain in a park near the Sorbonne, washing blood from his hands and face, and drying them in the sunshine. Young women strolled past with prams. Around him couples lay together on the grass, whispering and laughing.

One pair fondled each other openly, the woman occasionally eyeing Cormac as her lover stroked her thighs and slid his hand under her short skirt. She arched her back and closed her eyes with pleasure as he peeled off her sweater. Then, unashamed of her nakedness, she sat astride her lover, taking him into her in full view of the people around them.

Cormac watched for a while. Later, as he passed near the couple to leave the park, he realised it was Leonie he'd been watching, not Imelda as he had first thought.

The train jerked into motion again, jolting him out of his slumber. He looked out at the familiar landscape of the Curragh. Next stop Drumaan.

* * *

His trunk was lowered from the luggage car and a porter scooped it up on a hand-trolley. Aunt Maeve greeted him, holding out a gloved hand.

"Good Lord, Cormac, you look wretched. What am I to do with you? You need food and exercise as well as study, you know: you can't exist on a diet of books."

People bustled past them on their way out of the station. The minute hand of a platform clock jerked forward overhead.

She was well into part two of her lecture by the time he sat into the car beside her. "I know you like playing the part of the penniless scholar, but really you shouldn't come home looking like a refugee. Apart from anything else, it lets the side down."

"The side?"

He was so dishevelled, she went on, it was a wonder he hadn't been knocked down and robbed in Paris. She hoped he'd had the sense to steer clear of the student riots: the television was full of them.

As usual she accelerated through Drumaan as if the town housed some dreadful contagion. "So, what are you planning to do this summer – besides play cat-and-mouse again with poor Imelda Lindeman? I sometimes wonder if you get some perverse pleasure out of torturing that unfortunate girl. I've no idea why she puts up with it."

"Have you seen her lately?"

"Yes, she came by with her father once or twice. It's sad to see her looking around for traces of you – a photograph or a book, a garment on the coat rack . . . "

He asked about his uncle.

"He's not bad, I suppose. Sleeping a lot more than he used to. Leonie takes him for long walks these days. And she's even begun reading to him, believe it or not."

"Leonie?"

"Yes. She wheels him around the country in all kinds of weather, talking to him about God knows what. I really wonder if he's up to the exertion, but you know how stubborn he is. I don't know if they'll have got back from this morning's jaunt yet."

The sky was overcast and the Curragh seemed greener and more welcoming than ever. Leonie had once told him it was no-man's land, but in a strange way over the years it had become his.

"I'll miss the mare. I was sorry you had to sell her."

"She was so old we were lucky to find a buyer. But it was sad, I've got to admit."

"So, why did you want me to come home? Your letter made it seem quite urgent."

"We'll talk about that in due course. First, you should have a bath and get Leonie to do something about your clothes. Have they no dry-cleaners in Paris? To look at you it's hard to believe you've just arrived from the fashion capital of the world."

Seamus helped Cormac drag his trunk upstairs. By the time they reached the attic they had to sit on the bed to recover their breath.

"You must have halfa ton of lead in that yoke, Masther Cormac. Did you raid a buildin' site or what on yer way home?"

Cormac rummaged in the trunk and handed him a cobblestone wrapped in a Paris newspaper. The students were ripping up the streets and hurling them at the police, he told Seamus. "I went out to take pictures and ended up lending a hand."

The gardener held the stone reverentially. "Isn't that a fret?"

Cormac pointed to some blackened bloodstains. "The hallmarks of history," he said solemnly.

"An' what has them hurlin' the likesa that at the p'lice?"

"Years of oppression, Seamus. It's like the lid boiling off a kettle."

"Aye, that's for sure."

"Now the workers are occupying the factories. It won't end there, mark my words. 'Rise like lions after slumber . . . '"

"Lions is right."

He rummaged again in the trunk and handed Seamus a bottle of brandy which the old man stuck inside his shirt, glancing furtively at the door. Then, before disappearing downstairs, he whispered from the doorway: "Up the rebels!"

Later, on his way down, Cormac stopped at the Commandant's quarters. The room was still immaculate – polished every second or third day as a shrine to his uncle's faltering spirit. The Commandant's best uniform hung in the wardrobe, waiting for the one solemn occasion when it would be worn again.

Cormac heard footsteps in the hall and went on downstairs.

In the garden he found his uncle waiting to see him. He shook Cormac's hand and greeted him warmly.

Cormac offered him a cigarette. "Disque Bleu. They're an acquired taste."

"Horse shit!" the Commandant protested, coughing after the first puff; but then he smoked on, eventually nodding his approval.

"Aunt Maeve tells me Leonie takes you for long walks these days."

"Reads too. Papers, books."

"I thought she only read comics."

"No. Your books. Your letters. Reads a lot."

"Really? I'd better be more careful what I write in future. Seriously though, don't you think it's time she moved on? She's not getting anywhere in this job, is she?"

The Commandant looked about anxiously. He tossed his cigarette away and sat still, staring at the grass.

"I mean, look at it from her point of view. At least if she worked in a factory or a hotel she'd meet people and have a modicum of independence. What do you think?"

He could see the topic was upsetting his uncle, so he talked to

him instead about France. McEldowney had come to stay with him in Paris and they'd hurled themselves into the turmoil. They had even formed a Franco-Irish solidarity group, with branches in Dublin and Belfast.

"I suppose that makes us part of the international conspiracy, the scourge of the CIA and the right-wing press," Cormac said. "But if they only knew: we spend most of our time condemning other left-wing groups and polishing our manifestos – the way Leonie polishes the silver."

The Commandant chuckled. "Don't tell Maeve," he warned. "Might close account. No rev'lution without cash."

"She wrote me a mysterious letter, saying it was urgent I came home. You don't know what that's all about?"

His uncle shook his head.

"I was planning on going with the McEldowneys to Biarritz. His father has a villa and McEl D retires there from time to time, to recover from his political exertions. He spends months sunning himself by his father's pool, being waited on hand and foot while he plots the overthrow of capitalism."

"So, what plans for later?" the Commandant asked.

"I don't know. I'm still thinking I might go to Africa. There's a project I'm interested in, in Kenya . . ."

But before he had time to tell him any more, Aunt Maeve came out to the garden to announce that Leonie had served tea in the conservatory.

With her kitchen radio blaring, Leonie was preparing vegetables for the evening meal. Cormac watched her pressing pea-pods open and scooping the shiny peas into a bowl.

"And this week, still hanging in at number . . . "

She worked with extraordinary speed, pausing only to brush strands of hair from her face and to glance occasionally at her inquisitor.

"What are you askin' me for? She doesn't tell me what's on her min'."

"I wondered if it was something to do with the Commandant's health, but he seems in good shape."

"Here Comes the Sun . . ."

Cormac scoured the shelled pods for peas she might have missed.

"You'll have to wait till she talks to you herself. In the meantime why don't you go roun' an' see Imelda?"

"I will, I will."

"The times you spent prowlin' about like a horny ol' tomcat, gapin' at her every chance you got. An' now, when you've got her eatin' outa your palm, you're not interested. God, but men are the contrary breed, there's no doubt about it."

"Here Comes the Sun . . ."

"Does Aunt Maeve spend much time with David Lindeman these days?"

"A fair bit. Why d'you ask?"

"I was just wondering, that's all."

"He comes by the odd time, but not as much as he used. They spen' most of the time chattin' about property, if y'ask me. About what they'd like to do with the lan' aroun' these parts if they got their han's on it, that kinda thing. Sometimes it soun's like they're plannin' on buyin' up the whole county."

"I wouldn't put it past them."

"If you wan' my opinion, I think they're formin' some kind of a . . . what do you call it? A group that buys land . . . "

"A syndicate?"

"Yeah, that's it. They're even plannin' on buyin' some of the Grealeys' places. So I hear anyway. But the sale of Belmont fell through, I s'pose you heard that."

"And I say, it's alright . . . "

She poured the peas from the bowl into a saucepan and carried them briskly to the stove.

"It sounds like you've been polishing the hall mirror a lot lately."

"I'm jus' tellin' you what I hear comin' an' goin' about the place tryin' to min' my own business, alright?"

"OK, I believe you."

"And now, on a bluer note . . ."

"Why aren't you goin' over to see Imelda Lindeman instead of sittin' here interrogatin' me about nothin'?"

"I am, I am. I just wanted to say hello to you first. I'll call on Imelda tonight after dinner, don't worry. Or maybe tomorrow. There's no rush."

"Who's sorry now? . . . "

Leonie shook her head and disappeared into the scullery wiping her hands in her kitchen apron. When she returned she was replacing it with one of the frilly specimens she wore for her upstairs chores.

"And listen here you, no more pickin' at them peas while I go up to collec' the Comma'dant's medicine tray, d'you hear?"

"OK, I'm going. Keep your hair on."

"Who's sighin', who's cryin' . . . "

* * *

It was two days before he called on Imelda. A maid opened the Lindemans' halldoor. She was younger than Leonie, and Cormac thought he recognised her from somewhere. She had mouse-coloured hair tied back in a ponytail and sharp inquisitive eyes.

"Hello Cormac," she said, blushing and glancing over her shoulder.

Suddenly he remembered. "You're Eddie's sister, aren't you? What are you doing . . . ?"

"Sh! I'm on'y fillin' in here. Don't say an'thin', will you? An' don't tell Eddie whatever you do. He'd murder me if he knew."

"But Imelda and Ann Marie. They must . . . "

"Philomena!" Mrs Lindeman called out. "Is there someone at the door?"

"Yes, Ma'm. It's Cor . . . Master Mannion. He wants to see Miss Imelda." She lowered her voice again and giggled. "I s'pose it's not to see Maurice." Almost immediately there was the sound of feet skipping lightly down the stairs.

Cormac looked past Philomena as Imelda came into view.

She was glowing in the coloured shadows of the staircase, her cheeks bright with excitement. Her mother appeared in the hallway and Imelda slowed down; she stopped at the foot of the stairs, clutching her bare arms as if to hold them in check. Cormac couldn't take his eyes off her: she was wearing a red sleeveless mini-dress, and her long brown hair hung loose over her shoulders.

Mrs Lindeman smiled at him and shook his hand. "Come in, Cormac, why don't you? What are you two girls standing there for, looking shell-shocked? Mel darling, bring Cormac in for a welcome-home drink. David would like to hear all his student news, I'm sure. That'll be all, Philomena, thank you."

As they followed Mrs Lindeman towards the drawing room, he and Imelda laced fingers, pressing their palms together. He was amazed at the thrill of such a simple contact: if only he could have been alone with her at that moment.

Philomena glanced back at them as she made her way towards the kitchen. Mrs Lindeman turned too.

"I'm fine," Cormac said, answering a question that hadn't been asked, and he quickly released Imelda's hand. "I'm thrilled . . . to be home, I mean. Delighted, in fact."

Imelda bowed her head and smiled as he stood aside to let her go first into the room.

Leonie was sitting at the kitchen table turning the pages of a magazine. She glanced up as he came in. "Well, well! Look what the cat brought in. You look a bit under the weather."

He sat down opposite her and enunciated carefully his account of the evening. Imelda's father had wanted to hear about the student riots and had plied him with brandy. *Do they really believe the Soviet system is better than ours?* he'd kept asking.

"I think they're saying: 'A plague on both your houses'," Cormac had suggested.

"Whose houses?" Mrs Lindeman had piped in. "What plague?"

Leonie did not seem amused.

When he and Imelda had eventually been left alone, Cormac told her, they'd strolled to a summerhouse and sat holding hands for about half-an-hour.

Leonie looked up at him, her dark eyebrows arched. "Holdin' hands?"

"I swear that's all. And then Maurice arrived and nothing we could say would persuade him to go inside."

"He's a right little pest."

"So we've decided to go further afield the next time?"

"I see."

"The old hayloft maybe: I hear that's a good place . . . for a frank exchange of views."

Leonie returned her attention to her magazine. "Very funny."

"Well, don't look so disapproving."

"All I can say is, if you're gettin' that serious, you better . . . be careful. You don't want to hurt that girl."

"What are you sulking about?"

She flicked over the magazine pages and spoke without looking at him. "I'm not sulkin'. What you do's your own business. An' I won't be climbin' aroun' the place, spyin' on you either, you can rest easy on that score."

Cormac fiddled with the knobs of her radio. Some German and French voices wafted into the room, then faded. He turned it off. Leonie was still absorbed in her magazine, reading her horoscope. He reached across the table and laid his hand on the page. "Can I ask you something personal?"

She sighed. "There's no harm in askin', I s'pose."

"Why did you never go out with anyone after Bill Dwyer?"

She slid the magazine from under his palm and went on turning the pages as if she hadn't heard.

"I mean, you didn't, did you? It's not as if you hadn't the offers."

"Oh, I had offers all right. Offers galore."

"Well, why then?"

She closed the magazine and stood up from the table. "Why-oh-why?" she chanted. "'Why did Leonie have to live among fools, surrounded by high walls, fenced in by rules?'" She looked

at him in the mirror and laughed. "Remember that?"

"I heard it somewhere before all right but I can't think where."

"You'll have a woeful head in the mornin' so you will. If I was you I'd go straight upstairs without callin' in to see anyone. You don't wan' makin' a show of yourself in front of your auntie an' the Comma'dant."

* * *

A few days later he sat in the kitchen and listened to a French station on Leonie's radio. The turmoil on the Paris streets was giving way to endless rounds of debate and argument. The students were talking themselves back from the brink of revolution.

Maybe the Commandant was right: he had warned Cormac that the French were a hot-blooded race with nothing more than a passion for street theatre. It was their pattern to rush forward and then double back. Maybe half-baked revolutions were part of their culture – like Perrier water or *pâté de fois gras*. He turned the radio off.

Leonie came in late. "Well, well. Look who's here. I was beginnin' to think you'd gone back to Wes'meath." She took off her coat, hung it on the back of the door and sat at the table opposite him.

"Not yet. But I may do that one of these days."

"Where were you so?"

"Nowhere much. Walking about the countryside, putting nought and nought together and getting nothing." He poured her a glass of brandy.

"You're a week home now. Out before anyone's up, an' back at God knows what hour. Night after night drinkin' yourself into a stupor. Has your auntie told you yet what's on her min'?"

"No. She keeps putting it off. 'We'll talk in due course.' That's all she says."

"An' I s'pose you never wen' back to see Imelda." She sighed. "My God, but men are the selfish breed."

"All men?"

"Maybe there's one or two you could trust." She reached out to turn on the radio, but he intercepted and held on to her hand.

"Such as who?"

"Your uncle, for one. I'm . . . very fond of that man. Can you understan' that?"

"You mean you love him?"

"I s'pose – but not in the way you're thinkin'." She removed her hand gently from his and lit a cigarette.

"Would you feel that way if he wasn't in a wheelchair?"

"I don't know. I'd want to, but maybe I wouldn't get the chance."

"What do you talk about when you're wheeling him around?"

"Everythin' under the sun. It was queer at first: we hadn't an awful lot to say to each other. Then, one day it all changed. He started talkin' about his chil'hood an' growin' up in Belmont, so I tol' him about my fam'ly. I tol' him personal things. He asked me if I was still seein' Bill Dwyer."

"He did? How did he know about that?"

"Not a lot goes over the Comma'dant's head, believe you me. He may find it hard to talk but he takes everythin' in. He says the Congo opened his eyes to life. He talks about that a lot. Anyway, he's got you sized up to a tee, that's for sure."

"What does he say?"

"He says it'll take you time to fin' yourself after all you went through. He says you're only shelterin' yourself against any more knocks, perchin' up on your iv'ry tower. But he says you'll come down to earth some day, sooner than you think."

Cormac poured more brandy into both their glasses. "And what about you? What does he say the future holds for you?"

Leonie sat back in her chair, clutching the tumbler in both hands. "The future for me? I don't think we ever talked about that." She smiled and Cormac noticed a playful look in her eyes. "Who knows? I might go an' work overseas: in India or Africa – runnin' soup kitchens for the poor, that kinda thing, you'd never know . . . "

That night he dreamed of Imelda. They were racing across the Curragh in a red sportscar and when they reached the barracks he slowed down but she shouted "Go on! Go on!" He accelerated past the sentry and into the parade ground.

He swung the car twice around the square and sped back towards the barracks gate. A sentry was lowering the barrier and they ducked as the low-slung car swept out beneath the pole. He looked to see if she was all right – but it was Leonie he was beside, not Imelda.

In the rearview mirror he saw the sentry with his rifle raised; the barrel was aimed in his direction and seemed to follow him whichever way he turned. As a shot rang out he lost his grip and the car skidded: for a while it left the road and trundled across uneven grassland.

Without stopping the car Cormac regained control and brought it back to the road. Then he turned to find Leonie slumped against the dashboard, a thin crimson stream at the base of her skull.

It was dawn when Cormac got out of bed. After a moment looking at himself in the mirror above the sink, he dressed and walked straight around to the Lindemans' driveway. He stood at the halldoor and rang the bell.

At first there was no reply; then, as he turned to leave, he heard footsteps and Imelda opened the door. She was wearing a pale silk dressing gown and her hair hung loose about her face.

Immediately her cheeks coloured and she took a step back. "It's you. Where have you been?"

"I haven't been . . . I've . . . "

"You've what?"

He looked blankly at her.

"Were you sick?"

"Not exactly."

"What then?"

"Can we go somewhere and talk?"

"We are talking."

"Please, Imelda. It's important."

After a moment she pulled the door closed and started ahead of him down the steps. Then she walked around the side of the house in the direction of the summerhouse. Suddenly she stopped in the middle of the tennis court. "Well? I thought you wanted to talk."

"I'm sorry."

"I wish you wouldn't say that, especially when you don't care."

"I do care."

"Is that why you left me waiting for hours at the picket gate? If you were sick you could've sent a message."

"I wasn't sick."

"I see. You just decided to stand me up for no particular reason."

"I don't know. There are things I haven't worked out."

"What things?"

"Things that are happening."

"What are you trying to tell me, Cormac? Are you saying there's someone else?" She looked at him and her eyes were moist with tears. "I don't care how much it hurts: tell me the truth, Cormac, for God's sake."

He reached out and took her hand. "Imelda, I love you and I can't lie to you . . . "

"Then there is someone else."

"Yes."

"Someone you met in France, I suppose. I guessed as much. Do you love her more than me?"

"Yes. I think so. But in a totally different way. It's hard to explain. But if it's any comfort . . . "

Suddenly the last traces of composure deserted her. She slumped on the grass and buried her face in her hands. When he reached down to touch her, she pulled away. "Go away, Cormac. Leave me. I wish I'd never met you. Leave me. Leave me alone."

After a moment he turned and walked away. As he passed the house Mrs Lindeman met him and demanded to know what he was doing prowling about so early in the morning: it was not yet

six o'clock. He pointed her in the direction of Imelda and left as quickly as he could.

* * *

Eddie was wearing an ill-fitting brown suit when he arrived at the handball alley.

"There's a party meeting tonight. I'm standin' for the committee of the youth cumann," he explained when he saw Cormac's look of surprise.

Cormac held the handball he'd brought along for the occasion and stared at Eddie. "Don't tell me you've joined . . . "

"I am telling you. It's the only way to get things done around here." He tugged the flaps of his jacket pockets. "You wouldn't be interested in joining by any chance?"

"No thanks."

"Too bad: Ireland's loss. Well? I haven't much time, so what can I do for you? You mentioned on the phone that you wanted me to make some enquiries."

"It's to do with my uncle's will. I want to know who the beneficiaries are and all that. The whole package, right down the line."

"Jesus, Cormac, that's a tall order. I'm not sure the Grealeys would . . . "

"OK then. Just find out about Belmont."

"Belmont?"

"Yeah. You know he owns the estate and lands at Belmont. I want to find out why the plans to sell them fell through a while back. There's something going on up in our place and I can't figure it out. I've a feeling it's all to do with Belmont."

Eddie looked perplexed. "Then you don't know . . ?"

"I don't know what?"

"Belmont . . . " He stopped again.

"Belmont what?"

"Listen, Cormac. I'm not free to tell you, but I think you should talk to your uncle about Belmont. Ask him about it, but

don't say you spoke to me or anyone from Grealeys'."

"Eddie, what do you mean? Stop talking in riddles."

"It concerns your uncle's will. He revised it a year ago and lodged it with our firm. I'm not meant to talk about it."

A wave of rage swept through Cormac. "All our life . . . it's been the same."

"What do you mean?"

"Things coming up that we can't talk about. Taboos and fucking secrets. I'm sick of them." He picked up his coat and started to leave the alley.

Eddie caught his arm. "Where are you going?"

"I don't know. I'm just going."

Eddie held on to him. "What things are you talking about?" Cormac shrugged and shook his head. "If you're talking about . . . my father and Leonie, it's OK. She told me herself."

"Leonie?"

"Yeah. Leonie MacBride."

"Jesus, Eddie."

"I know all about it. It's OK, I swear."

"Have you any idea how that . . ?"

Eddie nodded. "I know. It only dawned on me a while back. That was the problem all along, right? Not what I thought it was."

"And she told you about it? Leonie told you?"

"Yeah. One night I met her bringing food to the old man and she said it right out. I half knew from seeing them together once – here, in fact. But that was years ago and I'd put it clean out of my head. I just couldn't handle it, I suppose."

"Holy fuck!"

Eddie began to laugh.

"What's so funny?"

"It was probably food she nicked from your auntie's place that she used bring Da. She's a right tearaway that one, there's no doubt about it: a law unto herself."

They stood looking at each other for a while and suddenly they both laughed.

"God, Eddie. I'm sorry. I should maybe have said something before. But how could I? I could hardly . . . "

"You're not to blame. You made your share of advances, God knows. I was the stubborn bollix."

"Well, one way or the other, it's all over now. If you weren't wearing that . . . party political uniform I'd challenge you to a game – just to celebrate." He bounced the ball and Eddie caught it.

"Never mind the suit. You're on. But whether you win or lose, I can't tell you about your uncle's will. That's a professional secret. OK?"

"C'mon, you professional bollix. Serve and shut up."

<p style="text-align: center;">* * *</p>

There was a knock on the door and it took Cormac a moment to get his bearings. He felt as if something was pinning his head to the pillow; his throat was raw. He turned over in the bed.

There was another knock and a female voice asked: "Cormac, can I come in?" Before he could answer, Angie was in the room. "Hi, stranger," she said. "I was sent to get you up for lunch."

"Angie. What are you doing here?" His voice was little more than a whisper.

She kissed him on the forehead and sat on the bed. "Everytime I see you you're in bed, you know."

"When did you arrive?"

"About an hour ago. I drove over. Aunt Maeve invited me to lunch."

"And Dad? Is he here too?"

She shook her head.

"Is he OK? Is that why I was summoned back from Paris?"

"He's OK, I suppose. At least he's not drinking."

"You don't sound too happy. Is something wrong?"

"We'll talk about it later. Come down and have some lunch." She opened the window.

"I don't feel up to lunch somehow." His voice was still croaking. "'We'll talk about it later.' That's all I ever hear."

"It sounds like you had an overdose last night. I hope you're not following in Dad's . . . "

"Last night was an exception."

"Like the one before, and the one before that. I heard all about it from Leonie."

"I keep dreaming I'm back in Paris. Oh, my head!" There was a cup on the bedside table. Cormac picked it up and swallowed some cold coffee. "Good old Leonie."

"I must say she looks after you better than you deserve." She went to his bookshelves and spent some time examining his books. "Have you read all these?"

"No. Most of the ones I read I give away." He tried to sound chirpy. "You can tell a lot about a person from the books he hasn't read." He lit a cigarette. "How's that for an early morning aphorism?"

She smiled. Watching her there reminded him of how he used to see his mother when he came to Drumaan first.

"Yes, she really pampers you, doesn't she?" she said, coming back to sit on the bed.

"Who?"

"Leonie."

"I suppose she does."

"She's a strange girl. I wonder what keeps her in a dead-end job like this."

"I don't know. I keep expecting to come home and find she's left."

"Aunt Maeve tells me you've got involved with some African aid project."

"Yes. I'm thinking of going to work in Kenya in a couple of months' time. It's a Canadian project aimed at improving the country's grain yield. The idea is that with a new variety of seed . . . "

"Oh, Cormac. Not another . . . "

"You don't understand. They're adapting fertilizers to suit the soil . . . "

"They're promoting Canadian technology, that's all."

"What do you mean?"

"I mean the Kenyan government has taken over large areas of scrubland that's been used for generations for grazing. In the end the country will need more and more imported machinery and the old African lifestyles will be wiped out."

"Where did you learn all that?"

"In Westmeath, believe it or not. We have newspapers now. And television. It's so long since you were there you probably didn't know that."

"Oh, oh! So that's what this visit's about. I was beginning to wonder."

"In short, yes. At least that's why I agreed to come."

"And is Aunt Maeve part of this plot to get me back to Westmeath?"

The gong sounded from the hall and Angie said: "There's no plot, believe me. Just surprise that you don't seem to care for anybody unless they're three thousand miles away and dying of starvation. You'd better get dressed quick and come down. Think of it as feeding time in the mission hall."

Leonie was already ladling soup into plates when Cormac arrived in the dining room.

Aunt Maeve looked at him as he sat down. "Well, at least you're here in time to say grace."

"Angie'd better do the honours," he croaked. "I've lost most of my voice – and almost all of my religion."

Leonie served out the soup. Then she stood aside and blessed herself as Angie said: "Let me see, do I remember this? Bless us, O Lord, and these thy gifts, which by thy bounty we're about to receive through Christ Our Lord, amen."

After grace Angie was the first to break the silence. "Cormac was telling me about the project he might be working on in Africa."

"I'm not sure a French degree in arts and letters will be of much use in the African Bush," Aunt Maeve commented.

"Oh, I don't know. He can always teach languages – that's assuming he ever gets his voice back."

Leonie was fiddling about at the sideboard. Aunt Maeve flicked open her table napkin. "I'll ring when we're ready for the main course, Leonie."

"Yes, Ma'm."

She set a little golden bell beside Aunt Maeve and left the room. Angie watched her leaving.

Aunt Maeve noticed. "I know you think it's a bit old-fashioned of us to have a maid, Angela dear. And maybe it is. But I could never manage on my own, what with Frank in his present condition. Leonie's more like a nurse or a house companion than a maid really. But she does tend to go into trances from time to time and forget where she is."

"I hope you don't mind me saying so, Aunt Maeve: if she's a house companion, you should treat her like one. Not like some undomesticated waif to be banished to another room."

The colour drained from Aunt Maeve's cheeks. Cormac glanced around the table. The Commandant had perked up, alerted by the sound of battle.

Angie was clearly agitated. "I'm sorry, Aunt Maeve. I didn't mean to imply . . . It's just that, I don't know, over the years Leonie's role has obviously changed – maybe in such a gradual way that you haven't really noticed." She waited for a response, but Aunt Maeve said nothing. "Surely the era of the maidservant is over, even in Drumaan."

Cormac was surprised enough to partially regain his voice. "Bravo, sister! Welcome to the proletarian camp."

His uncle looked at him sternly.

Aunt Maeve stared at the floral centrepiece, sullen-faced. "I can't really argue with you, Angela. Maybe you're right. Maybe Leonie should eat at the table with us and sit with us in the evening, but a change like that would probably be as disturbing for her as it would for us. You do understand that?"

"I'm sure it would," Angie agreed. "Change is never easy. It takes courage on all sides. What do you think, Uncle Frank?"

The Commandant fiddled with his napkin ring. "We don't

want . . . to lose her . . . " And he flashed another cautioning look at Cormac.

Aunt Maeve picked up the bell and, after a moment's hesitation, tinkled it to beckon Leonie from the kitchen. "Maybe we'll all feel better when we've had some roast beef," she said.

While Angela put her radicalism into practice and helped Leonie with the dishes, Cormac sat on the garden swing-seat beside his aunt. The Commandant was dozing in the sun some distance away.

Aunt Maeve said she was knitting a cardigan for her husband, something he could put on and take off himself. "He values every little bit of independence he can get, you know."

"That's very thoughtful."

"It's the least I can do, though I was never very good at knitting. I must admit he depends on Leonie a lot more than on me at this stage. You've no idea how much she does for him. Nothing seems to . . . disturb her." She sighed and was silent for a while. "I suppose I shouldn't resent how he favours her. Did you notice his panic during the argument at lunch?"

"Was that what it was? I was wondering. He seemed to be warning me not to add fuel to the fire?"

"Yes." She smiled. "Angela's a plucky girl, always was. But you should know she's going through a bit of a crisis at present. In her personal life, I mean. That's why I didn't put too much store by what she said."

"What do you mean, a crisis? Has she spoken to you about it?"

"She had a relationship that broke up recently, you know. I don't know the details. It seems she had to choose between some impatient young man and her commitment to looking after your father. She made the difficult choice."

"My father? But I understood he was off . . . "

Aunt Maeve spoke quickly. "Shh! Here she is now. He's not drinking but he's been suffering very black depressions. You should think about going to see him more often . . . Ah, there you are, Angela dear. Come and sit down."

"Aunt Maeve, I want to apologise for what I said at lunch. It was neither the time nor the place."

"Don't worry, dearest. I know you've been . . . under pressure recently. No harm done."

Cormac sighed. "And so one more revolution bites the dust. 'Oops, there goes another rubber-tree plant.'"

While Leonie took the Commandant for his afternoon stroll, Aunt Maeve ushered Cormac and Angie into the drawing-room and poured three glasses of sherry. As she handed them around she explained why she had convened this little family conference.

She had just learned, completely by accident as it happened, that almost a year ago to the day their uncle had revised his will. While she was to inherit the house in Drumaan and all his pension rights, the bulk of his inheritance, namely the estate and adjoining lands at Belmont, was being let go out of the family.

"Let me guess," Cormac interjected. "He's leaving it to the local people. Good old Uncle Frank!"

"Not quite," Aunt Maeve said. "Even that would seem . . . less crazed."

"Then to who?"

"To some charity, perhaps," Angie suggested.

"No. He's bequeathed Belmont, the house and all its lands, to Leonie MacBride. Keep your voices down. It's more than likely she doesn't know yet. And, if I have my way, she never will."

"I don't believe it," Cormac exclaimed.

"I found it hard to believe at first. But I have it on the best authority . . . "

"You mean you didn't ask him outright?"

"No. Knowing Frank as I do, that would be a disastrous move."

Angie looked uneasy. "So what do you expect us to do?"

"For the moment, very little. Frank's still in good health, comparatively speaking, of course. And if he's revised his will once, he may well decide to revise it again. What I can't

understand is how the Grealeys allowed a man in his condition to make such a will. They must know he's on heavy medication. But then lawyers are a self-serving breed, as I've learned to my cost more than once. But, one way or the other, the will must be changed or contested, either before or after he dies, preferably before."

Cormac stood up and paced about the room. "I can't believe what I'm hearing."

"Well, you'd better believe it. You're the one he has passed over. The irony is Frank always said: 'Family is the first line of defence'. But, apart from the loss of the property, can you imagine the gossip this could cause? How it will look if his estate is left to the young woman who nursed him so intimately in his latter years?"

Angie looked at Cormac but he was speechless. "I'm still not sure what you think we can do, now or in the future," she said.

"Well, for a start we can be on guard, all of us. We should watch her very closely. It's utterly impossible for me to let her go in the light of this. If he feels so strongly about her, he would surely go public in her defence."

"What do you mean 'be on guard'?" Cormac asked.

"I mean watch out for any signs that she has taken advantage of her role or of his condition to influence his decision. We must pool our observations. There are rumours about her that should be investigated, you know. If it comes to it, we may well be depending on such evidence when we contest the will."

"I think I need some air," Cormac said, going to leave the room. Before he reached the doorway he stopped. "I'm not at all sure I can go along with this. I'm not sure it isn't an inspired decision on Uncle Frank's part. I need to think about it a bit more."

Angie stood up and followed him. "Wait, Cormac. For once in your life don't run away. This is important. There's a choice to be made here."

"I know. That's why I want to go and think . . . "

"*Stay* and think, why don't you. For once. First, you should

know the situation. Dad is getting on in years and he's not well set up for the future. In fact, he's seriously depressed at the moment and I'm scared to death he's going to go back on the drink. Don't you see? If you were to inherit Belmont, it could change everything."

"Angie, what are you saying? I can't rewrite Uncle Frank's will. And even if I could . . . "

Aunt Maeve stood up and went over to the sherry decanter. "I think you could play a part, Cormac. Frank's very fond of you, you know. He holds you in the highest regard. You above all people are in a position to influence his decision." She refilled his glass and handed it to him.

"Listen to what Aunt Maeve's saying, Cormac. It's one thing to want some measure of equality and dignity for Leonie. I believe in that too. But there are limits. Even you must see that."

"If there are limits, Angie, it's not up to me to decide them. Why should we have an automatic right to inherit property and not Leonie? She has devoted herself to working for him, far beyond anything that might've been expected . . . "

"Maybe she knew very well what she was doing."

"Angie, really. Uncle Frank has made his choice and as far as I'm concerned he's done it for the best possible reasons. Not just as a reward to Leonie, but in the interests of the people of Belmont."

Aunt Maeve intervened. "Do you really believe it would be in their best interest? Do you think she's capable of a task of that scale?"

"Yes, I do."

Angie sighed impatiently. "Cormac, do you not feel even the slightest trace of resentment that you were passed over?"

"Yes, of course I do, Angie. But I despise that in myself. I'm not going to make that kind of thing the basis for how I live. Now or ever."

Angie went back to the sofa and sat down in exasperation. "Oh, what's the use? You don't care a damn for your father. Or me, for that matter. It's only some damn high-falutin' notions

you picked up from that lunatic Belfast friend: that's all you care about. That and growing wheat in Kenya."

Aunt Maeve patted her hand. "Don't be upset, dear. Maybe Cormac *should* go and have some air. Maybe he does need time to think about it. We've got to be patient." She raised her glass. "Here's to good sense: may it prevail."

"I'll drink to that," Cormac said.

But Angela sat with her arms folded, staring at the hearthrug in front of her.

* * *

The next morning Leonie came to Cormac's room very early.

"This arrived for you yesterda' but I didn't wan' to leave it lyin' about the place." She handed him a postcard with a French stamp and opened the curtains to give him light to read it. The card was a reproduction of the painting *Déjeuner Sur l'Herbe*.

> Mon cher,
> Finally I take your advice and leave my boring lodgings. I ring two or three times from Lorient to tell you I move. Someone called Leone (?) is answering always, saying you are away.
> There are many young people here, not like chez Lorient! Still, I miss our little after school rendezvous. I write you my new address soon. But I expect by now you are back with your blue-eyed irlandaise!
> Amour et chagrin,
> C.

"Well, is it good news or bad?"

Cormac laughed. "Are you tryin' to pretend you didn't read it?"

"I've tol' you before, I don't read other people's letters. Or their pos'cards, for that matter."

"Well, there's no talk of pregnancy, if that's what you're worried about."

"I see. Is she the reason you cooled off Imelda?"

"Maybe. Maybe not."

Leonie lit a cigarette and absent-mindedly played with a metal lighter. "I s'pose you'll be off again now, traipsin' about the country like a los' sheep."

"Probably." He reached out and grabbed the lighter out of her hand. It was crudely engraved: *To Leonie, from Bill. June 1960.* He looked at her and handed it back.

She examined it before returning it to her pocket. "Yeah, I s'pose I never really got over Bill Dywer. I don't understan' it, to tell you the truth. It's not as if he was that . . . Oh, I don't know. Who understan's these things?" She glanced at his books. "Does anyone, d'you think?"

"Don't ask me. I don't, that's for sure."

She picked a pillow off a chair and tossed it at him before sitting down. "So, tell us. Who's this C one, an' how did you meet her?"

"Claudette, you mean? Hey, I thought you said you didn't read other people's cards." He tossed the pillow back at her. Leonie caught it and laughed.

"You should've heard her on the phone. 'When you sink he comes back?' It sounded like she was gettin' desperate. 'He missing his French conversation lessons, for sree week in a row.' Some lessons! 'What are you missing?' I felt like askin' her."

"My, but you jump to conclusions."

"It's jus' as well it was me answered the phone an' not your Aunt Maeve. She thinks butter wouldn't melt . . . "

Cormac interrupted her: "Tell me: how long have you known about the Commandant's will?"

She looked at him blankly. If it was an act, it was a good one. "What will?"

"The revised will. You must've wheeled him over to Grealeys'. Or did they come to the house some day Aunt Maeve was out? About this time last year."

She stood up and walked to the door. "I don't know what you're talkin' about."

"I know: like you don't read other people's letters. Or listen outside doors."

"You're one to complain about spyin'."

"So, what do you know about it?"

"I know he asked me to bring him over to Grealey's. I'd to ring them first an' set up the meetin'. Then the three of them sat for an hour downstairs in Carol Phelan's record shop. I was sent to do a few messages an' Carol had to lock up for th'hour. Beyon' that I know nothin'. An' why should I know? Whatever they talked about had nothin' to do with me."

"I know when you're lyin', Leonie. It's as clear as daylight."

"All right," she said, going back to her chair. "He tol' me one day he was leavin' a small token to myself an' Seamus. I was to use it wisely, he said. Sometimes a win'fall like that could bring more harm than good. That's what he tol' me."

"So, what do you reckon it is?"

"God, what a way to be talkin' an' him still breathin' below! I don't know. Maybe it's a few hundred pounds. Wouldn't that be somethin'? Enough to get me started some place on my own."

He looked at her and lay back in the bed. "Then you really are a remarkable creature, there's no doubt about it. So it's Bill Dwyer that's kept you here, not what I was beginning to believe."

"You know what I think, Cormac? I think you've always had it in for Bill, ever since you firs' came here. An' d'you know why?"

"Why?"

"Because you knew I was mad about him."

"Are you serious?"

"You were jealous, why don't you admit it?"

"Well, well! Guess who fancies herself?"

"I know what goes on in your head, even if you don't know it half the time yourself."

"What do you mean?"

She tossed the lighter across the room and he caught it. "Here you can keep that. I won't be needin' it any more. I'm givin' up smokin'. An' I'm also givin' up dreamin' about th'impossible."

"Wait a minute, Leonie . . . "

He leapt from the bed to stop her leaving, but by the time he reached the door she was already on the landing below.

* * *

Apart from a milk van purring from door to door, the Pearse Estate was lifeless. Cormac stood outside Eddie's house and rang the bell for a second time. He heard the sound of bare feet on the stairs and the door opened.

A young woman with long blonde hair stood in the hall in a dressing gown. She looked at Cormac without saying anything.

"Hello, I'm Cormac Mannion. I'm sorry to wake you at this hour. I wonder if I could talk to Eddie."

"Come in. I'm Eleanor."

She led him down to the hall to the kitchen and asked him to wait there.

"I'm sorry to have got you up so early."

"That's OK. Would you like a cup of tea?"

"I'll make it myself. You go back to bed if you like."

She smiled. "OK. I'll get Eddie up, but it could take a while. He's like a bear in the mornin' at the best of times and he spends ages groomin' himself, so make yourself at home."

She pulled the kettle over to a hot plate on the range and showed Cormac where the tea things were kept. Then she smiled again and left the room, closing the door behind her.

The kitchen was warm and tidy, the children's toys and comics neatly stashed away in an alcove. In another alcove beside the stove clothes were drying on a rack. There were pictures on the mantelpiece above the range, including a wedding photograph showing the Corporal and Eddie's mother. There was also a photograph of the old woman Cormac had spoken to in Belmont. She was standing in the doorway of her cottage beside a tall, dignified-looking countryman with a pipe.

Cormac sat at the table sipping his tea. Eddie had washed and dressed himself before he came to the kitchen. He scratched his

head and yawned a lot, but insisted he was glad Cormac had called. "I've often wondered what the world looks like at seven in the morning."

"This part of it looks good. At least to my eyes."

"Yeah, this room's OK. I like it too."

"You never told me you had such a beautiful sister."

Eddie laughed. "I reckoned you'd enough complications in your life. And so has she."

"I saw her briefly the day I came to visit you when you had the flu."

"That's going back into history, isn't it?"

Eddie brought over a mug and filled it with tea. "I suppose you're wondering what we found out about Belmont. I was going to contact you today."

Cormac stayed talking to Eddie till, one by one, the whole family converged on the room. The kids were surprised to see a visitor so early in the morning and he enjoyed their curiosity. He was intrigued at how Eddie's mother prepared them for school and dealt gently with them, making each one feel especially cared for, the centre of all her attention.

When Philomena appeared and saw Cormac she blushed, but he winked to assure her he would not reveal her secret employment. Eddie was busy preparing breakfast and Mrs Dwyer insisted that Cormac stay and eat with them.

Eleanor was the last to appear and it was clear that she'd gone to some lengths to do herself up. Her hair was swept back in a tight bun and her face was finely shaded. One of the younger kids wolf-whistled when she came to the table, and everyone laughed, including Eleanor. Mrs Dwyer beamed at her daughter and seemed equally pleased that Cormac was so comfortable in her home.

When the younger kids had run out to play, Eleanor and Philomena tidied up and Eddie went to prepare himself for work. Cormac looked at the photograph on the mantelpiece.

"I met your mother once," he said to Mrs Dwyer. "So I think I know where you get your hospitality from."

Eleanor breezed about the kitchen, cleaning the table and brushing the floor, and Cormac found it hard not to stare at her. Once or twice she caught him admiring her and smiled. And when he was preparing to leave with Eddie, she nudged her mother – who promptly asked if he would come to dinner with the family the following Sunday.

"She means lunch in your lingo," Eleanor explained.

"I'd love to," Cormac said. "But I don't want to put you to any trouble."

Eleanor laughed. "As long as you don't object to our usual sorbet and truffles and roast venison with blueberry sauce, you're more than welcome."

"Don't mind her," her mother said. "We'll have a good stew and we'll put you in the pot."

"That sounds better to me."

Eleanor rolled her eyes playfully. "You're as bad as this lot. Sometimes I wonder why I bother."

On their way up town Cormac told Eddie about Imelda.

"Jesus, Cormac. You've really been in the wars."

"Imelda's the one that's left with the scars. Maybe you and Ann Marie would try to distract her if you can and include her in your plans. I hope she meets someone who treats her . . . better than I was able to."

"So, what are you goin' to do if you go back to Westmeath?"

"I don't know yet. Get a teaching job, if I can, and try to look after my father for a while. I'll see how it goes. All I know is Angie needs a break. She's held the fort single-handed all these years and I think the strain is beginning to show."

* * *

After he'd spoken to Leonie she stood up from the kitchen table and went upstairs to her room. He made his way to his own room and sat at his desk to write her a letter. It took a lot longer than he expected, in spite of the many hours of preparation since his return to Drumaan.

When he had finished the letter – and had written shorter notes to Aunt Maeve and the Commandant – he packed the possessions he needed into two cases and left the room. On his way downstairs he slid one letter under Leonie's door and put the others on the hall table. Then he let himself out of the house by the front door, closing it quietly.

He had an hour to wait in the station before the train for Athlone arrived. It was futile to dwell on the situation he was leaving behind. He had said all he had to say. The next moves were Leonie's and Aunt Maeve's. He tried to turn his attention instead to his father and Angie.

In two hours he would be walking up a steep driveway to a flat-roofed, two-storey house. The bus from the station would drop him quite near his home, but it would be still a long haul. It was part of his father's stubborn character, Aunt Maeve had once told her bridge friends, that he had put such a plain building in such a lofty setting. It was probably the only decent hill the length and breadth of Westmeath and he had crowned it with a concrete slab.

Suddenly the train was there, pulsing impatiently while people boarded. He sat at a window and looked out at Drumaan station. Eddie was right: he had only been passing through. Other passengers were reading magazines and papers, oblivious of where their journey had paused. The first person Cormac had met when he waited on that platform so many years before was Leonie's lover and Eddie's father.

Two hours later, as he stood in front of his father's house, he could see some truth in his aunt's perspective. It was an unspectacular grey construction, designed and built by his father while he was still an engineering student in the late forties. Its plainness was almost aggressive, a proclamation of sorts, a rejection – as though its location on a hill overlooking a small lake was all that had to be said. It had a rough concrete finish and made no concession to ornament or frill: lichen stains were the only relief.

It was hard to imagine a greater contrast to the house Cormac

had lived in all these years – he would miss the verandah and balconies, the dormer windows and ornamental gables. After Drumaan his father's house seemed smaller than he remembered, its grounds more cramped. His mother's flowerbeds had long gone to seed.

As he examined the "concrete slab" he became aware of a figure not unlike his mother in one of the upstairs windows. Angie was watching him and had both her hands on her cheeks in an expression of disbelief. When she realised he had seen her, she waved her arms above her head.

Moments later she ran down the driveway towards him and held him in her arms. Then, as she led him towards home holding him close to her, his father appeared, smiling, and waited for them in the doorway.

* * *

It was over a week before Cormac had any word from Drumaan. The first letter was from Aunt Maeve. As usual it began as a catalogue of rebukes.

> I suppose you're very proud of yourself for having defied my wishes and alerted all the world to your uncle's revised will. Really, Cormac, after all these years I think you might have handled the matter more discreetly. I feel I should be more angry with you than I am. Maybe, in some ways it's a bit of relief to have it out in the open. At least I won't have to wake up now having nightmares about Belmont.
>
> But I can't imagine why you apprised Leonie of her new status at this stage. The net result was that she went moping around the house in a state of shock for days after you left. Really she looked as if it was her who'd been abused and not us.
>
> At one stage I began to fear we were about to lose her and I even found her packing furtively in her room. In the end I had to plead with the silly girl and remind her of the Commandant's dependence on her. I offered her a new position in the house *and* the Commandant's old room, but she declined the latter; instead, she said if you

weren't coming back she'd prefer to move into your room. (I can see her point as it's easily the airier of the two in that part of the house).

All of which brings me in a roundabout way to the question of your plans. Should I give her your room or not? Even if I do, we'll expect you to come and stay from time to time – and I trust, for your uncle's sake, you will do just that and remember how kind he has been to you over the years.

Perhaps I should advise you that, sadly, the prognosis for Frank's life is not very encouraging. It's expected that he will regress in the next few years and that he may not be with us for long after that. But we must take each moment as it comes and thank God for every day he remains in our company.

Cormac, I don't know if you still plan to go to Africa or not, but we want you to know you will always be part of our lives and we will continue to help you in any way we can. Frank has asked me to tell you he has money set aside for you to continue your studies and that remains at your disposal as long as you need it. Write to him soon in response to this offer; it's the least you owe him.

In the meantime give our best wishes to your father and Angela – and try to refrain from telling the *whole* world of our tribulations.

Your devoted aunt,
Maeve.

PS: I had a visit from your friend Eddie and his very elegant sister a few days ago, wondering why you had failed to turn up for a luncheon appointment. Really, Cormac, you *are* impossible. Such a lovely, mannerly young pair. Write and apologise without delay.

The second envelope, when it arrived, contained a hand-written letter – as well as another postcard from Paris which Cormac read and tossed aside. He left the house then and walked down to the lakeshore to read Leonie's letter without interruption.

It was a calm morning and the black water was mirror-still. A solitary heron swooped off a rock and curled over the lake to the far shore. He watched till it had found itself another perch and

declared its new territory with a sharp cry. Then he looked back up the hill at the rock he now called home.

Dear Cormac,
I got your letter and ran after you when I read it, but you were gone. I was going to follow you to the station but I had to look after the Commandant. Your auntie was in that bad a state of shock when she read your note, she nearly had to be nursed the same as himself.

I did what you asked for Seamus and gave him the stone from your room. You'd think I was after giving him a real diamond. He went away polishing it and mumbling poetry. I don't know which of ye is the madder, you or that old headcase!

About the other things you wrote in your letter, I had to do a lot of thinking. It was nice you writing like that, especially as I was feeling let down by you going so sudden like. At one stage reading your words I thought I was dreaming. Over the years I often woke up too, thinking about you that way and I wanted to go across the landing just like you did. But then I was always afraid you wouldn't feel the same.

But those times are over now. Too much has happened since. You're a man now and you speak French and understand politics. You travel in foreign countries and sit in posh restaurants talking about things I know nothing about. You belong with the Lindemans and Donovans and Connollys, being served tea by the likes of me – not trying to hide me in front of your kind.

You wrote that you only came to know how you felt through your dreams. Well, if that's how these things are discovered I must have the same feelings about you. I know I was wild jealous of that Claudette one after she phoned and I had bad nightmares about her – somehow I never dreamt about Imelda. I suppose I knew that couldn't last.

I've got to go now. Your uncle needs to be given his medicine and probably a change of clothes as well. He always says "Horse shit!" whenever he does that to himself. He's such a proud man, it's hard on him you know.

I'll probably take him for a walk then and we'll chat about you and your auntie and what can be done about Belmont. Since you told him I knew about the will, he

talks a lot about Belmont and I feel a bit less frightened about taking it on than I did at first.

The house is always quiet when you're away. You should hear the silence in the dining room. Sometimes I think the clock must be mortified that it ticks so loud. But, funny enough, there's something I like about the quiet here. I think, after all the years, I'd miss that and all the familiar voices if I went to live somewhere foreign with you the way you said you wanted.

I hope you'll write to me from time to time and maybe come and visit. You can tell me the ordinary things in your life, how you're getting on, who you met, that kind of thing. I'll pass on your news to your uncle. But don't tell me too much about your personal life: that would only make me have nightmares again.

I will be looking forward to hearing from you soon,
Your loving friend always,
Leonie.

PS: I'm still off the fags, you'll be surprised to hear – but I haven't been doing so well quitting dreaming about the impossible.

THE END